A SURVIVAL KIT FOR THE SECONDARY SCHOOL ART TEACHER

Helen D. Hume

Parkway West High School
St. Louis County, Missouri

PEARSON

Pearson Education, Inc.
Upper Saddle River, New Jersey 07458

Library of Congress Cataloging-in-Publication Data

Hume, Helen D., 1933–
 A survival kit for the secondary school art teacher / Helen D. Hume.
 p. cm.
 ISBN 0-87628-798-4
 1. Art—Study and teaching (Secondary)—United States—Handbooks,
manuals, etc. I. Title.
N363.H86 1990 89-77071
707′.1′273—dc20 CIP

© 1990 *by* The Family Education Network

Permission is given for individual classroom teachers to reproduce the student project and notes pages for classroom use. Reproduction of these materials for an entire school system is strictly forbidden.

Printed in the United States of America

20 19 18 17

We thank the following for permitting us to use their artwork:

The Saint Louis Art Museum
Smelt Brook Falls, Hartley; *Keith*, Close; *plate, bowl and jar*, Martinez; *Ancient Mycenaean statuettes; Little Fourteen Year Old Dancer*, Degas; *New Continent*, Nevelson; *Woman in Armchair*, Matisse; *Fishing Boats at Saintes Maries-de-la-Mer*, Van Gogh; *Builders #1*, Lawrence; *The Auvers Stairs with Five Figures*, Van Gogh; *Peruvian jug (human head); The Lamp*, Stella.

The Museum of Modern Art
Cow, Calder

The Coyote's Paw Gallery, St. Louis
New Guinean mask

Artists
George Schweser, Barbara Aydt, Kent Addison, Martha Ohlmeyer, John Dunivent, Mary Ann Kroeck, Elizabeth Concannon, Holly Hughes, Judy Lehmer, Annette Ellis

ISBN 0-87628-798-4

FAMILY EDUCATION
NETWORK

www.pearsonhighered.com

ACKNOWLEDGMENTS

Art teachers acquire knowledge in so many ways: from our own professors, hands-on experience, research, and contacts with art teachers and other professional artists who generously share their own methods and ideas. I am grateful to all those who have added to my knowledge, and especially to my colleagues at Parkway West: John Dunivent, Mary Ann Kroeck, Joan Pirtle, and Timothy Smith, whose students' work is often used for illustrations.

Ideas and techniques shared by art teachers Beth Goyer, Bill Vivrette, Carlin Coleman, Carolyn Baker, Lauren Davis, Margot Hebert, Delores Stacy, Sonia Huxhold, Carolyn Uhley, Nancy Chrien, Alan Framm, Linda Bauer, Marilyn Bradley, Ann Grundy, and Ron Harriman were much appreciated and greatly enriched the book. In addition to the work of Parkway West students, other teachers who generously shared projects and allowed me to show their students' work are: Liz Busselmann, Mary Jo Wilmes, Steve Warren and James Saale. Pamela Smith-Hellwege and Dr. Elizabeth Vallance of the St. Louis Art Museum and Carol Washburne and Sue Hooker of the Museum's Educational Resource Center have proven an invaluable help in relating art history to classroom lessons.

Warm acknowledgments are owed to these professional artists who shared their expertise and, in some cases, photographs of their work: Dr. Harold McWhinnie, Jane Sauer, Holly Hunter, Bin Gippo, James Reed, Diane Beasley, Gretchen Brigham, Dion Dion, Barbara Aydt, Betty Concannon, Carolyn Uhley, Martha Ohlmeyer, Robert Fishbone, Sandy King Martin, George Schweser, Annette Ellis, Mary Jean Rowe, Kent Addision, Tom Yahnke, and Donna Stovall.

A special thank you is due the museum professionals and gallery owners who have helped obtain photographs for reproduction: Patricia Woods of the St. Louis Art Museum; George McKinna and Linda Dost of the Nelson Atkins Art Gallery, Kansas City, Missouri; Ruth Jensen and Richard L. Tooke of the Museum of Modern Art, New York; Alan Suits and Ann Lehman of the Coyote's Paw Gallery, St. Louis, Missouri; Sherron Gwynn of the Washington University Art Gallery; and Marie Waterhouse of the St. Louis Post Dispatch. Thanks also to Lelani Lattin Duke of the Getty Center for education in the arts, and to MacArthur Goodwin, the state art consultant of South Carolina, for allowing us to reproduce portions of publications on current research in art education.

Several of the projects in this book have been previously published in *Arts and Activities* and *School Arts*. I appreciate the generosity of these publishers for allowing the material to be used again.

Finally I wish to thank the staff of Prentice Hall who shared in shaping the book. Editor Ann Leuthner and readers who gave suggestions greatly influenced portions of the manuscript. I especially want to thank Sandra Hutchison, the editor who encouraged me and saw the manuscript through to publication.

I am very much in debt to all the people who have shared in the creation of this book. I hope that it adds to the store of knowledge of those who teach young people.

To Jack and Susan,
who made this possible

ABOUT THIS RESOURCE

Survival Day-by-Day: READY-TO-USE LESSONS AND PROJECTS

A Survival Kit for the Secondary School Art Teacher is for all art teachers who are looking for new ideas and techniques. The first ten chapters present ready-to-use lessons and projects with instructions and notes you can reproduce for student use. Each chapter contains enough projects to function as the basis of a semester course. Projects may also be taken from chapters throughout the book for a general art course. Chapters 1 and 2 focus on two- and three-dimensional design, respectively, using a variety of techniques. Chapters 3 through 10 focus on particular disciplines: drawing, painting, advertising art, ceramics, sculpture, crafts, printmaking and photography. Chapter 11 and the appendix give information about contemporary curricula and offer a variety of teaching strategies.

The art of teaching art is in a constant state of change, but the elements and principles of art on which our discipline is based remain the same. They offer us an ordered way of examining both student and historic artwork. In most of the teacher introductions there are references to historical artwork you can use when presenting the project to students.

We know that students must learn certain basic skills before they are able to produce quality works of art. Learning to *appreciate* art is also a skill to be acquired. Whether the technique is traditional, as with drawing or painting, or uses modern technology, as with photography, we are teaching students to see and to interpret what they see.

Helen D. Hume
Parkway West High School
St. Louis County, Missouri

ABOUT THE AUTHOR

Helen Hume is a teacher and department leader at Parkway West High School, St. Louis County, Missouri. In addition to the art history and photography courses she currently teaches, she has also taught painting, drawing, printmaking, sculpture, ceramics, and commercial art.

She has had several articles published in art education publications. A member of the National Art Education Association, she has presented art methods at a number of national conventions. She holds degrees from Webster University.

She is a member of the Board of Governors of the St. Louis Artists' Guild and specializes in printmaking, photography, and oil painting in her own artwork. While studying painting at Het Vrij Atelier, Antwerp, Belgium, she taught art at the Antwerp International School. She has also taught at the International School in São José dos Campos, Brazil.

CONTENTS

Chapter 1: TWO-DIMENSIONAL DESIGN

OBJECTIVES

- To teach students composition through the elements and principles of design
- To explain new concepts and the uses of tools and materials
- To improve basic artistic skills
- To build self-confidence by showing students that they are unique and that their ideas have merit
- To introduce students to art history and appreciation
- To offer open-ended projects that allow personal interpretations

INTRODUCTION

At the secondary level there generally should be an introductory course in art. It may be called Art I, Basic Design, Design Arts, or Foundation of Arts. Although students may enroll in advanced courses without having taken a preparatory course, most art educators consider a solid foundation a necessity.

Design is the vocabulary of art. This chapter will contain projects to encourage good composition through the exploration of the elements and principles of design. The elements and principles rarely are used by themselves but are combined to create a composition. Students should be encouraged to critically analyze their own artwork to determine if it could be more successful by adding or eliminating something.

The elements that will be explored in this chapter through one or more projects are: **color, line, shape, value,** and **texture.** The principles of **balance, repetition, space,** and **variety** should also be discussed with students. (See reproducible student notes, "Principles of Design" and "The Element of Color," which follow.)

Some students may never have taken a formal art class, while others may have been creating art for years. Let students know that although they have different ideas and degrees of skill, each one's experience is valued and you are there to build upon what they already know. It sometimes takes great finesse on the part of the teacher to draw out their ideas.

The first project should be nonthreatening—perhaps not a drawing project, but one where all students have the same opportunity to succeed no matter how well they draw. If students get off to a good start, they are usually willing to try anything later.

Although it is easy to give students something to copy, such as a scene from a magazine, this is not really teaching art. It is teaching copying, and fosters neither the feeling of achievement nor the originality that are so important. Students may use their own photographs as springboards for ideas, but when they copy photographs from a magazine, that is not the same as referring to an encyclopedia or other type of book to get information about a specific subject. One is called research; the other, plagiarism. Art teachers should teach a creative process that allows students to produce original art rather than guaranteeing a beautiful picture copied from another artist.

Students respond well to a variety of methods of presentation. As you choose projects to explore, think of ways to present them that do not involve long lectures. One of my students recently pointed out to me that "students our age have a twenty-minute attention span." Many cooperating school districts have film and videotape libraries that are rich in resource material. If possible, invite an artist to talk with your class.

In addition to introducing the elements of art, a good design course should teach students a few of the skills that they might learn in advanced courses. Art history and art criticism should be a basic part of each

course. A semester or one-year course could include introductory projects in various media. At the end of an introductory design course, students could be expected to have learned the following skills:

1. Recognize the elements and principles of art in composition
2. Understand how the picture plane relates to the composition
3. Take care of equipment and supplies properly
4. Make a thumbnail sketch
5. Recognize and be able to name artwork from a number of artists
6. Draw with various media: pencil, pen, brush
7. Paint with both transparent (watercolor) and opaque paints (tempera or acrylic)
8. Cut a mat to display work
9. Work with three-dimensional design

Student Notes 1.1: THE PRINCIPLES OF DESIGN

The principles of design are simply ways in which the elements of design are organized to obtain unity. In composing or analyzing a work of art, these principles need to be considered as they are used by an artist to create a desired effect.

Very few successful artworks exist that do not have a **center of interest**, or dominant area, sometimes called the **focal point**. This may be the lightest or darkest area in a work of art, and is usually the place that is first seen in the composition. *The center of interest is rarely in the center of the picture plane.*

PROPORTION: the pleasing relationship of all parts to each other and to the whole of the design.

SPACE:
> *THE ILLUSION*: three-dimensional space may be created on a two-dimensional plane.
> *ACTUAL SPACE:* space around a sculpture or architectural and environmental works of art.

VARIETY: the differences in scale, surface, line, value, and shape that gives interest to a composition.

BALANCE: balance is the equilibrium of various elements in the artwork.
> *FORMAL BALANCE:* symmetrical balance occurs when each side of a format has the same or similar elements.
> *INFORMAL BALANCE:* asymmetrical balance is achieved when each side of the format appears to have the same "weight," but the two sides are not alike. The objects vary in size, shape, color and position, creating an implied balance.

REPETITION: refers to the use of a motif or color in more than one place in a composition.

PATTERN: established through the repeated use of line or form.

HARMONY: the unity of all the visual elements in a composition.

RHYTHM: rhythm may exist in an artwork just as it does in music. It is the flow through a painting by the repeated use of similar elements such as color, line, or shape. It is the smooth transition from one part to another.

Student Notes 1.2: THE ELEMENT OF COLOR

Every time you choose something to wear or decorate a room, you are instinctively working with a color scheme. Because color awareness is an important part of your life, you should know that there is a theory of choosing colors that complement each other.

Color Wheel. The color wheel is a means of organizing the colors in the spectrum. The only colors not on it are black, white, and gray.

Colors are divided into groups

PRIMARY COLORS: cannot be produced by mixing other colors together: red, yellow, blue
SECONDARY COLORS: produced by mixing primary colors: violet, orange, green
INTERMEDIATE COLORS: produced by mixing a primary and a secondary color: ex.: blue green, red violet
NEUTRALS: white, black, gray, and brown

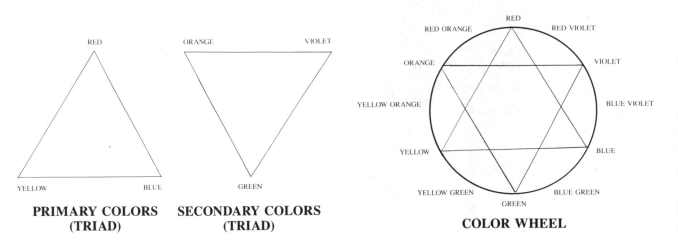

PRIMARY COLORS (TRIAD) **SECONDARY COLORS (TRIAD)** **COLOR WHEEL**

How to choose a color scheme by using the color wheel

 Color schemes may be selected by choosing colors from the wheel that will complement each other. These are:

MONOCHROMATIC: several values of one color. ex.: light blue, medium blue, dark blue
ANALOGOUS: colors that are next to each other on the color wheel. ex.: yellow, yellow orange, orange, and red
COMPLEMENTARY: colors that are opposite each other on the color wheel. ex.: red and green, violet and yellow
SPLIT COMPLEMENT: three colors that are opposite each other on the wheel, but to either side of the exact opposite. ex.: red, blue green, and yellow green
DOUBLE SPLIT COMPLEMENT: four colors, two on either side of two complements, but not the complementary colors. ex.: red orange and red violet, yellow green and blue green

TRIADIC: colors that are at equally spaced intervals on the wheel. ex.: red, yellow, blue, and orange, green, violet

ACCENTED NEUTRAL SCHEME: not based on the color wheel; uses neutral colors with one color as accent. ex.: black, white, red

Properties of color

HUE: the actual color, such as red

INTENSITY: the brightness or dullness (grayness) of a color

VALUE: different intensities of a color ranging from very light to very dark (tints and shades)

SHADE: change made in a hue by adding black

TINT: change made in a hue by adding white

The emotional properties of color

Colors are often associated with emotions. Most people have a favorite color, probably stemming from long traditions and impressions of color. The feelings one has about certain colors may come from the association we have with warm and cool colors in nature.

RED: often associated with evil or danger. It is dynamic when used in a design.

BLUE: a calm, soothing, and tranquil color, sometimes associated with sadness or depression.

YELLOW: a cheery color that embodies warmth and light.

BLACK: associated with bad luck; mournful, stark, dramatic.

WHITE: symbolizes purity, truth, innocence, and light.

PURPLE: a symbol for royalty or wealth.

GREEN: signifies life or hope.

Color Project: THE PAPER MOLA

FOR THE TEACHER

Molas are decorative pieces of cloth approximately twelve by eighteen inches in size that traditionally have been made by the Cuna Indians of the San Blas islands off Panama to use as the fronts of blouses. They are made from several pieces of colored cloth layered together; holes are cut in each layer to allow the different colors to show through. The sewing of these layers together is a form of reverse applique. Many of the molas are also decoratively embroidered. The bright colors and charming designs have made them known all over the world. Many of the designs are based on abstractions of animal and plant forms or simple geometric designs, but some of the artists also use modern designs such as boats and planes.

The paper mola is a variation of the cloth mola. Most students instinctively choose colors that go well together, but this project offers a good opportunity to select a color scheme based on the color wheel. Almost any combination of colors is effective, and the design may be complex or simple. To complete and unify a mola use small decorative designs such as the rectangles seen on the cloth molas.

MATERIALS NEEDED

Student Project 1.1: *The Paper Mola*

Construction paper, all colors, 12 by 18 inches

Newsprint, 12 by 18 inches

X-acto knives or single-edge razors

Newspapers

Polymer medium

Brushes

Photo 1–1 Mola 12″ × 16″, from collection of author.

6

Student Project 1.1: THE PAPER MOLA

DIRECTIONS

SAFETY NOTE. *Because the paper will be cut with razor blades or X-acto knives, keep your hand behind the cutting edge of the knife in case it should slip.*

1. Draw several rectangular thumbnail sketches. Choose one.
2. Enlarge the design on 12 by 18 inch newsprint. Completely fill in around the design with ½ inch wide rectangles of different lengths.
3. Hold the paper up to a window and trace the design with pencil on the back of the paper.
4. Tape the back of the newsprint onto a piece of construction paper.
5. Redraw the design on the front of the newsprint. This will transfer the design onto the construction paper.
6. Because the picture will have several different colors in layers, each opening should be a minimum of ½ to 1 inch wide. (The first layer of construction paper may appear quite flimsy by the time everything has been cut from it.)
7. Glue the cut paper onto a solid piece of construction paper by coating the second piece of paper completely with polymer medium. While it is still wet, place the cut piece of paper on top and also completely coat the top layer with polymer. Let it dry overnight before cutting the next layer.
8. When the first two layers are dry, cut inside the openings, leaving at least ⅛ inch "border" to show the underneath color inside each opening.
9. A third layer may be glued onto the bottom in the same way as the second layer. The paper appears a bit bubbly, but will flatten later. It is effective to glue it this way because the picture has a gloss to it and the construction paper won't fade. Molas should be allowed to dry for a few days before stacking together.
10. If there are large openings that could use more detail, small areas may be cut and different colors of paper glued underneath.

© 1990 by The Center for Applied Research in Education, Inc.

From Reality to Abstraction: PASTEL EVOLUTIONS

FOR THE TEACHER

This three-part project leads students from realistic drawings to abstractions of those drawings. The photo is a student interpretation of figures in a square.

 Because oil pastels used in schools have limited colors, introduce students to the idea of substituting unrealistic color for real subjects. The work of the Fauves (called the "wild beasts" because of their unrestrained use of color) illustrates this very well. Reproductions of work by Maurice Vlaminck, Franz Marc, and Henri Matisse exemplify work of this period.

MATERIALS

 Sulfite drawing paper 12 by 12 inches and 6 by 6 inches

 Oil pastels

 India ink

 Brushes

 Student Project 1.2: *Oil Pastels*

Photo 1–2 Student work. A small portion of this could be selected to reproduce to create an abstract piece.

Student Project 1.2: OIL PASTELS

DIRECTIONS: FOUR SQUARE

1. Fold a 12 by 12 inch piece of paper into fourths. On one of the corners, use pencil to fill the square with an abstract shape.
2. Fold the square over the one next to it, and rub on the back of it with pencil. This transfers the design onto the square next to it.
3. Go over the design on the front of the second square with pencil. Fold the paper in half, and rub on the backs of both squares. Now the design is exactly the same on all four corners.
4. Color each corner of the paper exactly alike with oil pastels, filling in completely.
5. Paint over the drawing with india ink and, before it dries totally, wash it off in running water.

DIRECTIONS: FIGURES IN A SQUARE

1. Draw two or three figures in a 12 inch square piece of paper. Use the space totally, putting the figures into an environment. They might be people at the beach, or two wrestlers, or yourself and a friend. It isn't necessary to show the whole person; it could be just a head or the torso. The figures may overlap.
2. Use oil pastels and color in carefully. You may show rounded form by shading.
3. When finished, paint over the drawing with india ink, allow to dry slightly, then wash with running water.

DIRECTIONS: CREATE AN ABSTRACT DRAWING

1. Make a viewfinder by cutting two "right angle" pieces from corners of a piece of paper. Use this viewfinder to select a portion of your drawing of people that you will reproduce. The area you choose may be very small, but it should not be recognizable as a person.
2. Reproduce the portion you have chosen on a six-inch piece of paper. These pastel drawings will be little jewels.
3. Mat the finished artwork with colored construction paper to complement the colors in the drawing.

CREATE A LINE ENVIRONMENT

FOR THE TEACHER

Begin this project by asking students to make lines on newsprint, to experiment and find how many different kinds they can make. Examples on the accompanying hand-out, "The Element of Line," may give them some ideas. These preliminary exercises are important to free their imaginations. Show them examples of line as it has been used throughout the history of art and as it is being used by artists today. Hartley's "Smelt Brook Falls," below, utilizes strongly linear designs.

 Don't tell the students in advance why they are being asked to draw their lines in ink in various places on the paper, or the results will be predictable. After their preliminary lines are placed on the drawing paper, begin a discussion about environment. Students may need help deciding what type of environment to make. Photographs of work by Henri Rousseau, who painted exotic jungle pictures based on his studies at the botanical garden in Paris, may help them to get started. Remind them it is not a race to the finish, but that care and quality are important. Move around and talk with students as they are working to help them see possibilities.

MATERIALS

 Student Notes 1.3: *The Element of Line*

 Student Project 1.3: *Create a Line Environment*

 Pencil

 Newsprint

 Sulfite drawing paper, 12 by 18 inches

 Ink pens or fine line markers

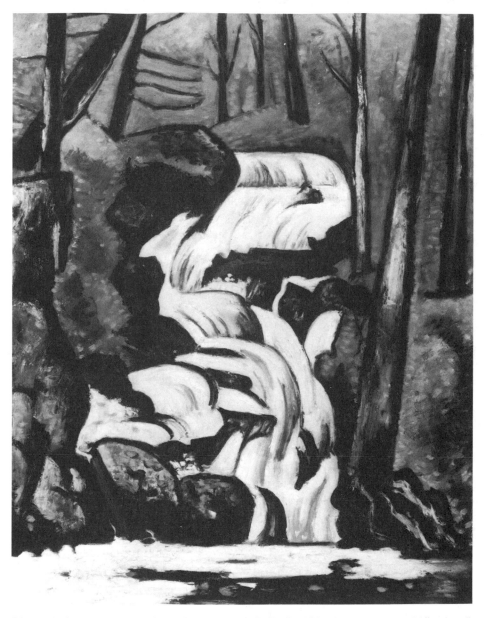

Photo 1–3 Marsden Hartley, "Smelt Brook Falls." 1937. Oil on board. 22″ × 28″. The Saint Louis Art Museum, Eliza McMillan Fund.

Student Notes 1.3: THE ELEMENT OF LINE

From the time you first held a crayon you have been using line to express yourself. As your skills in art continue to grow, you will rely on line to convey an idea quickly. Designers use line to plan utilitarian objects such as roads and buildings. Calligraphers employ line when writing with decorative alphabets. Artists use line as the basis for composition.

We see line as we look at the branches of a tree in winter, the patterns on a rock, the edge of a road going off into the distance, or the horizon where sea and sky meet.

As artists began representing nature by drawing, certain styles repeated by the artists in a community came to represent that society. Examples of this would be the curved lines on the animals found in cave drawings of primitive man; the vertical and horizontally balanced lines seen in the Greco-Roman temples; the right angular lines used by the Bauhaus in Germany in the 1930s; the Baroque line of sweeping curves and bold detail seen in Renaissance Italy.

Physical properties of line

DIRECTION: vertical, horizontal, and diagonal

TYPE: curved line
angular line
straight line, which could include parallel or converging lines

MEASURE: the length and width of a line

CHARACTER: differs depending on the medium used to make the line. A line made with a brush could be uneven and totally unlike that made with a pencil or ballpoint pen

Emotional qualities of line

VERTICAL: lines are formal and suggest poise, balance, and support.

HORIZONTAL: lines are quiet and calm, used to represent horizons.

SPIRAL: lines suggest infinity.

CURVED: lines suggest restfulness and are graceful.

ANGULAR OR ZIG-ZAG: lines are restless, suggesting excitement or confusion.

DIAGONAL: lines produce tension and suggest movement and action. Because they are not parallel with the edges of a picture, they contrast and dominate attention.

PARALLEL: lines may suggest speed.

LINE EXAMPLES

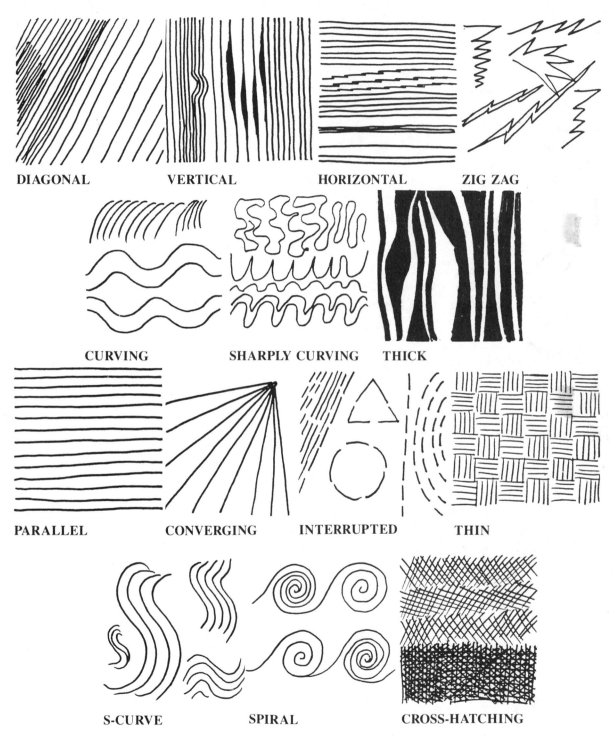

Examples of quality and direction of line.

Student Project 1.3: CREATE A LINE ENVIRONMENT

DIRECTIONS

1. On a piece of newsprint, use pencil or marker to make as many different kinds of lines as you can think of. Try combinations of lines, different widths, and different lengths. Feel free to repeat lines in different areas of the paper while varying the size.

2. Select several of the most interesting lines and draw at least twelve different types of lines on a large sheet of drawing paper. Include curved, straight, horizontal, and any variations you can come up with. Some may be quite long, others small and intricate.

3. Examine the lines and consider what kind of environment you can make of them. The more you use your imagination on this, the better it will be. Use the lines you have created as the starting point for plants, animals, or buildings. It will challenge you to invent shapes never seen before. Some possibilites are:
 a. An imaginary space station or futuristic city
 b. A garden or jungle where the plants and animals are like none ever seen before
 c. A deep underwater environment full of strange fish
 d. Your own bedroom as it might be one hundred years from now
 e. A mountain scene in the summer
 f. A zoo with a cage full of different species of animals

4. Make some lines darker than others by doing cross-hatching. In a black and white composition, learn to emphasize some areas by making them dark, while leaving other areas white. Look at your work from a distance to see if you have significant differences in value.

FURTHER SUGGESTIONS

1. If you have used permanent ink, these drawings may be colored by going over various areas with water color paint.

2. Cut up and combine pieces of everyone's drawings, pasting them onto a 36-inch wide piece of paper. Add lines as needed to unify the entire composition.

Introducing Shape/CREATE SHAPES WITH GLUE

FOR THE TEACHER

Use Student Notes 1.4: *The Element of Shape* to show students how line is used to create shape. Then introduce an activity in which students will create shapes with glue.

 Although this is a planned project, the student will not have total control of the line created by the glue. This is a good time to discuss the unintended, "the happy accident," that can give charm to a work of art. Accepting changes that occur as the work progresses is essential to being an artist. In some liquid media, such as watercolor, artists actually *cause* accidents to take advantage of unplanned and natural forms created.

 This project is effective with any geometric pattern, human figures, or a landscape. See below for examples of student work in this medium. You might also show students Japanese woodcuts to emphasize the use of line as it relates to shape. Follow up this project with Student Project 1.5: *Negative Shapes*.

MATERIALS

 Student Project 1.4: *Create Shapes with Glue*

 Tracing paper or newsprint

 White glue in small bottles

 Black india ink

 White sulfite paper, 18 by 24 inches

 Watercolor paints

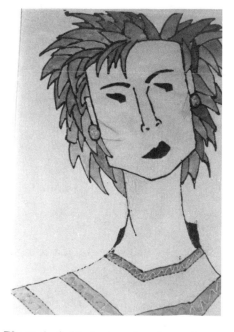

Photo 1–4 Student work, glue and watercolor.

Photo 1–5 Student work, glue and watercolor.

Student Notes 1.4: THE ELEMENT OF SHAPE

Shape is an area that is enclosed by line. It has two dimensions, height and width. An object may be identified by its shape. For example, an elephant is still an elephant, even if it is pink. We know a tree by its shape, whatever its color.

Although almost any art composition relies on more than one element of art, a number of artists have strengthened their work by emphasizing shape. Josef Albers, in his explorations of color, relied almost exclusively on the square. Henri Matisse's paper cutouts relied on shape as much as color to express his feelings. Franz Kline, a modern painter, uses shape for its expressive qualities in his great black and white paintings.

Types of shapes

GEOMETRIC: triangle, rectangle, circle, square, trapezoid, ellipse, oval, hexagon

FREE FORM OR AMORPHOUS: abstract shapes that may be of any size or configuration, such as a spill of oil on a wet driveway or a cloud

ORGANIC OR BIOMORPHIC: shapes that suggest the forms of living organisms, such as fish or flowers

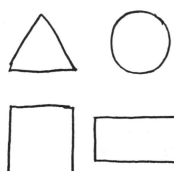

GEOMETRIC SHAPES **AMORPHOUS SHAPES** **ORGANIC SHAPES**

Characteristics of shape

VOLUME: may be shown by showing differences in value on rounded surfaces (modeling). A shape can appear to have volume by showing more than one plane, such as a building. Examples: shading on the sides; showing a lighter front of a rounded surface.

OVERLAPPING: shapes create a feeling of depth.

INTERRUPTED SHAPE: A shape almost entirely enclosed by a line appears to be a complete shape, even if the line is interrupted.

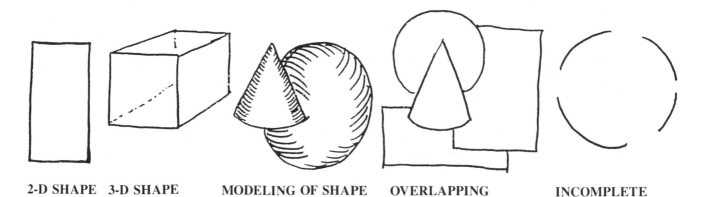

2-D SHAPE 3-D SHAPE MODELING OF SHAPE OVERLAPPING INCOMPLETE

Placement of shape on the paper

The appearance of the shape is affected by the shape of the picture plane. A square may look totally different if the picture plane is round rather than square.

SHAPES PARALLEL: to the sides of the paper create a feeling of tranquility.

SHAPES AT ANGLES: to the sides appear to be pulling the sides inward.

LARGE SHAPES: placed at the bottom of a composition give it stability.

LARGE SHAPES: placed at the top give the feeling that the artwork may topple any minute.

Positive and negative shape

POSITIVE: shape is the subject, or main focus of a composition. The background may be considered the negative shape.

NEGATIVE: shape should be considered as important as the positive shape; if you learn to draw the negative spaces that surround a shape, you will perceive differently than before and will be able to better draw what you see.

POSITIVE SHAPE

NEGATIVE SHAPE

Student Project 1.4: CREATE SHAPES WITH GLUE

DIRECTIONS

1. Do some thumbnail sketches in proportion to the size of the large sheet of paper that will be used. Select the best sketch. Think about background (negative shape) as well as the subject.

2. Enlarge the drawing onto a large sheet of white paper with pencil, drawing very lightly.

3. Mix black ink into the glue bottle thoroughly (it will end up dark gray). It is also possible to do this project with white glue on white paper, but the black line is more effective.

4. Lay the large paper flat on a table and go over the pencil lines with a line of glue. You must move fairly fast. It is almost impossible not to have some spots where the glue puddles. Accept those wide spots as "happy accidents." If you accidently get glue where you did not intend to, just leave it there. If you try to remove it, you will ruin the entire effect.

5. Allow the glue to dry thoroughly until it is hard.

6. Paint with watercolor, using a well-planned color scheme, with a limited number of colors.

Student Project 1.5: NEGATIVE SHAPES

MATERIALS NEEDED

Viewfinders
 (openings cut in tag board in proportion to the paper)

Sulfite drawing paper

Black tempera or ink

Brushes

A tree, or an arrangement of twigs or branches

DIRECTIONS

You may already be familiar with a number of optical illusions that cause you first to see the figure (subject) and then to see the background (See above). In this project you draw the space surrounding the branches and not the branches themselves.

1. Use a pen or pencil for this project. Instead of drawing the limbs or branches you see, try to look at and draw the surrounding spaces.

2. If you have drawn an entire tree, use a viewfinder to select an area that is interesting all by itself— one that doesn't even particularly look like a tree, but where the negative space is full of interesting shapes.

3. Enlarge this portion onto a new piece of paper. Select which shapes will be black and which will be white.

4. Paint the black shapes completely. It won't be necessary to paint the white ones.

ANOTHER SUGGESTION

1. Draw the same tree onto a piece of black construction paper. Use an X-acto knife to carefully cut it out in one piece. Carefully remove the positive shape, leaving a negative shape. Mount the positive on white paper of the same size, and place white paper behind the negative shape. Display them side by side.

The Element of Texture/MAKING A COLLAGE

FOR THE TEACHER

Because making a collage involves shape as well as texture, use Matisse cutouts or works by Robert Motherwell and Picasso to introduce these two elements. Discuss with students how the artists abstracted shapes from reality and combined them in a composition. Point out repetition, differences in size, and open space. You can also distribute Student Notes 1.5: *The Element of Texture*. If the collage is not too large, when it is totally finished it may be used as a collagraphic plate to make a print. (See directions at end of project).

Students may want to interpret something real such as a landscape, cityscape, or animal. Show them an expressionistic painting that is nothing but abstracted geometric shapes, such as that of Hans Hofman. Imaginative use of materials seems to come naturally as they rummage through fabrics to find something that will fit a space.

MATERIALS

Student Project 1.6: *Make a Collage*

Tag board for base

Fabric in a variety of weaves

Yarn

Corrugated cardboard

Screen wire

Mesh bags (potato bag)

White glue

Scissors

Mylar

Student Notes 1.5: THE ELEMENT OF TEXTURE

In art, texture may be real, or it may be made to look real (simulated). Rarely does a work of art exist that has no texture in it. When looking at texture, we almost seem to "feel" it. Through association, we may see it with both our eyes and our fingers. An example of real texture would be the surface on a Van Gogh oil painting.

Texture and pattern are often confused. The basic difference is that pattern is repetitive, two-dimensional, and often used for decorative purposes. Pattern is often used to create a feeling of texture. It has been effectively used by Picasso to enliven and emphasize areas in many of his paintings.

Real texture may also be added to a work of art by collage, which means actually gluing the texture to the surface. Assemblage is another means of adding texture to a two-dimensional work of art by attaching three-dimensional objects.

Physical characteristics of texture

ACTUAL: the feel of a surface such as a highly textured painting or a collage

SIMULATED: an area that looks like it could be three-dimensional

ABSTRACTED: a deliberately changed interpretation of real texture

INVENTED: application of media to give an impression of real texture. An example would be the leaves in a Rembrandt drawing of a tree or the fields in a Van Gogh painting

Reasons for using texture in a composition

RELIEF OR EMPHASIS: is offered

VALUE: is changed

TO ENLIVEN: a composition

Examples of texture

BARK　　　　　**LEAF**

Pattern may also be used to represent texture.

Examples of pattern

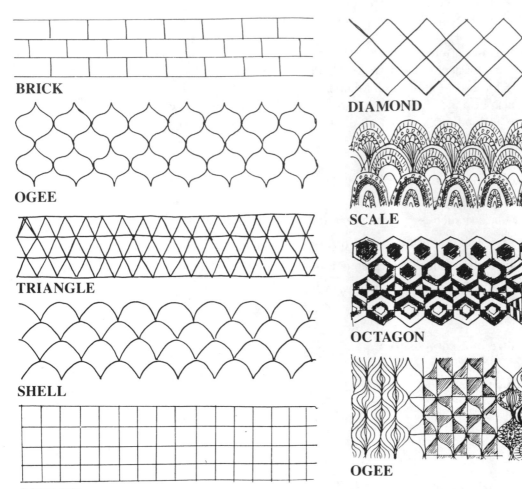

BRICK

OGEE

TRIANGLE

SHELL

SQUARE

DIAMOND

SCALE

OCTAGON

OGEE

Student Project 1.6: MAKE A COLLAGE

DIRECTIONS

1. Look at materials that are available. Do a few thumbnail sketches to get an idea how you might use the materials in a design. You might choose to combine geometric and organic shapes. You could create something "real" such as a landscape or forest.

2. Work with a color scheme. Don't use too many colors, or the composition will be confusing.

3. Use tagboard as a base to glue materials on. Don't glue anything down until you are satisfied that you have used the space well. This cannot be done in one day, so wait until you have thought about it for a while before gluing. It is perfectly all right to repeat shapes or textures or to use line (such as yarn) to unify a composition.

4. Use a variety of textures. If you use nothing but rough textures, there is no smooth place to rest the eye.

5. After moving materials around until you are satisfied with their placement, secure everything with white glue, using enough so the edges adhere well.

FURTHER SUGGESTIONS

1. Interpret your collage by reproducing it as faithfully as possible with marker or paint. Invent some textures if you have to.

2. Coat the collage generously with polymer medium to protect it. Let it dry overnight. Brush on tempera paint or use printers' ink and a brayer to coat the "plate" and print it onto another piece of paper. To print, place a clean piece of paper on top of the collagraphic plate and rub on the back of the paper.

3. Create a three-dimensional assemblage, using found materials attached to a three-dimensional base such as styrofoam or a box.

The Element of Value/THE PORTRAIT WITH DIFFERENT VALUES

FOR THE TEACHER

Introduce students to the historical uses of value by showing examples of how artists have utilized it through the ages. Rembrandt and Leonardo da Vinci used "chiaroscuro" (areas of light and shade) so their figures would stand out from the background and appear surrounded by space. Matisse used value in a different manner to produce two-dimensional pattern and create decorative effects. Hand out Student Notes 1.6: *The Element of Value*.

Value is used by many modern artists to unify a composition through organizing space. Some of the photo-realist painters use values of gray to resemble a photograph. (See Chuck Close's painting, below.)

For this project students may use their own photographs to interpret in shades of gray. The photo at the right is student work.

MATERIALS

Student Project 1.7: *Make a Portrait of Yourself or a Friend*

Construction paper in shades of gray, black, and white

School picture of your face (preferably 8 by 10 inches)

Tracing paper

Scissors

Pencil

White glue

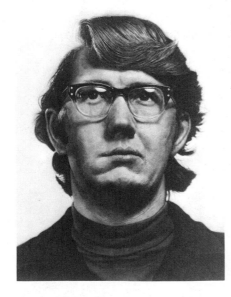

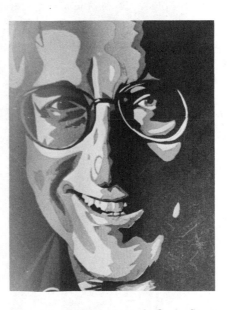

Photo 1–6 Chuck Close, "Keith." 1970. Acrylic on gessoed canvas. 175 × 215 cm. The Saint Louis Art Museum. Gift of the Schoenberg Foundation, Inc.

Photo 1–7 Student work from Steve Warren's class, Parkway Central High School.

24

Student Notes 1.6: THE ELEMENT OF VALUE

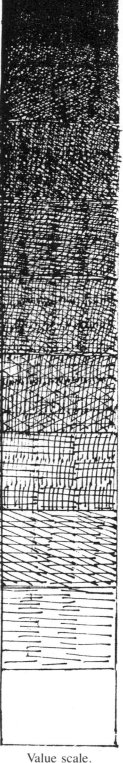

Value represents the lightness or darkness of a hue. For example, the values of gray range from white to black. Most compositions have a variety of values, including light, dark, and the middle values. Contrast, which is created by differences in value, is seen in almost every artistic composition, particularly in photography and drawing.

Physical characteristics of value

Two entirely different colors may have exactly the same value. This is easily seen in a black and white photograph, where red and black look the same. This property has been exploited in the work of the "Op" artists, who used equal values of contrasting colors to cause the viewer's eye to move involuntarily.

How to use value in composition

Separate the subject from the background or nearby objects by showing differences in value.

Give weight to a composition by using dark values near the bottom with lighter values at the top.

Show distance by making closer items darker than the ones farther away. This "aerial perspective" has been employed in landscape for hundreds of years.

Indicate the direction of light and three-dimensionality by leaving areas light where a light source would illuminate them, and darkening the areas that would fall in the shade.

Use value to show volume by darkening (shading) the areas in shade.

Don't rely literally on values you see, but use your own interpretation of those values in making a composition. Often exaggeration of reality will strengthen a composition.

Sharp contrasts in value are strong and dramatic and call attention to a composition.

Emotional characteristics of value

Dark pictures generally represent menace, mystery, fear, the unknown, the melancholy, as well as dusk or nighttime.

Compositions that are mostly light in value represent the brighter, more cheerful aspects of daylight, clarity, openness, and charm.

Value scale.

Student Project 1.7: MAKE A PORTRAIT OF YOURSELF OR A FRIEND

DIRECTIONS

1. Look carefully at the photograph you will be enlarging onto tracing paper. Squint your eyes as you look at the photo to eliminate color and to see several different values of darks and lights.

2. Enlarge the face from the photograph onto tracing paper. Now look carefully at the photograph and draw shapes on the tracing paper that represent different values seen in the photo. There should be approximately five different values ranging from white to black, with two to three different values of gray. Write symbols like B (black), W (white), LG (light gray), MG (medium gray) and DG (dark gray) on the various shapes so you will know the colors of paper to use.

3. Place your original tracing-paper drawing face down on a light box or tape it with the original drawing against a window, and trace over the lines on the back of the paper with pencil.

4. Select a colored piece of paper at least 12 by 18 inches. Until you are ready to glue everything down, keep the cut pieces on this paper.

5. Begin with the value you have chosen for the largest part of the face. Trace the outside of the face onto the construction paper and cut it out. The face will be gradually built up, with one layer pasted on top of another.

6. Trace the other sections onto various values of gray or black and cut them out.

7. Place layers on top of one another. Stand back and look at it. Is there enough detail, or does it somehow not look just right? Perhaps you need more contrast or detail in some areas.

8. When satisfied that further improvement cannot be made, glue it down, layer by layer. Use small dots of glue to prevent glue from showing on the front of the picture.

9. Mat and display.

FURTHER SUGGESTIONS

1. Try this same technique in color instead of black and white. It is effective in tints and shades of red, green, or blue.

2. Paint a portrait in tempera using this technique of making distinct separation of values, rather than depending on shading to indicate volume.

3. Consider working with three people to create a very large portrait, using the technique described above. There is no limit to size.

Chapter 2: THREE-DIMENSIONAL DESIGN

OBJECTIVES

- To develop students' ability to think abstractly by the use of visualization
- To teach respect for the properties of various materials while learning to use them
- To introduce skills in handling the materials and tools of three-dimensional art
- To explain the concept of spatial relationships
- To reinforce the application of the elements and principles of design while working with a variety of three-dimensional media

INTRODUCTION

Just as students can learn the elements and principles of design by creating two-dimensional works, completing three-dimensional projects will help them reinforce those concepts. The explanations of the elements in Chapter One apply equally to three-dimensional design.

An interesting thing happens when students create three-dimensional art. Even students who draw well sometimes have difficulty envisioning how to make something that looks good from all sides. They need to be gradually led into thinking abstractly, into visualizing how something will look when changes are made. Often in three-dimensional work the materials seem to have a life and will of their own. Even with a preconceived design, the work may change greatly while being created. Students can do extraordinary, exciting work if they "flow with it" and adapt to changes and limitations forced on them by the properties of the material.

The three-dimensional projects given here are introductory. The chapters on ceramics and sculpture will give complete information and more complex projects using the same materials.

Line Experiment: CERAMIC COIL POTS

FOR THE TEACHER

Every society has made vessels by the coil method. American Indian pots, so valued by collectors, are still being made this way. A San Idlefonso, New Mexico, Indian woman, Maria Martinez, became famous for her coil-built pots. Her work is well-publicized in books, movies, and videos. The Japanese consider some of their potters so important that they have been designated as "living treasures." Discuss with the students the respect given to potters in some societies. Ask why they think that occurred. Has this same respect been accorded potters in our society?

A project in making a vessel with coils will challenge students and require them to visualize what the finished pot will look like. Remind students to think about coils as lines. An exercise in drawing various kinds of lines and designing what the bowl would look like will give better results than making a pot without planning.

MATERIALS

Student Project 2.1: *Ceramic Coil Pots*

Medium-sized plastic bowls
 and pitchers of various shapes

Clay (about 2 pounds)

Pieces of canvas

Glazes

Brushes

Small plastic bags
 (garbage, sandwich, shopping)

Large, smooth pebbles
 or back of spoon for smoothing

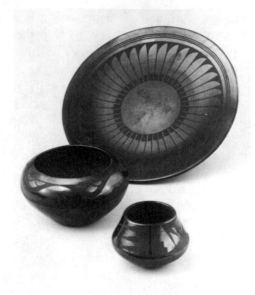

Photo 2–1 This plate, bowl and jar by Maria Martinez demonstrate the black glaze she made famous and her mastery of the coil technique. The Saint Louis Art Museum.

Student Project 2.1: CERAMIC COIL POTS

DIRECTIONS

1. Select a plastic bowl that has an appealing shape. You will be forming your coils inside this bowl, so your clay vessel will be the same shape.

2. Place a piece of canvas down so the clay won't stick to the work surface.

3. Get a two-pound piece of clay. Before making coils, wedge the clay to eliminate air bubbles by kneading it as if it were bread dough. Use a string to cut it open to see if there are still bubbles (they are very obvious). Bubbles in clay trap moisture. When the ceramic is heated, it may explode as the heated moisture tries to escape.

4. Keep your clay moist while you are working on it by leaving it in a ceramic bag or covered by moist paper towels. To see if it is the correct consistency for coils, roll a small coil 1/4 inch in diameter and try to fold it over the end of your finger. If it cracks, the clay is not moist enough. Add moisture by kneading water into it. To avoid surface cracks, it is far better to keep the clay moist than to add water to the surface while you are working.

5. Select a piece of clay a little larger than a walnut. Roll it into a coil on the canvas, first with your fingertips to spread it out, then with the palms of your hands to make it even. It should be about 1/4 inch thick when you are done and no longer than 10 to 12 inches.

6. Starting at the center of the bottom inside the container, make a spiral coil of the clay. Place the clay so it touches the pieces next to it. To make these coils stick together, "score" the coils before adding slip (liquid clay) in order for them to adhere. Use a popsicle stick or a pencil to make scoring marks on the two surfaces that will touch each other.

7. After coiling clay for the bottom and 1 inch up the sides of the bowl, you may wish to add some decorative areas between normal horizontal coils.
 a. Make small spiral coils and put them next to each other.
 b. Make small round "marbles" of clay and arrange them in a design on the sides.
 c. Make equal-sized vertical lines and put them closely together.
 d. Make wavy lines of equal size. You may even leave open spaces if you join the coils securely.

8. While the bowl is in progress, keep it moist. Wrap it in plastic with a damp paper towel inside when not working on it.

9. When finished, let the bowl dry for about a week. The clay will shrink as it loses moisture, so you can easily remove it from the plastic bowl for firing.

10. After bisque firing the bowl, you may leave it in its natural state or glaze it. The bowl must be refired after glazing. To glaze it, select a color and simply paint it on until all the clay is covered. An interesting effect is made by glazing the inside one color and the outside another, or leaving the outside unglazed. A clear glaze will allow the clay to show through, yet make it shiny and waterproof.

FURTHER SUGGESTIONS

1. Use your finger to smooth either the inside or the outside surface of the bowl to contrast with the roughness of the other surface. This will add strength to the bowl. Most Indian pots are so smooth

that coil marks are impossible to see. You may even make the clay shiny, as the Indians do, by rubbing it with a stone or the back of a spoon when it is "leather hard."

2. Join coils by the "twist and turn" method. Pinch two coils between thumb and forefinger, then turn your fingers to twist the clay to a different angle. This method gives an interesting texture.

3. Use a sharp instrument and make vertical or diagonal marks to pull clay from one coil to another. This rough texture is a nice variation.

Use variations in coiling techniques to make the bowl more interesting.

When rolling coils, score and apply slip before joining them.

USING LINE IN WIRE SCULPTURE

FOR THE TEACHER

Just as you introduce line drawing on paper, you may introduce line drawing with wire in space. The same types of lines are made in space: spirals, curves, circles, and right-angle bends. Straight wire will not support itself, but wire with bends will.

There are many different kinds of wire: fine gold and silver, aluminum armature wire, or annealed black stovepipe wire. Many types of wire will not bend without being heated (annealed). Annealed stovepipe wire or aluminum armature wire is most adaptable for classroom use. You may also use scrap telephone wires which are pieces of copper coated with colored plastic. Copper wire is quite flexible, though more expensive than stovepipe wire.

Although it is possible to make a solid form by repeatedly wrapping wire around a base, the delicate lines are usually more interesting than large, chunky figures. Show students pictures of work by Alexander Calder such as the one below.

NOTE: *Supervise students using wire cutters or soldering.*

MATERIALS

Student Project 2.2: *Wire Sculpture*

Wire: annealed stovepipe wire, aluminum armature wire, copper wire, or coat hangers

Pliers: needlenose, utility; wrap electrical tape on ends of pliers to prevent scratching the wire

Wire cutters

Wood scraps for mounting sculpture

Dowels of various thicknesses

Optional: drill with cup hook, soldering equipment, hammer and nails

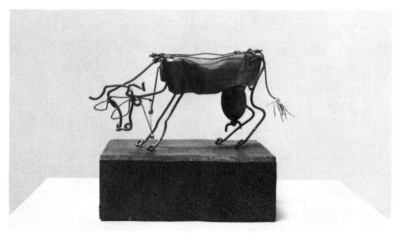

Photo 2–2 Alexander Calder, "Cow." 1929. Wire. 6½″ × 16″. Collection, The Museum of Modern Art, New York. Gift of Edward M. M. Warburg.

Student Project 2.2: WIRE SCULPTURE

DIRECTIONS

1. Think about whether you want to do an abstract design or a figure. You might want to draw different kinds of line: spiral, curved, right–angle, zig–zag, coiled, straight.

2. Although you may have done wire sculpture before, remember that this project calls for open, airy sculptures. You want to show that something has the three dimensions: height, width, and depth. Rather than actually filling in solidly with wire, leave open spaces to let the lines show. You will probably combine different types of lines with different thicknesses (gauges) of wire for variety.

3. Consider doing a contour (outline) drawing in wire of a figure or face. Remember that extra lines are not important as long as you can see the original form. Some ways to make wire forms are:
 a. Coil wire around dowels, tin cans, or a square board (1 inch by 1 inch). Place these coils close together or stretch them apart. You may stretch a coil and join both ends to make a circle or semicircle of coils.
 b. Drive nails in a board (carefully!) and use pliers to tightly stretch the wire around the nails. This enables you to easily make right-angle bends in the wire.
 c. Use pliers to bend the wire into sharp angles, or make right angles by bending the wire over the edge of a table.
 d. Loosely coil the wires so it fits within a form such as a small box.
 e. Twist the wire by cutting a length, folding it in half, placing the two ends into a bench vise, and twisting it with pliers. A drill (electric or hand drill) with a cup hook in place of a drill bit may also be used. Hook the cup hook into the loop formed when you folded the wire in half, and slowly begin twisting.

4. There are various ways to join pieces of wire together.
 a. Make loops to join one piece to another.
 b. Overlap two thick ends of wire side by side, and wrap them with thin wire. Before wrapping, carefully use a file or hacksaw to make a small indentation in the thick wire, to make sure the thin wire stays in place.
 c. Solder the wire if you have the equipment. Be sure to have teacher supervision.

5. Consider the thickness of the wire you are working with. If it is too thin to support the structure, use several pieces of wire and wrap them with thinner wire for strength.

6. Decide how you intend to display the wire sculpture.
 a. It may be suspended from the ceiling on a wire.
 b. It could be supported on a wooden base by making loops on the bottom and driving tacks through the loops.
 c. Make a base by pouring plaster of Paris into a disposable form such as a milk carton or large plastic cup. Just as the plaster is setting, place the base of your wire sculpture into it.

FURTHER SUGGESTIONS

1. Let the wire form show, but cover some of the wires with papier-mâché. Paint it with acrylic paint when it has dried.

2. Sew fabric onto the wire armature.

3. Fill in some sections with tissue paper by dipping small sections of tissue paper into a mixture of water and white glue. Fold the edges of the paper over the wire, pressing the edges firmly together.

4. Make a small piece of jewelry with 12 gauge copper wire.

5. Do a drawing of your sculpture in colored pencil. Display the two artworks side by side.

Exploring Form: PAINTED CLAY FIGURES

FOR THE TEACHER

This project challenges students to think about human proportions and interpret them in clay. Because this may be the students' first project in clay, encourage them to think about the balance and stability of the figure.

In introducing students to working with the human form, they should see work by Henri Matisse, Auguste Rodin, Aristide Maillol, and others who specialized in realistic sculpture. Particularly discuss with them the emotion and mood expressed by the slope of a shoulder or the movement of a figure. The photo at left shows several ancient interpretations of the human form. The more realistic Degas "Little Fourteen Year Old Dancer" at right helps demonstrate how a stance or attitude gives "life" to a human form.

MATERIALS

Student Project 2.3: *Painted Clay Figures*

Approximately 1 pound of clay

Plastic bags

Damp paper towels

Acrylic paints

Spray bottle filled with water

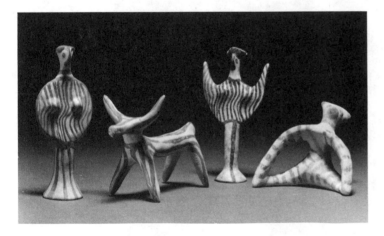

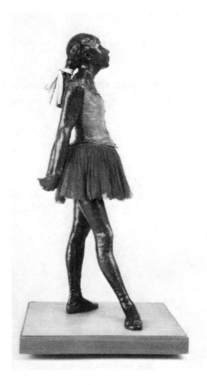

Photo 2–3 Left to right: Mycenaean statuettes: female figure (Phi type), bull, female figure (Psi type). 1300–1100 B.C. Pottery, modeling, painting. Bear figurine, c. 1200 B.C. Terra cotta with painted decoration. Gift of Edwin and Betty Greenfield Grossman. The Saint Louis Art Museum.

Photo 2–4 Edgar Degas, "Little Fourteen Year Old Dancer". 1880. Bronze, gauze and satin ribbon. 97.6 cm. high. The Saint Louis Art Museum. Gift of Mrs. Mark C. Steinberg.

Student Project 2.3: PAINTED CLAY FIGURES

DIRECTIONS

1. Wedge the clay to eliminate air bubbles by kneading it as if it were bread dough. Use a string to cut it open to see if there are still bubbles (they are very obvious). Bubbles left in clay will trap moisture. When the ceramic is heated, it may explode as the heated moisture tries to escape.

2. It is important not to overhandle the clay, or it will dry out. Between working sessions, keep it moist by putting it in a plastic bag and surrounding it with damp paper towels. Don't use water to smooth the surface because that causes the surface to crack. Instead, use your fingers or small tools to make the details you want. If it dries out while you are working with it, you may lightly spray it with water kept in a spray bottle.

2. Before handling the clay, think about what you intend your figure to be doing. You may wish to have a person stooping, seated, or kneeling. It is hard for a standing figure to balance because it will be small and fragile. To keep hands and feet from breaking off, keep them close to the body, or touching each other.

3. When your figure is completed, smooth it or add texture to the surface. Allow it to dry slowly by covering it with damp paper towels. Do not enclose it in plastic. Because the form should dry evenly, keep any smaller, thin areas covered with damp towels until the last. Do not touch the figures while they are drying because greenware is extremely delicate.

4. The figures should be bisque fired. If any pieces break off during firing, reattach them with white glue before painting.

5. After the bisque firing, paint designs with a fine brush using acrylic paint. Limit your colors, or you will detract from the form. Use a pattern such as paisley or checkerboard. Paint with great care. One advantage to acrylic paint is that you may paint over a mistake.

FURTHER SUGGESTIONS

1. Interpret this form in another material, such as balsa wood or firebrick shaped with the use of files and sandpaper.

2. Do a large painting of the form, filling the paper to the edges on all sides. It is not important to have the entire form on the paper. Fill the picture plane by surrounding the drawing of your sculpture with the same pattern that is on the sculpture, perhaps in slightly different colors, so that the form's outline is very subtle.

Exploring Form: ASSEMBLAGE

FOR THE TEACHER

A three-dimensional assemblage can be made of almost *anything*, including materials thrown away by local factories or scrap items from home. Let students know well in advance that they should start looking around their homes for items they can use. Materials that could be used are cardboard, metal, and foam products (such as foam forms from packing crates, foam cups, or styrofoam balls). Have a place in the art room where similar items could be grouped together. It students prefer to furnish their own materials, they could keep them in their lockers until needed. Many artists have done wonderful sculpture using found materials. Show students examples of work by Louise Nevelson, (below), Marisol Escobar, or Richard Hunt. One of the first people to make an assemblage was Marcel Duchamp, whose bicycle wheel mounted on a stool was considered a great "put-on." It now holds a place of honor in the Philadelphia Museum of Art. Discuss how, even when no one else was doing it, these artists adapted various found materials to show their own concepts of art. Encourage the students to work in a variety of media so there are no look-alikes. When they are finished, ask the students to discuss their work and tell what they had in mind when they were doing it.

NOTE: *Supervise any student using power tools or cutting utensils.*

MATERIALS

Student Project 2.4: *Assemblage*

Scrap materials

Glue, nuts and bolts, fasteners

Drill and drill bits

Wire

Photo 2–5 Louise Nevelson, "New Continent." 1962. Wood, painted white. 97.5 × 109.4 × 25.6 cm. The Saint Louis Art Museum. Purchased with funds from Miss Martha I. Love, Mr. and Mrs. George S. Rosborough, Jr., The Weil Charitable Foundation, Mr. and Mrs. Warren Shapleigh, Mr. Henry B. Pflager, The Lea-Thi-Ta Study Group and Nancy W. Gilmartin.

Student Project 2.4: ASSEMBLAGE

DIRECTIONS

1. An assemblage can take any form you want. If it is easier to represent a "real" object such as a car, tree, or animal, then use found materials to make that shape. You may also experiment by putting materials together to form an interesting abstract shape. There is no right or wrong when you are doing an assemblage. Alternatives include:
 a. An assemblage of one basic material, such as all wood or all metal.
 b. An assemblage made of units such as styrofoam balls, small match boxes, toothpicks, foam cups, or small identical cubes of tag board.
 c. A variety of materials with contrasting textures such as smooth and rough; or velvety and glazed.

2. After choosing your materials, move them around before deciding how to start. Sometimes the most ordinary idea becomes something totally different as you work it out.

3. Decide how the finished work will be displayed. Will it be mounted on a board or piece of driftwood? Will it simply rest on a table, hang from the ceiling, or be mounted on the wall? It may help you choose how to construct the assemblage if you have given this some thought in advance. For example, it is difficult to hang lawnmower gears from the ceiling on a string, but they will easily serve as a base if they are mounted on a board or rest on a table.

4. Although your assemblage does not have to be enormous, make it large enough so details can be seen from a distance. As you work, keep examining your work from various sides. The shape around the outside and holes made in the middle (the negative shape) may become as interesting as the positive shape of the objects.

5. Attach objects to each other by whatever means will give the assemblage the most stability. Use white glue, epoxy cement, rubber cement, brad fasteners, nuts and bolts, nails, or wire. The assemblage will probably be moved around, and it should be well put together.

6. When it is finished, look at it critically to see if there is too much detail or not enough. Consider whether to spray paint it or add color to one area for emphasis.

FURTHER SUGGESTIONS

1. Work as a class to make one monumental permanent or temporary assemblage for the school or art department such as metal or wood assemblages.
2. Interpret a portion of the assemblage in clay.

MONUMENTAL ASSEMBLAGES

FOR THE TEACHER

The three-dimensional mural should be considered far more permanent than a painted mural because of holes made in brick or stone walls when hanging it. This size and type of assemblage should be a class project where many hands can make a big job manageable.

 The first step is to decide on a location for a wall sculpture and measure it. It is suggested that any assemblage be made on a plywood base. Decide on the size, and have the plywood cut into easily handled pieces. Drill holes in it in advance to facilitate hanging. Invite the person who will hang the project on the wall to give you advice before you begin. If ladders would not be steady enough for handling the piece while hanging it, you could rent a scaffold or "cherry picker." Once the size and location have been decided, involve the students in designing the sculpture. Because these assemblages are mostly "found materials" that cannot be changed without cutting and welding, the design is more likely to be abstract. Materials can be moved around for a few days until a unifying design emerges. The photo below shows an assemblage made of wood on a plywood base, with one or more students designing and creating specific sections. If a division of space is made in advance, the students work out designs before cutting them on a jig saw. Sheet copper or brass can be used with the wood to give differences in texture and to accent certain areas.

NOTE: *For safety's sake, supervise all students using cutting or power tools!*

MATERIALS NEEDED

Student Project 2.5:
Monumental Metal Wall Sculpture

Scrap metal of all sizes

3/4 inch plywood

Paint for background

Screws, wire

Nails

Hammers

Drill

White glue

Photo 2–6 Assemblage. 4′ × 8′. Wood, copper, brass. Created by Parkway students under the direction of James Saale.

38

Student Project 2.5: MONUMENTAL METAL WALL SCULPTURE

DIRECTIONS

1. Collect any type of metal. Look around your home for anything that is scrap metal, from shotgun shells to sewing machine legs to hub caps. Ask metal factories for donations of scrap metal left over from stamping shapes. Unless everyone contributes to the scrap heap, you will never have enough.

2. Spray paint the plywood base. It will show slightly, and could be considered a part of the design. If you intend to hide it entirely, spray it silver so it does not detract from the metal.

3. Attached the metal pieces by various methods, depending on their weight:
 a. Ordinary white glue works fairly well for lightweight pieces
 b. Drill holes and screw in heavier items. Be sure to have teacher supervision.
 c. Wire items on by drilling two small holes and bringing the wire through to the back side and twisting it.

4. You may wish to unify the design by carefully driving nails closely together to fill in some areas.

5. Before hanging the assemblage, spray it with metal lacquer to prevent a color change.

FURTHER SUGGESTION

1. You can also create a monumental wall sculpture from wood scraps.

This 12 × 6 foot assemblage was created of metal affixed to a plywood base. In includes copper stampings, brass shotgun shells, silver-plated spoons, keys, and sheet metal of various colors.

Negative Shape: SAND–CASTING WITH PLASTER

FOR THE TEACHER

Sand–casting helps students to explore negative shapes because they make depressions where they want raised areas in their finished piece. You will need sand and containers for it (any grade sand will do, although fine white sand gives the nicest finish). The sand should be at least three inches deep to allow for a one-inch deep form, although details may be much deeper than one inch. If you live near a beach, this would be a wonderful project to do directly on the sand.

Plaster of Paris is gypsum, a mineral. It is long lasting and has many uses in the creation of art. Because it causes a chemical reaction when added to water, it will be warm when it is setting. You can speed up the mixing time by starting with warm water.

The finished artwork will be a bas-relief that may be mounted on board or hung on the wall. Plan to have several students do their casting at once so plaster will not be wasted. Pour excess plaster into empty cardboard milk cartons. These rectangular forms could be carved later.

MATERIALS

Student Project 2.6: *Sand–Casting*

Sand (purchase or bring from a beach)

Containers for casting (shoe boxes, trays, garbage can lids, aluminum roasting pans)

Plaster of Paris

Buckets for mixing plaster

Various instruments for making depressions: pencils, foam cups, balls, small boxes

Shells, small twigs, other decorative natural materials

Paper clips or wire for hanging bas-reliefs

Student Project 2.6: SAND–CASTING

DIRECTIONS

1. Place the sand into a container, making it at least two to three inches deep. Dampen it enough for it to retain any shape pressed into it.

2. Think about the principles of design you have learned. Repeat a design or shape in different sizes. Make a raised line simply by making a depression in the sand. Make a depressed line by building up a thin wall. Make indentations into the sand with paper cups, boxes, round balls, pencils, or your finger. If the box is not deep enough, build a one-inch high edge of sand to contain the plaster.

3. To mix plaster, put warm water into a plastic container (a flexible bucket can easily be cleaned when the plaster dries by flexing it). DO NOT POUR PLASTER DOWN A SINK. Add plaster slowly to warm water until it has formed a "mountain peak" in the center of the water. Don't start stirring the plaster until the plaster has mounded in the center and is above the surface of the water. When it is ready, put your hand to the bottom of the bucket and gently move your fingers around to prevent bubbles. Remove your hand from time to time; when the skin on your hand cannot be seen and the plaster is about the consistency of thick cream, it is ready to pour. From that moment you have only a few minutes until it is "set."

4. Pour the plaster into the damp, prepared sand, and allow it to set overnight. Because the hardening is a chemical reaction, the plaster will become warm. For hanging, put a loop of wire (such as a large, half-straightened paper clip) into the back just as it is setting.

5. When the plaster is cool and hard, remove it from the sand. Brush off excess sand.

FURTHER SUGGESTIONS

1. Embed objects such as shells or rocks in the sand upside down so they will be right-side up on the casting. Do this with care to enhance your design.

2. Cast similar small forms (such as indentations made by pressing a match box or a ball into the sand) and put them together later with white glue to make a three-dimensional sculpture.

Exploring Color: PAPIER-MÂCHÉ

FOR THE TEACHER

Various cultures all over the world make papier-mâché objects. The French made tables and trays of papier-mâché. The Mexicans use it to create outstanding papier-mâché animals, lively dancing figures, and musicians. The colors and patterns they use are brillant and have little to do with reality. Papier-mâché boxes from India are exquisite, meticulously painted with minute designs. A number of modern artists continue to use papier-mâché because of the ease in making large forms.

Papier-mâché projects may be small or oversized, depending on the student's preference. If you choose to make large projects such as people or animals, divide students into groups of two or four to work together. A strong armature is a necessity for large papier-mâché sculptures.

SAFETY NOTE: *Use only those brands of wallpaper paste that are identified as non-toxic.*

MATERIALS

Student Project 2.7: *Papier-mâché*

Newspapers

Old grocery bags, brown kraft paper, or brown paper towels

Wallpaper paste

Bucket for paste

Gallon or half-gallon ice cream cartons

Masking tape

Scrap wood

Pliers

Hammer and nails

Chicken wire

Paint (tempera or acrylic)

Brushes

Shellac or varnish

A gigantic papier-mâché head such as this one from the annual St. Louis River Faces parade could be made as a group project.

Student Project 2.7: PAPIER-MÂCHÉ

DIRECTIONS

1. The armature you will make will vary considerably depending on the size of your sculpture. *To make a small papier-mâché*, (12 to 14 inches) make the base by rolling newspaper or forming loose balls of paper to make forms. Hold these together with string and masking tape. If you prefer, you may use chicken wire to make an armature, then "flesh it out" by tying paper around the wire.
 For a very large piece. Build an armature to support a large sculpture. Make the armature of two by four or one by two inch lumber. Cut and nail the boards together in the general shape the form will take. Use pliers to cut and form chicken wire around the armature to the shape you want. Do this step carefully, as proper preparation will save you time later. Staple or nail the chicken wire onto the wood. Before applying papier-mâché, make certain the form is sturdy and well-balanced.

2. Mix wallpaper paste in a bucket half full of water. Slowly pour in powdered wallpaper paste, stirring with your hand until it is the consistency of cream. There should not be any lumps. The paste will keep for several days at room temperature. Carry an individual container of paste to your workplace. When you are finished at the end of the day, pour the excess paste back into the bucket.

3. Tear newspaper vertically (with the grain) into strips approximately 1½ inches wide by 12 inches long. Tear enough to use in one working period (usually several double sheets of newspaper).

4. Dip a newspaper strip into the paste. Gently pull it upwards between your first two fingers over the paste bowl to remove excess paste.

5. Put the newspaper strip over the armature. Keep overlapping strips until the entire armature has been covered with at least one layer. As you work, carefully overlap and smooth the strips to eliminate rough edges. Allow it to dry slightly between coats.

6. Place two more layers of strips over the first ones. If there are places you would prefer to be more rounded, wad a small piece of newspaper, and fill in the "hole" by holding it in place with more newspaper strips. The strength of papier-mâché comes from these successive layers of newspaper.

7. When the newspaper has covered the entire form, tear grocery bags, kraft paper, or brown paper towels into pieces roughly two inches square. Dip these in the paste and remove the excess. Overlap the brown paper, covering the entire form. The torn edges are soft, and blend to form a smooth surface. Let the sculpture dry for several days before painting.

8. Your papier-mâché sculpture will be more exciting if you do not paint it realistically. You will know by its shape what it is. Consider painting patterns or unusual color schemes. Use your imagination to create a unique piece of sculpture.

9. After you have covered the surface with paint, allow it to dry completely. Shellac it or take it outside and spray it with two coats of lacquer to give a shiny finish. If you have a very large piece, you may choose to spray paint a base color or paint gesso on it before painting designs.

FURTHER SUGGESTIONS

1. Cut up pieces of fabric and glue them on the surface by dipping them in a thinned mixture of white glue or polymer medium.

2. Smooth the surface with plaster or sand and seal it with polymer medium before painting.

Exploring Color: CLAY POST CARDS

FOR THE TEACHER

This project, created by Mary Jo Wilmes and used by permission, starts off with a session of dreaming about far-away places. Bring in post cards and also ask students to bring examples. Discuss post cards and their purpose: the kinds of things you would write on them (considering that anyone may read them), the kind of mood you are in when you write one, even what clothes you might be wearing while writing a card.

Ask students to put their heads down and close their eyes, then think of their favorite place to visit, or a place they might visit when they are free to travel any place in the world they want to go. They have to think about what it will look like there—what the landscape is like, or the people.

Hand out copies of the blank side of a post card. Each student should write a post card to a friend. Now they must decide what the front of the "card" will be. They could send a birds-eye view, a close-up, a seascape or landscape. These paper post cards will be glued on the underside of the clay post cards.

MATERIALS

Student Project 2.8: *Clay Post Cards*

Copies on white paper of back of post card

Tagboard, cut into pieces 4 by 6 inches

Colors (paint, colored pencils, or crayon)

Clay, 1 pound per person

Rolling pins or 1 inch dowels for flattening clay evenly

Knives

Underglazes

Clear glaze

Photo 2–7 A student of Mary Jo Wilmes created this three-dimensional clay postcard.

44

Student Project 2.8: CLAY POST CARDS

DIRECTIONS

1. Write a post card to a friend. Trace around a tagboard pattern on white paper to get a standard post card size of either 4 by 6 inches or 6 by 8 inches. Draw the other side of your post card to go with the message you have written. Color it with paint, crayons, or colored pencils.

2. Decide what your postcard would look like if some of the objects on the drawing became "live" and no longer were flat. The trees could stand upright, and waves on an ocean could have texture. Buildings could actually be cubes, not just facades. People could even stand upright on your postcard.

3. Interpret your drawing in clay. Work on canvas so the clay won't stick to the surface. Use a dowel to flatten the clay for a base of a standard size card of either 4 by 6 inches or 6 by 8 inches. The clay should be approximately $1/2$ inch thick so you will be able to handle it and it will support the objects you put on it.

4. You will quickly find out how thick or thin to make the objects you put on the base. They have to be sturdy enough to support themselves, but not so thick they won't dry. If a piece is thicker than one inch in diameter, it should be hollowed out on the bottom with a pencil. Score the post card and the bottom of the objects before attaching them with slip.

5. While you are working, keep your piece moist by covering it with damp paper towels and a plastic bag. When it is finished, remove it from the canvas and put it in a place where it will not be moved again until it is dry enough for firing. Clay is very delicate at this stage.

6. After the clay is bisque-fired, paint it with realistic ceramic underglazes. Try to make your colored three-dimensional post card look as much like a real one as possible. When these have dried, coat with clear glaze before firing.

FURTHER SUGGESTIONS

1. Paint the post card with acrylic paint after the bisque-firing if glazes are limited.
2. Students could coordinate their work and do scenes from their own city. These could be displayed someplace in the city so people outside the school could see how their city looks in post cards.

Chapter 3: DRAWING

OBJECTIVES

- To teach drawing, the basic skill needed for creating art
- To reinforce the application of the elements and principles of design as they apply in drawing
- To explore the use of wet and dry drawing media, and combinations of both
- To help students learn unique ways of seeing and recording what they see
- To introduce perspective drawing
- To explain a number of techniques for drawing the human figure

INTRODUCTION

Everyone can be taught to draw! However, by the time many students reach a secondary art course, they are firmly convinced that they cannot draw and therefore cannot be artists. Through simple exercises and gradual skill-building assignments, students can learn to express themselves by drawing. These techniques will provide students with a wide variety of skills and methods of working. They may find through experimenting that they prefer one media over others. Encourage them to do further work in that medium.

Collect examples of drawing throughout the history of art to exhibit around the art room. Viewing many ways of drawing may help students solve their own problems. Show slides of drawings by the masters, such as Matisse's "Woman in Armchair," right, so students can see that the drawings weren't "clean" and

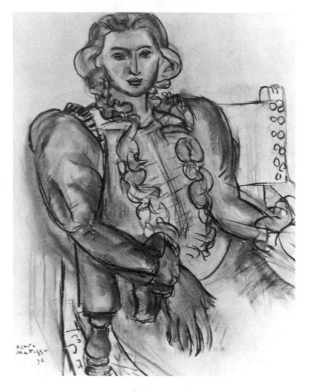

Photo 3–1 Henri Matisse, "Woman in Armchair." 1936. Charcoal drawing. 21″ × 15¹⁵⁄₁₆″. The Saint Louis Art Museum. Gift of the Friends of the Museum.

that even great artists had to experiment until they got exactly the line they wanted. Encourage students to bring in drawings that they find in the newspaper or magazines.

Take the time to talk about an assignment after it is complete. Encourage the students to analyze and criticize work by saying "Each one of you will be called on to tell something about a work of art that appeals to you. Tell why it works. Have several ideas in reserve to discuss in case someone else talks about your subject." Students also may be willing to talk about their own work and why they chose to do something a certain way.

A few general reminders for students are:

Don't worry about making mistakes. Don't erase unless you absolutely must. Eraser marks ruin the paper and detract from the drawing. Draw lightly and go over the "right" line to emphasize it.

Unless the drawing is a real disaster (the teacher's opinion, not the student's), one sheet of paper for a project is all each student should get. If students start over each time something goes wrong, they demand too much of themselves.

BLIND CONTOUR DRAWING OF A FIGURE

FOR THE TEACHER

This is a warm-up project to train students to quickly draw what they see and not worry if the results are less than perfect. Demonstrate by drawing on the board or a large piece of newsprint to help them understand how to do a blind-contour drawing. When they see you making mistakes and not caring, they become a little more willing to try. Show them how you look not at the drawing, but at the model only, not lifting the marker or chalk as you draw. It is as if the marker is touching the contours of the body.

Work with marker for easiest results. Get a volunteer model to sit on a platform or table where all the students can easily see. Have students change position if they can't see the front or sides of the model. Work in ten-minute sessions before the model changes position.

MATERIALS

Student Project 3.1: *Blind Contour Drawing*

Newsprint or white sulfite drawing paper, 18 by 24 inches

Markers of various colors

Student Project 3.1: BLIND CONTOUR DRAWING OF A FIGURE

DIRECTIONS

1. When the model has chosen a position, choose a place on the figure to start drawing (such as a shoulder), and place the marker on the paper as if you were placing the point directly on the shoulder. Remember that you are not going to lift the marker from the paper.

2. Look at the model and, without actually looking at the paper, move the marker *slowly* along the paper as if tracing along the human form. Show wrinkles in clothing and details of the face and hands.

3. If you run off the sides of the paper, peek and get back on track. Don't be concerned if you run out of space on the paper.

4. When the model changes position, do another contour drawing on top of the first drawing *on the same side of the paper*, but in a different color marker.

5. When the model changes position again, do a third drawing *on the same side of the paper* in a third color of marker.

FURTHER SUGGESTIONS

1. On this piece of paper, fill in areas with marker where shapes are formed by lines crossing. You could use various textures, or color shapes in solidly.

2. Make a mixed-media collage of tissue and ink drawing.
 a. Tape the original drawing on a window or light box.
 b. Place an 18 by 24 inch piece of tagboard on top and trace either the best drawing of the three onto it or use all three.
 c. Define the figures by gluing torn pieces of tissue on the tagboard. Paint the tagboard with polymer medium in small areas, apply tissue to these areas, and go over the top of the tissue with medium to make it lie flat and to give it gloss. Fill the tagboard completely. (There may be some bleeding of colors, but it does not detract from the final result.) Allow to dry.
 d. Draw over the original figure drawing in india ink on top of the tissue.

3. Use the best drawing as a pattern to cut pieces of construction paper. Glue these to a background of a different color. With charcoal, draw on top of the construction paper and make details in the contour.

4. Have a model do one-minute action poses. Use marker to depict motion. (Look at Picasso's Don Quixote drawings to see how simple lines depict so much.)

CONTOUR DRAWING OF HANDS

FOR THE TEACHER

Ask students to draw hands by using the same contour method of drawing that they used when they drew a figure. Suggest they use a mirror propped up on books so that they can draw views that they might not ordinarily be able to see. Show examples by M.C. Escher, Michelangelo, Albrecht Durer.

MATERIALS

> Student Project 3.2: *Contour Drawing of Hands*
>
> Drawing pencils, 6B and 4B
>
> Mirrors (12 by 12 inch mirror tiles may be bought at home supply store; cover any sharp edges with duct or masking tape.)
>
> Sulfite drawing paper

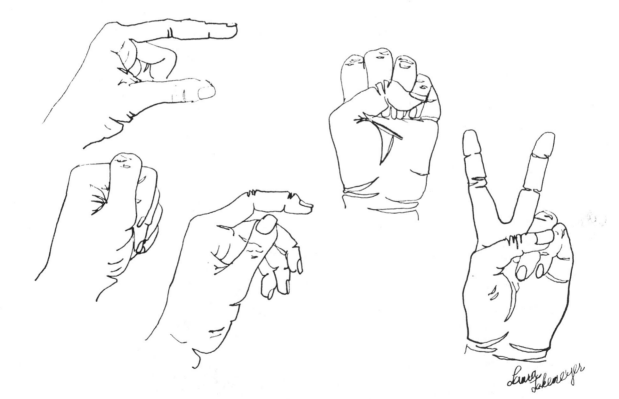

Contour drawings of a hand.

Student Project 3.2: CONTOUR DRAWING OF HANDS

DIRECTIONS

1. Do a blind-contour drawing of your hand by looking at the hand, not the paper, as you draw. Draw slowly and let it seem as though the pencil is actually going around and into each fold of skin. Do not lift the pencil from the paper as you draw. Complete one hand using this method.

2. Now try a modified contour drawing of the hand by lifting the pencil if you need to, and looking from time to time from your hand to the paper as you draw.

3. Draw at least five different views of your hand, with details and shading if you wish to show differences in shadow. Don't draw what you think you see, but *exactly* what you see. If you "know" what a fingernail is and draw the whole fingernail, the drawing will not be realistic.

FURTHER SUGGESTIONS

1. Cut out these drawings of hands, rearrange them into an interesting composition, and glue them onto a contrasting piece of construction paper.

2. Use these drawings as patterns to cut hands from construction paper to glue on another piece of paper. Resume the original poses with your hand, and draw on top of the new paper with another medium such as charcoal or felt-tipped pen.

3. With white or colored chalk, do a number of drawings of hands on black paper.

SELF-PORTRAIT

FOR THE TEACHER

Although a self-portrait sounds like an ambitious project for secondary students, it has a number of advantages. No other model will sit still as contentedly while being drawn; the artist is already familiar with the face being drawn; and if it isn't a true likeness, the sitter won't be unhappy with the artist. Go over the basics of the anatomy of a face with the students before they begin to draw.

Many artists have drawn themselves. Show students examples such as Rembrandt's self-portrait at fifteen or Durer's as a young man. A student self-portrait such as the one at left below is a good exercise for all art students. Students could also make a collage of their own drawings, then distort them by moving them while a copy machines is in the process of copying. When this copy is reproduced, as in the photo at right, interesting results occur.

MATERIALS

> Student Project 3.3: *Self-Portrait*
>
> White drawing paper
>
> Pencil
>
> Eraser (to be used only with teacher approval)
>
> Mirrors

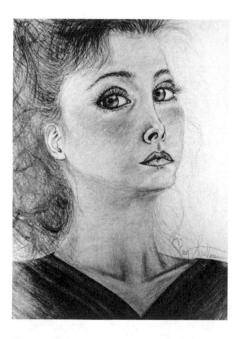

Photo 3–2 Student self portrait. Pencil. 18″ × 24″.

Photo 3–3 John Dunivent's students create simple collages which are then distorted by being moved and lifted as they are run through a copy machine. The students then interpret the distorted images.

Student Project 3.3: SELF-PORTRAIT

DIRECTIONS

Although each person's face is different, there are several things they have in common. You may wish to look at yourself in a mirror, using a ruler to confirm that these observations apply to your own face. The sketch shows basic divisions of the face.

1. The head is basically egg shaped, larger at the top than the bottom.
2. The eyes are halfway between the chin and the top of the head.
3. If the space between the eyes and the chin is divided roughly in thirds, the nose will be on one third and the mouth on the other third.
4. The space between the eyes is the width of an eye.
5. The bottom of the nose is in line with the place where the bottom of the ear is attached.
6. The eye is in line with the place where the top of the ear is attached. (Lesson: the ear is *big*.)
7. The corners of the mouth are directly below the centers of the eyes.
8. The edges of the nose are directly below the inner corners of the eyes.

These facts apply to a straightforward view of a face. Observe what happens when you put the mirror below your face and look down into it or hold the mirror overhead and look up into it. Try to draw what you actually see.

PRELIMINARY EXERCISES: Do these preliminary exercises on small pieces of paper, as they are not intended to be finished works of art (although some may end up that way).

DRAW EYES: Draw your eyes as carefully as possible. Look for a long time to observe areas that have visible line and areas with no apparent lines. Notice differences in value—where the paper should be left white and where it should be dark. Even though you don't see much black, an effective drawing has differences in value.

DRAW A NOSE: Look carefully and discern where you actually see line and where there actually is a difference in value. Draw the shape of the nostril by drawing the value you see. If there is no line visible, don't draw one. Look at drawings by great artists to see how they have shown the form of the nose by gently shading the sides.

DRAW THE MOUTH: Don't outline the lips, or the result will disappoint you. Instead, look in the mirror and draw the darkest part of the mouth, which is the line in the middle. The lower lip often is shown by the shadow underneath it rather than a line on the lip itself.

Practice more by drawing ears, hair, chin, and so on. The more you practice, the easier it will become.

DRAWING THE FACE:

1. Do a drawing of your face. It will take several days, so don't be in a hurry. Look carefully at yourself and the shape of your face. Don't attempt to depict all the details in a collar or sweater, but draw only part of it. Don't try to smile, as it is difficult to hold the pose, and often looks artificial.

© 1990 by The Center for Applied Research in Education, Inc.

2. Apply what you have already learned about the placement of your features on your face and how to draw them.

3. To draw hair, look at the direction your hair grows. Some areas of hair are darker than others. Don't try to draw every hair, and especially don't scribble it in, but try to draw some areas of hair in the direction it goes. You will have areas (highlights) that reflect light in your hair and in your eyes. Let those differences show.

4. Look for shadows that make shapes rather than using uninterruptred lines to draw the outside of the face.

5. Walk away from your picture and squint through your almost closed eyes to see differences in value. There should be blacks in the picture even if the only place you actually see black is in the pupil of your eye. Hold the picture up to a mirror and look at it to see if any improvements can be made.

FURTHER SUGGESTIONS

1. Choose pastel-colored construction paper and draw the face the same way with pastels. Don't copy your drawing, but do the face all over again. See how much easier it is this time.

2. Paint a self-portrait with tempera, oil, or acrylic paints.

DRAWING WITH COLORED PENCIL

FOR THE TEACHER

In the past, colored pencils usually resulted in very soft-appearing drawings. New technology has produced waxy colored pencils such as Prisma-color or Spectracolor that can be used to create paintings that resemble oil paintings in richness of color. The pencils are semi-transparent, allowing paper to show through, or allowing color overlays to blend. It is the combinations of colors that gives these drawings the rich effects.

Encourage students to experiment on a separate sheet of paper for different effects achieved by differences in pressure, gently overlaying one color on top of another, cross hatching with different colors, or putting white or black on top of a color. Pointillism effects can be achieved by making small marks of different colors laid next to each other. Show your students paintings done by the Impressionists to let them see how one color is affected by the one next to it. They may like the effect of cool and warm colors used together to give shadow.

Solvents can totally affect how pencil can look. Waxy pencils dipped in paint thinner or mineral spirits give an entirely different effect than normal use. These solvents can be brushed onto portions of a sheet of paper and drawn into: If you are using water soluble pencils, the effect of watercolor can easily be achieved. Colorless marker, used to extend colored markers, is a particularly easy solvent to use with waxy pencils, allowing them to almost flow. Colored pencils can be used on top of colored markers, on top of a watercolor wash, or on a good-quality colored paper. Black construction paper is particularly handsome as a base for colored pencil.

A variety of surfaces can affect the look of the drawings. Gesso painted on paper will give a highly textured surface. Canvas, wood, or any textured paper will give a totally different effect than plain drawing paper.

The still life paintings of Henri Matisse may help to free the imaginations of these students. His use of pattern, lack of care for perspective, positive-negative relationships, and brilliant colors are similar to the work that can be achieved with colored pencils.

MATERIALS

Student Project 3.4: *Drawing with Colored Pencil*

Prisma-color pencils, a set with at least 32 colors

Hand sharpener

Graphite pencil

Two erasers: one kneaded, one pencil eraser

Drawing paper

Fixative

Masking tape

Photo 3–4 This large student work was done in colored pencil.

Student Project 3.4: DRAWING WITH COLORED PENCIL

DIRECTIONS

1. Although colored pencils are effective for drawing almost any subject, they are particularly good for drawing still life. Fine detail is possible. It is better to work small and do a picture well than to do a large drawing that becomes discouraging because it takes so long.

2. Don't attempt to use all the colors available, but decide on a color scheme. You might choose to do a warm color scheme, with complementary colors as accent, or vice versa.

3. Either use the pencil to gently color in areas, or press harder to make the color more intense. Work slowly and evenly without letting the paper show through.

4. You may wish to fill in an area with pattern in different colors.

FURTHER SUGGESTIONS

1. With a brush, apply paint thinner to a small portion of the drawing. Draw into it and see the difference you will have.

2. Use an X-acto knife to scratch into a thickly overlaid surface. This will reveal underneath layers of the paper.

3. Lay a tracing paper drawing over the drawing paper and firmly redraw it with a sharp graphite pencil. This will depress lines into the drawing paper, and when you go over them lightly with the colored pencil, the lines will remain white.

MIXED–MEDIA STILL LIFE DRAWING

FOR THE TEACHER

Allow each student to make an individual interpretation of a still life by setting up a *huge* still life that will be left in place for at least two weeks and that will include everything that isn't nailed down. Allow students to select a relatively small area of the still life to draw by using a viewfinder in proportion to the size of the paper. The arrangement should be interesting from all sides and visible to all students.

Suggestions for some objects to include are: ladders, stools, buckets, drawing table, wastebasket, cloth, machine parts, skulls and bones, skeleton, halloween masks...in other words, anything. Ask students to bring dolls, hats, costumes, or whatever they can find at home. Check with the music teacher to see if they are throwing away worn out instruments.

Explain "artistic license" to the students. They may not be aware that the artist can make his or her own reality. Students may not know that they may put two things together on their paper that are not really together, or that they can invent something if it helps the picture to work better. If they work in color, remind them that even a color scheme does not have to be true-to-life.

MATERIALS

Student Project 3.5: *Mixed–Media Still Life*

Still life materials

White or gray paper

Red conté (crayon)

Charcoal

Fixative

White tempera

Brush: flat, ½ inch

56

Student Project 3.5: MIXED–MEDIA STILL LIFE

DIRECTIONS

1. Use the viewfinder to select an interesting area. Transfer what you see through the viewfinder onto paper. The viewfinder is used just like a camera viewfinder, to select something interesting. Remember to always hold the viewfinder the same distance from your eye.

2. Start your drawing with charcoal, as it may be drawn over a number of times until you are satisfied. Continue until you have "roughed in" the drawing.

3. Squint your eyes to look at the still life, and decide which areas on your paper should be darkest and which should be lightest. Use the charcoal to emphasize the darker areas. If you wish, use fixative to keep the charcoal from rubbing off.

4. Experiment with "dry-brush" painting with the white tempera before putting any on the drawing. To do dry brush painting, shake most of the paint back into the paint container, and paint onto a piece of scrap paper until the brush strokes show. You then are ready to dry-brush some of the lighter areas of the painting.

5. Use the red conté as an accent. You might make thin lines or small, solid, areas of color.

FURTHER SUGGESTIONS

1. Use any combination of mixed media in any order for this project. Do different areas of the still life, and work in a variety of sizes.

2. On pastel-colored construction paper, do this project in pastels.

3. Do a still life drawing in ink on much smaller sulfite paper. Make a variety of patterns in some of the shapes. Have some shapes remain white, others very dark, and indicate different values by the use of pattern.

PERSPECTIVE DRAWING

FOR THE TEACHER

Although any drawing or painting is an abstraction of reality, perspective enables artists to do "realistic" drawings. Students may have been aware that their drawings were not "quite right," but didn't know what they needed to do to make them work.

 Formal perspective was discovered by Italian Filippo Brunelleschi. Italian artists devised formal rules for creating depth in a painting early in the Renaissance. Many of today's artists rely less on formal rules, but they use visual perspective such as in the drawing below.

AERIAL PERSPECTIVE: is easily understood by students, as they realize that objects farther away appear lighter. Color is brighter and pattern more distinct as they move closer to the viewer. Shade and shadow may be used to indicate distance.

DIMINUTION: is the principle that objects farther away are smaller. Although we know that railroad tracks in the distance are still parallel and the same size as those close to us, the distance between the tracks appears smaller with distance. People in the distance appear smaller than those closer to us.

Helen Hume, "Xian, China." Ink on paper. 8″ × 12″. In on-site work, the artist often relies on interpreting what is seen without the use of formal perspective.

FORESHORTENING: is most often applied to figure drawing. The portions of the body closest to the artist will appear bigger. A good example to show students is Rembrandt's *The Anatomy Lesson of Dr. Culp.*

OVERLAPPING: is understood by most secondary students. It shows which objects are in front and indicates depth.

VANISHING POINT: is an imaginary point at which parallel lines seemingly converge on a horizon. A horizon line represents the level of the viewer's eye. A worm's eye view would have a low horizon line, a bird's eye view would have one near the top of the picture plane.

To help students understand vanishing points, ask them to cut a *small* (2 inches) picture of a house or car from a magazine and paste it on a long piece of paper. Use a pen and ruler to draw through the various lines that appear on the photo until they converge at common vanishing points.

The appearance of a building varies completely depending on where the artist is standing to draw it. If viewed straight on, it is a flat rectangle. If drawn from the side, it resembles a cube. If looking straight up, the lines begin to converge at the top. If looking down, the lines begin to converge at the bottom.

Show students how to use a pencil or ruler to hold up and "sight" the angle of a corner of a room, or a roofline, and then transfer that angle to the piece of paper. A viewfinder may be helpful in helping them determine how a scene actually looks.

MATERIALS

Student Project 3.6: *One-Point Perspective*

Student Project 3.7: *Two-Point Perspective*

White typing paper for exercises

White drawing paper, 18 by 24 inches

18 inch rulers

Pencil

Water colors

Student Project 3.6: ONE-POINT PERSPECTIVE

DIRECTIONS

One-point perspective. For a simple exercise in one-point perspective, make the interior of a room.

1. Draw lightly! Draw a horizontal line approximately near the center of the drawing. Place a dot (the vanishing point) somewhere on the line.
2. While some of the lines will slant to lead to the dot, vertical and horizontal lines in the picture are parallel to the edges of the paper.
3. Use a ruler to draw vertical lines to represent walls, doors, windows, and furniture in a room.
4. Use a ruler, and draw a line from the top of a vertical line and draw to the vanishing point. Do the same with the bottom of the vertical line. Erase extra lines.

FURTHER SUGGESTIONS

1. Use 18 by 24 inch paper to do a one-point perspective drawing with a number of rectangles. Make a variety of sizes, and overlap some. Make a vanishing point on an imaginary horizontal line. Connect "sides" of the boxes to the vanishing point. These may be colored with oil pastel, marker, or tempera.
2. Make your initials in squared-off letters, approximately 2 inches thick. Place a vanishing point somewhere on the page. Draw the sides of the letters off to the vanishing point. See example below.

Initials drawn with one-point perspective.

© 1990 by The Center for Applied Research in Education, Inc.

Student Project 3.7: TWO-POINT PERSPECTIVE

If you have ever drawn a cube, you have done perspective drawing. Although perspective doesn't have to be exact in a realistic picture, it is important to know how to use it if you need it. (Some artists deliberately choose to ignore the rules of perspective to give emotional impact to their work. "Primitive" artists had no knowledge of how to use it.)

A building seen from a corner has two vanishing points. The lines retreat in two directions. The same would be true of a chair, refrigerator, or car. The vanishing points often are not even on the picture plane itself, but exist somewhere in space out to the side of it.

Cityscape using two-point perspective

Draw lightly with pencil until you are certain you have the buildings the way you want them. Then use fine line marker, pastels, pen and ink, or colored pencil to make the lines and details. Remember that the sides of the buildings are parallel to the sides of the paper.

DIRECTIONS

1. Draw a horizon line and place two dots on its near the edges of the paper.
2. Make a vertical line through the horizontal line. Use a ruler to draw lines (lightly) to the two vanishing points from the top and bottom of the vertical line. Make as many more vertical lines as you wish to represent a number of buildings. See example below.
3. Put detail in the picture, such as windows, signs, people on the sidewalk (don't forget that people and cars must also be measured by the vanishing point).

FURTHER SUGGESTIONS

1. Shadow and aerial perspective may be indicated by showing pattern and darker values in the forms closest to the viewer.
2. Draw details with India ink, allow it to dry, and do washes with water color over the ink.

DRAWING WITH PEN AND INK

FOR THE TEACHER

Although most drawing media are dry, students enjoy using pen and ink because they look like "real drawings." They are not familiar with ink wash or depicting realistic textures with line, and time needs to be set aside for them to experiment. Vincent Van Gogh's "Fishing Boats at Saintes Maries-de-la-Mer," below, illustrates differences in value achieved with line only.

MATERIALS

Student Project 3.8: *Drawing with Pen and Ink*

Ink pen-holders and nibs

Soft brush for applying wash

Watercolor paper or good white paper

India ink, sepia or black

Containers for water

Newspapers

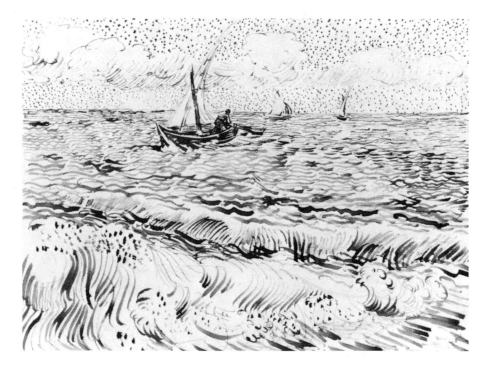

Photo 3–5 Vincent Van Gogh, "Fishing Boats at Saintes Maries-de-la-Mer." Brown ink and graphite on wove paper. 24.3 × 31.9 cm. The Saint Louis Art Museum. Gift of Mr. and Mrs. Joseph Pulitzer, Jr.

Student Project 3.8: DRAWING WITH PEN AND INK

DIRECTIONS

Exercises in texture

Make five different types of texture.

Exercises in ink wash

Create five different values in ink wash by following these directions. Always test the value of the wash you will be applying to the artwork by making a practice stroke on a piece of scrap paper or newspaper. Dip the brush in ink, then in water until it is as light as you want it to be. It is not difficult to make an area darker, but much harder to lighten it after you have made it too dark. A wash is often built up in successive layers until the desired degree of darkness is attained.

1. To make a drawing with an ink wash, plan which areas will remain white, which will be very light, and which will be darkest. Apply the wash. If it is too dark, blot it. You may even like the texture you get from blotting with a paper towel.

2. Either let the wash dry before drawing on it again, or work "wet-in-wet" by drawing directly into the wet area with pen dipped in ink. This will cause the line to "bleed," but it makes an interesting line. When working with a wet medium, you cannot erase or cover over mistakes, so learn to accept and value what the medium does. You may even tilt your paper and move the wet area around.

4. When the drawing is finished, you may darken some areas by painting in with ink or by cross-hatching to achieve differences in value.

FURTHER SUGGESTIONS

1. Use a water color wash and draw over it with ink.

2. Draw with a nonpermanent fine line marker and go over it with water color. The water will cause the line to bleed, giving an interesting effect to the drawing.

Student Project 3.9: USING LINE TO CREATE NEGATIVE SHAPE

DIRECTIONS

This drawing will give you experience in drawing the space around a shape rather than the shape itself. Choose a complex subject like a chair or ladder. See below.

1. Use the marker to make only vertical lines around the shape. Don't actually draw the shape, but draw the spaces you see around and inside it. Don't be concerned if your lines accidentally go inside the shape you are making. Little "mistakes" add charm to a drawing and make it less mechanical looking.

2. Use different lengths of vertical lines. If you need to show dark areas (underneath a chair, for example), put the lines closer together. As you fill in the these spaces, the chair will become a white negative shape in a dark positive background.

FURTHER SUGGESTIONS

1. Try combining shapes such as figures or trees, and filling in the space around them with lines.
2. Use diagonal lines instead of vertical lines.
3. Make a design entirely of cross hatching to build up values.

© 1990 by The Center for Applied Research in Education, Inc.

SCRATCHBOARD DRAWING

FOR THE TEACHER

Working with scratchboard is an engraving process, as the details are made by scratching into a hard surface. As in an engraving, details such as line and value add greatly to the subject's richness.

Although it is much easier to reproduce a photograph from a magazine, this is plagiarism as surely as if you retyped a story by O. Henry and signed your name to it. Don't let yourself and your students fall into the trap of basing your art on that produced by someone else.

Scratchboard drawings need to be very detailed. Students enjoy doing them. They do have to be done very carefully, and mistakes can rarely be covered up. This should be a small drawing, as it is time-consuming to work this carefully.

SAFETY NOTE: *Urge students to exercise caution.*

MATERIALS

Student Project 3.10: *Scratchboard Drawing*

Scratchboard (posterboard or other heavy board treated with several coats of gesso, then covered with india ink). It may be purchased ready-made. If you make your own, sand lightly between coats

Tools for scratching: needle, tip of compass, empty ballpoint pen, dental tools, or etching tool with fine point

Tracing paper

Student Project 3.10: SCRATCHBOARD DRAWING

DIRECTIONS

1. Choose a subject that has a lot of fine detail such as animal fur or a dried weed. Scratchboard portraits are also interesting, and you may choose to work from a portrait you have already drawn in pencil.

2. This will be the opposite of drawings you have done before because the background is black, and you will show value differences by making detail white.

3. Make your original drawing on tracing paper. When it is finished, place the tracing paper on a window or a light box, and go over the drawing on the back with soft pencil.

4. Turn the drawing over and tape it onto the scratchboard. Draw over the design once again, and you will have faint lines to use as guidelines. Refer often to your original drawing.

5. Look critically at the scratchboard drawing. If you stand several feet away, can you see it? You may need to exaggerate the light value in some areas to make details show. At this point forget your original drawing entirely and concentrate on finishing the scratchboard. To be effective, at least 50 percent of the drawing should be white.

FURTHER SUGGESTIONS

1. If you prepare your own board, color the dried gesso with watercolor in various areas before applying the ink. When you scratch away the ink, you will have colors in some of the lines.

2. Untreated white scratchboard can be pre-colored with watercolor, leaving white lines on a colored surface rather than on the traditional black surface.

DRAWING BONES

FOR THE TEACHER

Do your best to get a real or replica skeleton. Students can raise money to buy it, or persuade a parents' group, a business, or your district that you must have one. Perhaps your biology department has one you can borrow. It is good to have various kinds of bones around for students to draw. Ask your butcher to save bones for you (boil away the meat and let the bones dry). People who have farms often have skulls from animals, and hunters may find skulls in the woods. Tell your students you would like to have some *clean* bones, and hope that they can get some for you.

Much of Henry Moore's sculpture is based on the structure of animal bones. Show pictures of his work, or that of Georgia O'Keefe, who often made wonderful paintings that incorporated animal skulls.

Drawings of bones can vary from straight pencil renderings to exciting, colorful interpretations. Each student sees differently, and you should encourage the use of different media for these drawings. Scale is not at all important. A small bone may be drawn to appear huge. Below is an example of student bone drawing.

MATERIALS

Student Project 3.11: *Drawing Bones*

Bones: any and all kinds

Paper: white, construction, bogus paper, butcher paper, brown paper

Drawing media: ink, pencil, pastels, charcoal, conté crayon, crayon

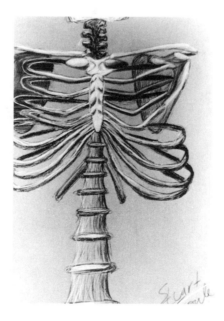

Photo 3–6

Student Project 3.11: DRAWING BONES

DIRECTIONS

1. Look from all angles at the bone you will be drawing. Decide which angle is most interesting. Consider drawing it larger than it actually is.

2. Choose a medium that you have enjoyed using in the past, and think how you would like your finished picture to look. Don't be afraid to use color even though bones have little color. They still have differences in value, and you can show those differences in color as well as in black and white.

3. When your drawing is complete, decide if you would like to do something further to it. It may need to be enlarged to actually run off the edges of the page. You may want to draw other bones with it or put it in an environment such as a desert.

FURTHER SUGGESTIONS

1. Interpret the bone drawings in cut construction paper, glued onto a background. Draw on them in charcoal or leave "as is."

2. Try drawing combinations of manufactured objects such as machine parts with organic materials such as bones.

CHARCOAL AND ERASER DRAWING

FOR THE TEACHER

This assignment acquaints the student with the eraser as a tool for drawing with charcoal, so no preliminary drawings are done. This could be combined with figure drawing by asking students to model on different days for this project. They may choose to draw only the face or the entire form. Show them how to use one-inch pieces of charcoal lengthwise to create small lines for roughing in the form. Explain that these drawings will not be clean, that they will get smudged, and to draw over and over the same areas to emphasize different values. The only two tools are the charcoal and a kneaded eraser to create lighter areas if desired, as in the landscape below.

MATERIALS

Student Project 3.12: *Charcoal and Eraser Drawing*

Drawing boards

Charcoal paper

Soft charcoal

Kneaded eraser (chamois or rag could also be used to lighten areas)

Fixative

Photo 3–7 George Schweser, "St. Louis Cathedral." Charcoal. 18″ × 24″. Mr. Schweser often works with charcoal, a rag, eraser and white chalk. Courtesy, the artist.

Student Project 3.12: CHARCOAL AND ERASER DRAWING

DIRECTIONS

1. Look carefully at the model. Decide how much of the figure you intend to draw. It isn't necessary to put down every detail, but you will want to show folds in clothing and differences in value in the face, hair, hands, and clothes.
2. To begin, use the side of your charcoal to draw small straight lines to indicate the form. Later you may use the end of the charcoal and the sides for shading. When this picture is done, very little of the paper will show through. It will mostly be dark, with highlights.
3. Keep emphasizing the dark areas. Use your kneaded eraser to lift away charcoal to create highlights.
4. Walk away from your drawing and look at it from a distance to see what can be done to improve value relationships. Squint through almost closed eyes to see dark and light areas.
5. When it is finished, spray the picture with fixative outside, since the fixative should not be inhaled.

FURTHER SUGGESTIONS

1. Use white conté to emphasize some areas.
2. Use harder charcoal to create an entirely different shade of black along with the softer charcoal already used.

Chapter 4: PAINTING

OBJECTIVES

- To learn basic methods of painting in a variety of media
- To introduce methods of painting through examining the work of master painters
- To explore color relationships as they apply to painting
- To encourage application of the elements and principles of design in painting

INTRODUCTION

The history of painting is an integral part of any painting course. Introduce various methods of painting and make them more meaningful by showing historical examples. The painters' choices of subject were influenced by how and where they lived, the materials available for painting, and the customs and traditions of the time. Encourage students to see for themselves the many different methods of painting by going to exhibits and museums and through reading books.

Many painters became famous not because they painted "beautiful" paintings but because they explored new ways of painting. Pablo Picasso is one artist whose work exemplifies original thinking, as does that of Leonardo da Vinci, or Vincent Van Gogh. Some unique twentieth century painters are Mark Rothko, Helen Frankenthaler, Jackson Pollock, Robert Rauschenberg, and Robert Indiana.

Traditionally, painting students copied plaster casts and old-master paintings to learn technique. A more recent development has been to place students in front of a canvas and encourage them to "do their own thing." Probably a compromise is possible. Introduce students to painting through exercises and experiments. After they have acquired some control, urge them to paint subjects of interest to them.

Explain techniques and care of materials, critique from time to time, and encourage students. Assure them that their paintings don't have to be realistic interpretations and that it is not necessary that other people admire their paintings. A painting should, however, fulfill certain requirements: it should be interesting to look at; make good use of the picture plane; have a center of interest; have a color scheme that expresses the mood of the painting; and be original. Students may have trouble knowing when a painting is finished. If they think that the next thing they do may ruin it, then it is probably time to stop. Suggest that it is better to put the painting aside and look at it awhile than to go ahead and do something that can't be undone.

Although students could spend years learning to use just one painting medium, you may choose to have them experiment with a variety of techniques. Students can paint with dry media such as pastels or oil pastels or wet media such as watercolor, tempera, acrylic, and oil paints.

PASTELS

FOR THE TEACHER

Painting in pastels is a good introductory project because it is a direct method of applying pigment that does not require brushes, turpentine, water, or drying time between layers. Many different subjects, from still-life to portraiture to landscape, are easy to paint with pastel. Encourage students to experiment by using colors that are not normally found in the subject matter they are drawing.

Pastel may be used as a drawing or painting tool. The difference is that in drawing, line is allowed to show more often. A pastel painting may have a combination of drawing and painting, with some areas carefully finished (such as a face in a portrait) and other areas left sketchy. Much of the charm of some pastels is their casual, unfinished quality.

The use of pastels originated in northern Italy in the sixteenth century. During this period, painters blended pastel to resemble oil painting. In the late nineteenth century, Edgar Degas and other French impressionists changed the traditional method of application by emphasizing individual strokes and by placing colors side by side with little or no blending. Degas was one of the great masters of pastel. Show students his work to illustrate the many ways pastel may be applied within one work of art. He achieved luminosity in his paintings by working from dark to light and using a variety of strokes.

Other famous painters who used pastel are Mary Cassatt, Paul Gauguin, Paul Klee, Willem de Kooning, Leonardo da Vinci, Jean-Francois Millet, Joan Miro, Claude Monet, Edvard Munch, Pablo Picasso, Odilon Redon, Henri de Toulouse-Lautrec, and James McNeil Whistler.

MATERIALS FOR EXERCISES IN PASTELS

Student Project 4.1: *Exercises in Pastels*

Paper: construction or drawing

Pastels

Drawing board or pad

MATERIALS FOR PASTEL STILL LIFE

Student Project 4.2: *Pastel Still Life*

Objects for still life

Pastel paper

Pastels

Charcoal

Fixative

Student Project 4.1: EXERCISES IN PASTELS

DIRECTIONS

Experiment before actually painting with pastel by making small patches of color about two inches square. Work on a medium-value paper (gray, gray-green, light blue, violet) with light-colored pastels. In pastels you can only mix colors by laying them on top of each other or side by side, allowing the viewer's eye to do the mixing. See below.

1. While pressing hard, apply pigment in a small area with the side of the pastel. Do this again, pressing softly.

2. Make lines with a sharp point.

3. Use firm pressure to draw a line. Press softly, and draw another line parallel to it.

4. Make parallel marks, then choose a complementary color to make parallel marks on top of that. Introduce a third color on a portion, and examine the difference. Pastel paintings often involve using unreal colors to create reality. As strokes build up, the blending will occur naturally. Be daring in your use of color. You rarely will find colors that don't work together.

5. Try "pointillism" by using small short strokes of one color next to strokes of a complementary color to make a third color (example: put yellow next to blue to make it view as green).

6. Blend colors together with a fingertip or tissue. This method is rarely used by modern artists and should not be used often, except perhaps to tone a background. As you apply strokes of pastel, they will appear to blend, making the surface more interesting.

7. "Scumble" by cross-hatching over a cool or dark color with a warm color.

Student Project 4.2: PASTEL STILL LIFE

DIRECTIONS

A still life could be of a jeans jacket on a peg, a girl's purse next to her coat, a notebook and book bag, animal bones, tools, or food. Any fairly small, inanimate object will do.

1. Before you start drawing, look carefully at the subject. Representing light in pastels gives life to a painting.

2. Sketch the still life lightly with charcoal. You can make dark areas with charcoal and light areas with white chalk before applying pastels. Remove the excess with a paper tissue before applying pastels.

3. Lay in the areas of color, putting the darkest colors first and the lightest colors last. Allow the dark tones of the paper and pastels to show through in some areas.

4. Use a variety of methods for applying color. Decide what is the most important part of your painting. Emphasize the area by painting more thickly, or lighter in value. Use short or long strokes, curved strokes to follow a form, or some irregular or scribbly strokes. If you absolutely must erase, first lightly scrape pigment from the offending area with a razor (be very careful—they're extremely sharp!), then erase with a kneaded eraser.

5. Put the highlights in last. Examine your artwork carefully to see if you have created differences in value. It may help you notice flaws by holding the piece up to a mirror and looking at the reflection.

6. Always protect the painting's surface with a sheet of clean newsprint before putting it away. When it is finished, you may spray with fixative (outside, to avoid inhaling fumes) to prevent smudging, but the fixative may dull some of the reflected light from the pigment. Instead of fixative, the painting could be protected if covered with acetate before putting it in a mat.

FURTHER SUGGESTIONS

1. Take pastels and a drawing board outside the classroom to do a large drawing. Draw something with detail, such as the custodian's closet or some interesting corner of the school. Look for strong light and shadow. Rough in the general shapes. Decide where shadows lie.

2. If you are doing a landscape, notice that the farther away things are, the lighter they are in color. The grass nearer you appears darker, and the sky directly over your head appears darker than that in the distance. Show this aerial perspective by making the distant areas lighter.

3. Do a portrait of a fellow student or of yourself by looking in a mirror as you work. Experiment with unlikely colors for the subject you are drawing. You will be surprised how much more lively and interesting your work is.

© 1990 by The Center for Applied Research in Education, Inc.

PAINTING WITH TEMPERA

FOR THE TEACHER

Because tempera is relatively inexpensive and easy to use, it is a common painting material in schools. Most secondary students have already painted with tempera, although they may not yet have had much experience in blending it.

Tempera has a number of advantages as an introduction to painting with a wet medium. It is water soluble, which makes it easy to clean up, and it is opaque, so mistakes can be covered over. It is ideal for learning to change values and tones by mixing with complements and analogous colors on the color wheel.

Tempera can be used as a wash by diluting with water, but it may also be painted more thickly to resemble oil. Tempera cracks if applied too thickly, so avoid building up layers of paint. Polymer medium can be added to give lustre not normally seen in a tempera painting. A dry painting of tempera may also be "varnished" with polymer medium.

Although each student could use small round trays with tiny depressions for painting, a disposable "palette" such as two pages from a slick magazine or fingerpaint paper eliminates clean-up problems. Students use less paint this way, and throw away the palette at the end of the hour. Colors are placed around the outside perimeter and are mixed in the center of the palette. This introduces students to the concept of keeping the hue pure, but mixing it with other colors in a different place, just as they will when they work with acrylic or oil paint. If the students are working large and need more color, place the paint in styrofoam egg cartons, mixing color in the lid, and close the carton overnight.

The work of Andrew Wyeth is painted in tempera. Point out the soft coloring and fine detail that can be achieved. The gouache painting by Jacob Lawrence below illustrates the fine detail possible with opaque paint.

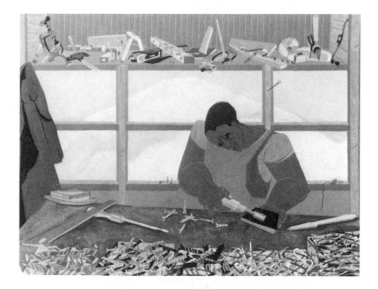

Photo 4–1 Jacob Lawrence, "Builders #1." 1972. Gouache. 21½" x 30". The Saint Louis Museum. Eliza McMillan Fund.

MATERIALS

Student Project 4.3: *Tempera—Bowl of Eggs*

Tempera paint

Still life of white eggs in white bowl on white cloth

Spot lights with color

Palettes: egg cartons or magazine pages

Brushes: watercolor nos. 11, 7, and 2

White paper, 12 by 18 inches

Student Project 4.3: TEMPERA—BOWL OF EGGS

DIRECTIONS

1. A white bowl of eggs on a white surface has no color. If the background is also white, you will have to use "artistic license," inventing color to make an interesting painting. Lightly sketch the still-life with pencil.

2. This is an exercise in working with a limited palette of colors. Decide whether you want to have a warm palette or a cool palette, and select analogous colors in that range.

3. To "gray" or darken colors, mix a complementary color with your chosen color, and lighten it by adding white.

4. Squint through almost closed eyes to discern differences in value and dark areas between the eggs, under the bowl, and in the folds of the cloth. Paint those shapes in the darkest value. If you paint the "negative" shapes—the shadows—the outline of the eggs will quickly emerge.

5. Work on the entire picture plane at one time. Don't attempt to complete one egg before starting on the next one; while your paint brush is loaded with a certain color, paint it wherever you see exactly the same value on the still life. Tempera paint dries and cracks if it is built up thickly, so plan ahead before you put on paint.

6. It may be necessary to "invent" a background. A subject such as a bowl of eggs can't just float in the middle of a picture, but needs to rest on something with some interesting detail in the background. Sometimes you may "break up" the background by drawing a line or two and painting different colors where there is a division.

7. You have been "graying" colors by mixing small amounts of a complementary color as you paint. It may enhance the painting to add a very small amount of pure color somewhere in the painting.

FURTHER SUGGESTIONS

1. This same type of painting could be done with a bowl of lemons on a yellow ground. A pitcher or other food related utensil could be added. Look at paintings of old Dutch masters, at the way they painted lemons by peeling one back slightly to reveal the inside of the peel. Onions, green peppers, cabbages, eggplants, and other vegetables or fruits are effective.

2. Each student could bring food items and utensils for a gigantic Baroque still life. Loaves of uncut bread, grapes, cheese, and fruit could make an interesting painting.

WATERCOLOR PAINTING

FOR THE TEACHER

Watercolor painting dates back to the ancient Egyptians, who painted in watercolor on papyrus, and the Chinese, who painted on silk and rice paper. During medieval times it was used for illuminated manuscripts and panels. Eighteenth century English artists are well known for their delicate watercolors. Show students work by famous watercolorists such as Winslow Homer and John Marin.

Portraiture in watercolor is shown in "Carpe Diem," by Barbara Aydt, while Kent Addison's "Still Life #1110" is an example of trompe l'oeil (fool the eye) paintings that appear to incorporate real materials but are actually realistic watercolor paintings. Other paintings may include real materials such as rice paper or grass.

Although students may have done watercolor painting previously, this is a good time to experiment with some watercolor techniques. If they see what can be done before they start on a picture, it will give them ideas that can be applied to later projects.

White sulfite drawing paper or white construction paper may be successfully used for classwork, although watercolor paper does give more reliable results and could be used after students attain more skill. Professional watercolorists either use heavy paper or stretch their watercolor paper by wetting and taping it down, but this step often is not necessary for the classroom. Moisten the watercolor pans several minutes before using to "bring them to life."

Talk with students about a few watercolor basics. Because an effect made with watercolor is difficult to change, students need to think before applying paint. If an area has been painted too dark, it could be diluted with water and blotted. It is much easier to paint by working from light to dark, building up color. There is no white in watercolor, so white has to be planned for in a picture by using a watercolor resist and painting over it or by not applying paint in some areas. Watercolor paper should never be erased, as erasing causes paint to soak into the paper unevenly. For the same reason, remind students not to scrub in paint, nor go over one area too many times. Inexpensive paper can easily be overworked.

Discuss the "happy accident." Students should always be looking for the unexpected thing that has happened in a painting. Watercolorists often encourage the unexpected, even tilting the paper and allowing runs to occur.

Encourage good work habits by telling students that colors are mixed on the lid of the pan or a palette, not by dipping the brush consecutively into different pigments. The brush must be washed often. Have two containers, one for dirty water and one for clean.

MATERIALS

Student Project 4.4: *Watercolor Experiments*

Student Project 4.5: *Watercolor Landscape Painting*

White paper: white sulfite, white construction paper, or watercolor paper

Watercolor paints: cake or tube

Brushes: nos. 12, 7, 1, or 2, Bright no. 10, and bamboo brush

Palette for mixing: glass on white paper, white plate, or butcher's tray

Water-soluble fine-line marker

India ink

Spray bottle

Water containers

Pencil

Art gum eraser

Resist: rubber cement, masking tape, white crayon, or Friskit (TM)

Tissues

Pieces of cardboard

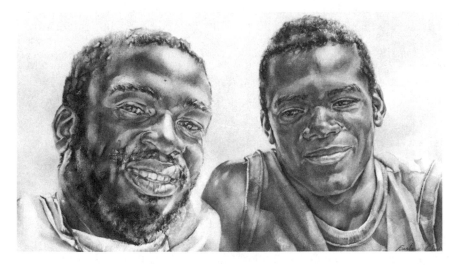

Photo 4–2 Barbara Aydt, "Carpe Diem." Watercolor. 34″ x 20″. Colors are carefully built up by glazing. Courtesy, the artist.

Photo 4–3 Kent Addison, "Still Life #1110." 1987. Watercolor. 22″ x 30″. Courtesy, the artist.

Student Project 4.4: WATERCOLOR EXPERIMENTS

DIRECTIONS

Before beginning a painting, practice some of the methods used by watercolorists. Make small areas of color and experiment with different brushes and colors. Always have a sheet of paper next to your artwork to test the colors on before you apply them to the actual painting.

1. Wet-in-wet: brush clean water onto the paper. Add pigment to the wet areas. Notice how they spread. Add another color onto a portion of the first. You will end up with unpredictable but interesting shapes.

2. Dry brush: remove most of the water from a brush by wiping it on paper; then put pigment on it and paint with the almost dry brush. Part of the paper will show through the brush-strokes.

3. Graduated wash: use almost pure pigment at the bottom of the picture, then dilute it with water as you get nearer to the top.

4. Even wash: keep the brush loaded with the same amount of pigment and water each time to make broad areas of color.

5. Stippling: use the brush tip to make little round dots. Try closely related colors and combinations of complementary colors.

6. Blotted: Load your brush with paint and lay in an area of color on the paper. Wad a tissue and use it to blot into the wet paint. The gradations and lines created by blotting give an interesting texture.

7. Watercolor resist: paint rubber cement or commercially prepared Friskit on the paper, allowing it to dry before painting, or draw designs or a landscape on white paper with a white crayon. If you use the crayon method, fill in some areas with pattern or cross-hatching. The more detail in this type of resist, the more interesting it will be.

8. Sprinkle Kosher salt into wet paint to create interesting effects. On a winter landscape, it makes a realistic-appearing snow.

9. Glue tissue or rice paper onto the painting surface and paint over it to give an Oriental feeling to a watercolor painting.

10. A palette knife may be used to scrape grass—like forms or designs into dark areas of a painting.

11. Experiment with mixing colors before beginning a painting.
 a. Mix the three secondary colors (orange, green, violet) using primary colors only.
 b. Mix a number of values of one pure color by varying the amount of water added.

Student Project 4.5: WATERCOLOR LANDSCAPE PAINTING

DIRECTIONS

1. Think of your favorite place to vacation: a lake, Disney World, New York City, perhaps the mountains. Now try to imagine the best time of day while you are there. Is it early in the morning, with mist rising from the lake, or when the sun sets down over the mountains? Think about what the sky looks like, what color it is. When you are painting sky and water, remember that the water is usually a little darker than the sky it reflects.

2. Use a pencil to *lightly* sketch in the main shapes before painting.

3. Paint in the sky first. If you choose to make a rainy day, you could use the wet-in-wet method for the sky. You might want to use a resist to make clouds. Usually if you want an area to be white, you allow the paper to show. For landscapes, paint should be applied from the background to the foreground, and washes should be laid in from top to bottom. Use broad brush strokes to put in areas of color, then use the smaller brush to fill in detail. Some artists use white gouache to add white to a painted surface.

FURTHER SUGGESTIONS

1. Cut a piece of corrugated cardboard, posterboard or tagboard approximately 1½ by 3 inches. The size may vary somewhat. Mix the pigment on the palette, and dip the end of the cardboard into the pigment. Hold the cardboard upright, and apply paint with the cardboard bottom edge. This method is particularly appropriate for buildings and cityscapes, and can be used to put in such details as shingles on a roof or boards on a barn or building. It also is effective for making water or sky or applying a variety of strokes for an abstract design.

2. Use your less-than-perfect paintings by tearing or cutting them and combining them in a collage with a new painting. They could also be woven like a checkerboard or combined with other materials such as string or twigs.

PAINTING WITH ACRYLICS

FOR THE TEACHER

Acrylics, a relatively recent addition to the painting field, have advantages and disadvantages compared with other media. They are fast drying, odorless, and water soluble—qualities desirable in the art classroom. Acrylic paints are flexible, have great adhering qualities, and do not crack like tempera paint when built up in layers.

Acrylics lack the texture that oil paint has when applied, but artists have learned to take advantage of that lack by painting "flat field paintings" with little modeling. If an artist prefers texture, modeling paste or gel medium mixed with marble dust may be painted on a canvas or masonite panel to give the impasto effect people are accustomed to seeing in oil paintings. Some artists use polymer medium as a glue to adhere collage items to canvas, often painting on top of them as shown in the photo below.

Acrylics may be used as opaque paint, resembling oil paint, or as transparent paint such as watercolor. They may be used on unprimed raw canvas as a stain. Successive colors may be added into the stains. Helen Frankenthaler's and Morris Louis's gigantic color-field canvases, found in most major art museums throughout the world, are stained with acrylic paints. Oil paints used in this same manner would cause the canvas to rot.

Op-art and geometric paintings became popular when acrylic paint first was being used because it was so controllable. Many artists painted with straight lines and geometric figures because acrylic paint allowed for that type of expression. Paintings by Victor Vasarely and Bridget Riley exemplify this field of painting.

Because of the fast-drying quality of acrylic, always put brushes into water when they are not actually in use. Special nylon brushes are recommended for acrylic paints. Students should protect their clothing while painting with acrylics.

MATERIALS

Student Project 4.6: *Acrylic Collage Painting*

Palette (piece of glass or glass plate)

Acrylic paint in a variety of colors

Brushes

Canvas, posterboard, watercolor paper, or untempered masonite

Gesso (used as a primer for canvas or untempered masonite)

Variety of materials used for texture

Photo 4–4 Martha Ohlmeyer, "Italy." Acrylic collage. 36″ x 40″. Courtesy, the artist.

82

Student Project 4.7: ACRYLIC COLLAGE PAINTING

DIRECTIONS

1. Use prepared canvas, or prepare untempered masonite by applying a primer of two coats of gesso: the first coat up and down, the other across. Acrylic paints may also be painted on heavy paper or poster board.

2. Look for interesting textures to use as collage materials in your first acrylic painting. Some suggestions are: needlepoint canvas, gauze, plastic bag, curtain stiffener, string potato or onion sack, net, dishcloth, almost any fabric, tissue paper, string.

3. Move these textures around, cut them into interesting shapes, and repeat them in various places in the composition. Use polymer medium generously underneath the collage materials as a glue, and again on top of them to make them flat and easy to paint.

4. Decide where the painting's center of interest is. Look at the shapes to decide how to call attention to the focal point instead of detracting from it. Although a totally abstract composition may have an overall pattern, generally the viewer sees one area of the painting. It may be the lightest, brightest, or darkest area, often located on an imaginary intersection of a tic-tac-toe division of the picture plane. This "rule of thirds" is often used as a compositional device.

5. The colors for this project could be variations of one hue or from one side of the color wheel. You might choose to make a triadic color scheme, variations on three colors, or a split-complement color scheme.

6. As you are painting, you may continue to add collage materials with polymer medium. The polymer medium can also be mixed with acrylic paint to add gloss.

7. Look often at your painting, even turning it upside down or on its side. It may suddenly strike you that your abstraction looks like something real. Be willing to change your mind. If one realistic object appears in the middle of unreality, it even might make your painting better.

8. Although you can go over the entire painting with polymer medium as a "varnish," it is not necessary for permanence and could dull your colors.

9. Clean up carefully. Wash out the brushes with soap and water, as even a tiny amount of paint left in the brush is usually there to stay.

© 1990 by The Center for Applied Research in Education, Inc.

THE ACRYLIC WALL MURAL

FOR THE TEACHER

In general, the teacher's role in supervising a mural is finished by the time the painting starts. The important decisions are made in advance. Remain involved, however, because things have a way of changing, and executive decisions sometimes need to be made.

MATERIALS NEEDED

Acrylic paint

Pencils

Brushes

Masking tape

Overhead projector

Ladder

Newspaper

Acetate

Permanent black ink

DIRECTIONS

1. Select a wall on which the mural will be painted, and have a fresh neutral background painted. Washable acrylic paint is suggested for the entire mural, since custom colors may be mixed and clean-up will be easy. Measure the wall to get the proportions for the design.

2. The mural could be based on student activities, musical instruments, sports, or a collage of various activities around school. Work on designs together, or have each student submit a design for consideration. Three suggested methods for making a design are:
 a. Draw a design on paper, using two to four values. Lay a piece of acetate on top of the drawing and draw the design on acetate with black permanent ink. Different values may be indicated on the original design by cross hatching, dots, stripes, numbers, etc. This acetate drawing can be projected onto the wall with an overhead projector.
 b. Make a transparency such as those used for overhead projections of an original high-contrast drawing on an office copy machine.
 c. Use a high-contrast film positive (Kodalith) of a photograph or combinations of photographs and project it directly onto the wall with an overhead projector. The Kodalith positive may be made commercially from black and white negatives, or follow directions in the appendix for making your own.

3. Put all paints into easily handled smaller containers with lids, such as butter tubs.

4. Two colors or three or four values of one color can be very effective. The wall background may be effective contrast for the mural and should be considered as one of the colors. Areas of paint may be kept "flat" or could be "modeled."

5. When the image is lined up and projected on the wall the way you want it, simply use pencil to draw it on the wall.

6. If straight lines are needed, use masking tape to keep straight lines clean. Measure to make sure the tape is straight, then press it firmly with the back of a thumbnail to attach it securely to the wall.

7. It may take more than one coat to adequately cover an area. Be sure to wash brushes carefully each time, as they are not usable the next time unless that is done.

ANOTHER APPROACH TO CREATING A MONUMENTAL MURAL

Artist-in-residence Robert Fishbone has another approach to creating murals with students. He states:

My work as a Public Artist and teacher is uniquely different from my in-studio creating. When working with a group, it is essential that the artwork reflect who the participants are and what their dreams might be. The art can then stretch their minds and spirits and open them to feeling life in expanded ways.

I know that the artwork already exists within the participants, much the way Michelangelo's sculptures were resting within, waiting to be released from their marble abodes. My job is thus to motivate the students through stimulating exercises.... I become a guide, leading the students on a grand journey of self discovery. I distribute a questionnaire to the student body. The answers to the questions (which are tailored to the age group, academic level and cultural region) give me impressions of how they think, what they know, and how they feel.... The questions include references to color, geography, ancestry, sports, music, likes and dislikes, feelings, anything that I feel will draw an informed response from the students. I make sure to include playful questions with the "serious" ones to help the students stay interested in finishing the survey and to keep them a little off guard (life is *not* all that predictable, right?)

Photo 4–5 "Breaking Barriers." 50′ x 10′ mural. Painted by Parkway West students under the direction of Robert Fishbone.

PAINTING WITH OILS

FOR THE TEACHER

During the Renaissance, artists began mixing oil with pigment and found it had wonderful qualities. It can be painted "into" while wet for interesting effects. The paint does not dry out quickly, as acrylics do. Oils may be applied thinly as glazes or thickly as impasto, and a range of textures are possible. It continues to be the medium of choice for many artists because of its color range, texture, and versatility. Show students oil paintings by Rembrandt, and point out the treatment of lights and darks (the chiaroscuro) in his and other old-master paintings. Point out how the Impressionists, such as Claude Monet, Edouard Manet, and Camille Pissarro used paint to show light and shadow.

Vincent Van Gogh's paintings, rich in impasto, have survived beautifully because he always painted "alla-prima," when the paint was fresh, therefore avoiding cracking of paint. Other artists may work for six months or years on a painting, by continually keeping the surface moist. The old masters, such as Jan Van Eyck, achieved the luminous quality for which oil painting is known by building up transparent glazes.

Most of the students will work quickly and probably do not need to be concerned about paint drying too fast, but they still should understand the concept of painting from "lean to fat" when painting with oils. To avoid surface cracking, an undercoat should always be "lean," meaning that an evaporating medium such as mineral spirits or paint thinner should be used to thin the paint and help it dry quickly. "Fat" is an additive such as linseed oil mixed with paint to provide greater flexibility and to retard drying. A painting may feel dry in a few days, but an oil painting sometimes takes six months to fully dry.

Brushstrokes should follow form where possible, such as strokes following a curved surface, but in general the direction of the strokes is not crucial. Photo 4–6 shows an excellent example of beautiful brushwork by Vincent Van Gogh.

SAFETY NOTES: *Most pigments are non-toxic, but the following are toxic inorganic pigments: Naples yellow, cobalt pigments, cadmium pigments, chrome pigments, manganese pigments, flake white, veridian, zinc yellow, raw umber, burnt umber, mars brown, and vermillion ("Safety in the Artroom," Charles Qualley, Davis Publications, Inc., Worcester, Massachusetts, 1986, p. 66). It is recommended that you work in a well-ventilated room and substitute paint thinner or mineral spirits for turpentine.*

MATERIALS

Student Project 4.7: *Oil Painting*

Student Project 4.8: *Portrait in Oils*

Stretched canvas, canvas board, or untempered masonite

Gesso

Palette, masonite or paper

Palette knife

Paint thinner or mineral spirits

Linseed oil

Brushes

Selection of paints

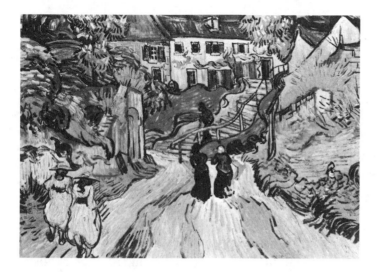

Photo 4–6 Vincent Van Gogh, "The Auvers Stairs with Five Figures." 1890. Oil on canvas. 20″ x 28″. The Saint Louis Art Museum.

Photo 4–7 John Dunivent, "Trans Am." 40″ x 54″. Oil. Courtesy, the artist.

Student Project 4.7: OIL PAINTING

DIRECTIONS

This first project in oils is just to teach you to mix paints and experience the variety of ways to apply oil paint. If you have a drawing that you like, you could use it as a starting point.

1. First, prepare the painting surface. Primed, stretched canvas or canvas board may be purchased, or an unprimed canvas can be primed by painting on two layers of gesso before painting. Prime untempered masonite with gesso as an alternative painting surface.

2. Place an assortment of colors in one-inch lengths around the outside of the palette. See below for a suggested arrangement of colors. Reserve the middle of the palette for mixing colors. Apply principles of color mixing you have already learned, making darker or lighter values of a hue by mixing with the complementary colors. Avoid relying on only black or white to darken or lighten your colors, as paints seem to be deadened by the use of those neutrals without the addition of other colors.

3. Begin your painting in one of two ways:
 a. Draw the design with vine charcoal and spray the drawing with a fixative. Apply colored pigment directly to the white canvas.
 b. **Underpainting**: dilute paint with thinner or mineral spirits and "draw" with paint. Paint areas dark, medium, or light over the entire canvas to indicate values. This thinned paint will dry quickly.

4. There are as many ways to apply paint as there are artists who work with it. Some use a palette knife as a brush and work quickly, while other artists apply paints in layers (glazing) for greater translucence. Some prefer to build up layers, creating an impasto effect. The secret is to work all over the entire picture plane. You cannot start in one corner and work down or totally finish one part before going onto the next; you must "rough in" the whole canvas before working to refine certain areas of it. Painting in oils is more time consuming than in watercolor because of time spent waiting while one area dries.

5. As with any composition, work should have a variety of textures, with flat areas for the eye to "rest," as well as areas with more detail.

A palette for oil painting is normally set up with complementary colors opposite each other.

PORTRAIT IN OILS

FOR THE TEACHER

Portraiture is one of the most difficult of all subjects. An inexperienced painter who tries to do a portrait needs to understand that "getting a likeness" is not important. It will certainly look like a person and could be a wonderful painting, even if it does not look like the person who posed. To help students review proportions of the face, refer to the section in Chapter Three on drawing a self-portrait.

Before students begin a portrait, talk with them about portraits done by other artists. Show them a variety of portraits such as a Rembrandt self-portrait, Henri Matisse's paintings, Vincent Van Gogh's painting of a green-faced baby, Amadeo Modigliani's long-faced portraits, or the amorphous faces found in paintings by Francis Bacon. If you show a number of disparate examples, they will realize that almost anything goes. Below is an example of a student self-portrait.

Encourage the students to "invent" a background or have the sitter wear or carry a prop such as a hat. Cropping (not including the entire face) is one way to change the concept of self portrait. Working larger than life-size can by dynamic.

MATERIALS

Stretched canvas, canvas board, or untempered masonite

Gesso

Palette, masonite or paper

Palette knife

Paint thinner or mineral spirits

Linseed oil

Brushes

Selection of paints

Photo 4–8 This student self-portrait is a dynamic example of how the student looks during an important period of her life.

89

Student Project 4.8: PORTRAIT IN OILS

DIRECTIONS

1. Look closely at the subject's skin. You could be your own subject by looking in a mirror as you paint. Notice all the colors you see; rich colors such as blues, yellows, pinks, oranges, and violet. Artists use such colors, even if they don't really appear to exist in reality. Look at the shadows and highlights. The whites of the eyes aren't really white, are they?

2. To show the shape of a face, it is necessary to model with paint. This means to show that something is curved by creating shadows and highlights. Use colors that seem extreme at times. It is amazing how colors that seem exaggerated as you put them on the canvas don't seem as strong later.

3. When painting hair, don't attempt to detail every hair, but paint in areas of color. Pay careful attention to dark areas, to reflections of light on hair. Feel free to put colors on the hair that don't really exist, such as purple, or orange. Imaginative use of color will strengthen your painting.

4. Look carefully at the lips. Show the form of the mouth by placing a dark shadow under the lower lip and painting the line between the lips darker than the lips.

5. As you are painting the face, paint some of the color used in the face into the background. An oil painting is different from other techniques because the entire surface is covered with paint.

6. Stand back and look at the portrait, or hold it up to a mirror and look at it. It should appear to have three-dimensional form through the use of shadow and highlights.

FURTHER SUGGESTIONS

1. Try to do a realistic painting of one or more people from a photo of your own.
2. Paint a real or fantasy landscape.

CHAPTER 5: ADVERTISING ART

OBJECTIVES

- To analyze and help students create original solutions for commercial assignments
- To introduce the tools, materials, and vocabulary of commercial art
- To teach commercial applications for fine arts skills
- To apply a variety of techniques for lettering
- To discuss some methods for making an effective poster
- To help students become aware of current and historical advertising art

INTRODUCTION

Commercial art courses taught at the secondary level are not generally completely technical. Rather, they offer an opportunity for students to find out what commercial art is and to learn practical applications of artistic skills. Students who love art are often concerned about whether they would be able to support themselves as artists. Such a course challenges students to be creative while learning the basic skills necessary to prepare work for reproduction. Industrial art classes or vocational-technical schools teach commercial art from a more technical viewpoint, concentrating on commercial reproduction skills.

Students will learn such skills as making thumbnail sketches, measuring, lettering, rendering, packaging, laying out (dummying), pasting-up, and preparing work to be reproduced. They also are challenged to use their creativity to find original solutions to practical assignments. Secondary schools have a constant call for advertising posters, covers for programs, graphics for the school, and entries for outside competitions. Students whose work is reproduced receive gratification and a meaningful piece for a portfolio.

A variety of materials and equipment may be used in commercial art classes. In addition to using materials such as watercolor, marker, ink, and colored pencil for renderings, consider combining materials. Encourage students to experiment with a number of media on some of these projects to find the one that "says it best."

Analyze commercial art in its various applications: posters, billboards, videotape covers, magazines, newspapers, product packaging design, and visuals used in TV advertising. Ask students to bring in examples of ads that appeal to them, particularly familiar artwork that has been "adapted" for advertising, such as the Mona Lisa, a Rousseau jungle painting or a Botticelli "Venus Rising from the Sea." Have them look for symbols: faces, hands, people, or animals that represent certain things. For example, the tiger may be used for strength or the rose for beauty. Many car ads use one type of image to symbolize ruggedness and another to symbolize wealth. Cigarette ads are prime examples of attempting to appeal to a certain segment of consumers through the use of symbolism.

Introduce a number of basic skills including how to arrive at original solutions to problems. A project has basic limitations such as format (shape and direction), words, size, or color. Suggest that students think about each word they will be using, associating them with objects or visual images. Explain that in the preliminary stages of problem solving, nothing is too far-fetched or ridiculous to consider.

One approach to stimulate creative thinking about slogans is the "Chinese menu" (take one item from each column) approach. Ask students to make a vertical column, writing every word of the idea they are selling (the title of a play or a slogan). Opposite each word write other words that come immediately to mind (such as visual images, rhyming words, or those closely related in sound). After doing that with individual words, try combining words or ideas. A play on words, with unusual images, may arrive as a result of these exercises. Drawing images to go with the words also fosters creativity.

TYPE

Learning about type is an important part of a commercial art course. It is easy to be so caught up in the drawing or image that we forget the message to be conveyed. Type is a crucial part of most ads and is often more important than the illustration. Space must be allowed for the lettering and for the message. Decide what is the most important thing to be said, then allow it to be in the largest type. Less important details may be in smaller type and grouped together.

Have students go through newspapers and magazines and select ten ads that are dominated by type. Then have them analyze how the type "works" with the product that is advertised. Is the type large or small? Is it on top of an image, or is it set off by itself? Is the typeface the same size everywhere in the ad, or does it vary? Are different typefaces used in the same ad?

There are literally hundreds of typefaces to choose from. The popularity of typefaces comes and goes and comes back again. Help students notice the type used on billboards and in ads. Suggest they select a typeface to go with the visual image they intend to use. There are some easily recognizable types such as "Old English," "P.T. Barnum" (circus style), or "Art Deco" that may be perfect for some ads and totally inappropriate for others.

Each type comes in many variations (fonts). For example, a common typeface such as Helvetica may be used in a number of different sizes and weights, as well as upper case (capitals) or lower case (small letters), bold, italic, or condensed. Many modern type fonts do not have serifs (the short lines stemming from the upper and lower ends of the stroke of a letter) and are called sans serif.

Students have many alternatives for applying lettering and should practice various ways for at least a week. Some suggestions for lettering methods are:

1. Use broad-nib felt-tipped markers as if they were lettering pens. Hold them at an angle to make letters thick on the sides and thin on top and bottom. These markers range in width from 1/4 inch to 3 inches.

2. Do calligraphy with pen and India ink or with calligraphy pens.

3. Use a brush to "write" letters in ink. Letters could also be applied with a dry-brush technique.

4. Use press-type lettering for relatively small projects.

5. Trace lettering onto a piece of tracing paper directly from a book of typefaces, lining the letters up very carefully. Then cut out the lines of print from the paper and use rubber cement or removable clear tape to place them on the layout.

6. Computer-created lettering often is already sized appropriately. This can be applied directly, or can be drawn over with tracing paper. If the size is not large enough, it can be enlarged on a school copy machine or transferred to an overhead transparency and enlarged by placing the transparency on an overhead projector.

MATERIALS FOR THUMBNAIL SKETCHES OR WORKING OUT IDEAS

MATERIALS

Student Project 5.1: *The Thumbnail Sketch*
Pencil
Newsprint, 8 by 10 inches
Tracing paper, 8 by 10 inches or smaller

MATERIALS

Student Project 5.2: Layout—*Design a Billboard*
Newsprint
Tracing paper
Masking tape
Illustration board
Coloring media: tempera, acrylic paint, colored pencil, or markers
Pressure-sensitive letters (presstype) or pen and ink for lettering

MATERIALS

Student Project 5.3: Paste-up—*Design a Business Card*
Illustration board
Acetate
Rubber cement
Non-photo blue wax pencil (not a blue pastel)
Masking tape
Pressure-sensitive lettering
India ink and lettering pens
T-square
Triangle

Student Project 5.1: THE THUMBNAIL SKETCH

DIRECTIONS

The thumbnail sketch is a method of organizing ideas on paper. It is not intended to be a beautiful drawing, but simply a quick, economical way of showing how finished artwork would look. Thumbnail sketches rarely take more than a few minutes each. You should try to do at least six sketches to arrive at the best solution.

It isn't necessary to solve all your problems on one sheet of paper. You may make a "mobile layout" by drawing details on several small pieces of tracing paper with, for example, a background on one, lettering on the next, and people on another. This method is particularly helpful with a complex design. When all the parts are arranged the way you want them, tape them down and draw a final sketch on one piece of tracing paper.

1. Use a pencil to draw on newsprint a minimum of four outlines in proportion to the format. If working within a rectangle, draw small rectangles approximately 2 by 3 inches. By working small in pencil, you can change the sketch easily.

2. In the first rectangle put down the first idea that comes into your mind. By getting something down on paper, you will find that one idea leads to another. After making six or seven thumbnail sketches you will find that one is definitely better than the others.

3. Select your best idea and refine it further. You could lay tracing paper over the sketch and try various alternatives. Consider how to combine lettering with the drawing or how to break up the background. Even after you have a solution, it may take several more quick sketches before you are ready to draw it more carefully.

4. You may enlarge your sketch freehand or enlarge it exactly by using a grid or an opaque projector.

5. If you are working large, make a mobile layout by putting the separate elements on different sheets of paper and moving them around until you are satisfied with the composition.

Student Project 5.2: LAYOUT—DESIGN A BILLBOARD

DIRECTIONS

The layout is a rough sketch or design that shows in detail what the finished artwork will be. Render the drawings or paintings in color with dummy type added to complete the layout. Large lettering may be printed in the same size and style that will be used. Small print may be simulated with wavy lines.

Look at billboards and notice that they are simple in design, with very short messages. They are read while people are driving by in cars, and there isn't time to read more than a few words. The lettering is large so it can be seen from a long distance and is usually brightly colored or very dark for easy reading. Try to use an image that is easily understood by anyone who sees it, such as call letters for a radio station.

1. Do several thumbnail sketches in proportion to the shape of a billboard. The lettering or slogan will be an important part of this billboard, so think carefully about what to say and the size of the lettering.

2. Think of an appropriate image to combine with the lettering you are using. It could be a symbol or drawing to illustrate music or baseball games or whatever the station is best known for.

3. It may be helpful to use several small pieces of tracing paper with parts of the billboard on each, such as lettering on one, the background on another, and an illustration on another. Move them around until you find the best use of space. You may want to "break up" the background rather than have figures floating in space. Sometimes you can use a portion of a geometric figure, such as a quarter circle or part of a triangle, to divide the background into more than one color.

4. When your design is ready for the final layout, draw a rectangle in proportion to a billboard onto illustration board or heavy white cardboard, leaving a border of 2 or 3 inches around the outside. This is to allow for handling the artwork without touching the illustration.

5. Lightly draw the image onto the board and illustrate it with colored pencil, tempera, acrylic paint, or markers. Lettering could be added with ink or presstype.

6. When the illustration is complete, cut tracing paper slightly longer than the size of the illustration board, fold one inch over the top and attach it to the top of the board with a single piece of masking tape across the top of the tracing paper and the back of the board. The tracing paper should be able to fold all the way back, with the masking tape acting as a hinge. See below.

FURTHER SUGGESTIONS

1. Make a billboard design with a public service message such as a warning against drunk driving.

2. Design a billboard to be used inside a ballpark to advertise a food or beverage item (no alcoholic beverages).

A tracing paper or acetate overlay will protect work. Make it one inch longer than the board to fold an inch over the top and tape it on the back.

Student Project 5.3: PASTE-UP—DESIGN A BUSINESS CARD

DIRECTIONS

Camera-ready art is sometimes referred to as a paste-up or mechanical. It is usually done on a piece of illustration board, complete with the lettering and artwork. The lettering and images are often placed on separate pieces of tracing paper and then applied to the board with rubber cement. Whatever the final color the printer will use, the lettering and images on the paste-up are normally black.

If more than one color is to be printed, an overlay of acetate with artwork or lettering (again in black) will be attached. For each color that is added, a separate overlay is made. Instructions to a printer specify colors to be used on each overlay and the paper stock on which the printing is to be done. Separation of colors for a four-color overlay would probably be done by a printer with a camera (or scanner) made for that purpose. To learn color separation, a two-color project involving one overlay is sufficient. Although most camera-ready art is done the exact size that it will be printed, small items such as business cards will print crisper if the artwork is double size. The printer is instructed to reduce the final version to half-size.

A business card is how you present yourself to the world. A traditional business card simply has your name and other information in readable lettering. It could also have an image that shows what you do or sell. Collect some business cards. Study the placement of the words on most cards. The name of the company is dominant, with details usually in smaller letters.

To begin designing your card, think about what you intend to be doing ten years from now. If you will work for someone, what will you be doing? If you have your own business, how would your business cards look? Perhaps your "company" will have a "logo" the incorporates your initials. A logo uses the initials of a business in design, often used on letterheads, cards, signs, and any other publicity purposes. Well-known logos are General Electric's GE initials, the NBC peacock, and Westinghouse's W in a circle.

1. To make a 2 by 4 inch business card, cut a piece of illustration board 6 by 8 inches. (Always make the board larger than the artwork to allow for handling and instructions).

2. With a blue wax pencil, outline a rectangle 2 by 4 inches in the center of the board, using a T-square and a triangle to make 90-degree angles (the copy camera does not "see" the blue line). If you prefer to work larger and have it "reduced," make a 4 by 8 inch rectangle. Most camera-ready art is done in the size it will be printed.

3. Decide how you will arrange your lettering. If you use a logo, where will it be placed? Where will your name or the company's name be? Where will you place the "informational data" such as address and telephone? Individual lines of type can be centered, lined up evenly on the left or right edge, or staggered like steps.

4. Apply the main lettering either with pressure-sensitive letters onto tracing paper or by lettering with pen and ink. Letters made on a computer could also be used. Lightly draw a straight line or line up with a T-square to ensure that the lettering will be straight. Use an X-acto knife to cut out the paper containing the lettering and coat it on the back with rubber cement. Then coat the board with rubber cement where the lettering will go. For a permanent bond, let the two surfaces dry before cementing them together. Remove any excess cement with a "rubber cement lifter" or an eraser.

5. Place registration marks outside the blue rectangle.

6. To add a second color, place a piece of acetate on top of the illustration board, using tape along the top as a hinge. An image or additional lettering done in a second color will be placed on this overlay (again rendered in black). The printer would be given instructions about which inks to use for the base and the overlay. Registration marks on the overlay matching those on the board ensure that it will be lined up when printed.

A registration mark.

FURTHER SUGGESTIONS

1. Design a logo for memos, an envelope, and letterhead stationery. For display, place the entire group of business stationery on a large piece of illustration board such as the one on this page.

2. Design a logo, name, or design for the sides and back of a delivery truck.

3. Design a program cover for a music concert at your school.

Student work.

PACKAGE DESIGN

FOR THE TEACHER

Students enjoy designing containers and can learn a number of different skills while stretching their creative muscles to come up with something original. They should be aware that no matter how good the product is, manufacturers know that the packaging influences how well it sells.

The packages designed for this project do not have to be large, but could be made to scale to represent larger packages. If the boxes are larger than cereal boxes, the cardboard should be very sturdy, or they will not hold up well.

Suggest that students look around in stores or at home for packages that are unique or eye-catching. Manufacturers of high-profit items such as cosmetics spend freely on attractive packaging and bottling. Let this project be not only a "do it" project, but also an opportunity for students to develop awareness of packaging and analyze how wonderful some solutions are and how ordinary others can be. Ask them to be particularly aware of color, to notice if some colors seem to be used more often than others, and why that might be. They might notice that some colors are not used at all in cereal packaging, but are commonly used in toiletry articles. For example, black is a glamorous color in packaging pefume, but not at all appealing in a cereal box. If students cannot bring in actual packages to talk about, have them sketch interesting boxes in the store. Require each student to bring in five real or drawn examples of packages that they consider effective to stimulate discussion about packaging.

Below is a student-designed package.

MATERIALS NEEDED

Student Project 5.4: *Package Design*

Box pattern hand-out

Newsprint

Pencil

Rubber cement

Poster board, 6 ply (colored or white)

X-acto knife

Poster or acrylic paint

Brush

Ruler

Student Project 5.4: PACKAGE DESIGN

DIRECTIONS

Begin by deciding what it is you want to sell. Your package could contain food, drink (nonalcoholic), cosmetics, clothing, toys or a game, tissues, or shoes. If the item you intend to package is large, make a smaller box (to scale) as a sample of what it would look like. You might consider using your own name as part of the product's name.

1. On newsprint, doodle ideas, names, and package shapes. Nothing is too fantastic to consider, so let your imagination go wild.

2. Make a pattern the size and shape of the box. Make boxes neatly by using tabs. Measure carefully to ensure that the box will close and that the sides will be straight. It is easiest to make a rectangular box, but the box may be any shape you wish, as long as it closes neatly.

3. The box will have a dominant side, where the largest lettering and most important image should be. The sides should be in harmony with the dominant side, however, so that the box is attractive and interesting from any angle.

4 Lay a pattern on a piece of poster board and use a ruler when drawing around it to make straight edges. Remove the pattern, and use an X-acto knife with a straight edge to make perfect cuts. To fold the sides easily and perfectly straight, "score" them by running a pointed object, such as scissors or an X-acto knife, along a straight edge on the inside of the tabs and folds.

5. Before gluing the box, lightly draw the images and letters with pencil. Use acrylic or tempera paint to carefully paint the background of the box around the lettering. Don't paint the tabs, or it will be difficult to glue them to the inside of the box. Paint the lettering carefully. Even if you prefer a "free-hand" look to the lettering, it still needs to be carefully planned in advance.

6. After the paint has dried, paint rubber cement on the tab and on the inside of the box where a tab will be glued. Allow these surfaces to dry, then carefully press them together for a permanent bond.

FURTHER SUGGESTIONS

1. Design a box for a children's game that looks as exciting on the ends as it does on the top, so that when it is stacked on a shelf, it makes you want to pick it up.

2. Design and paint a label for a one-gallon paint can that would be effective when the cans are stacked together. Do a drawing of how twenty of them would look when stacked together on a shelf.

3. Design a wrapper for special candy bars: size, shape, name and type of candy to be your own invention.

This drawing shows a way of cutting a box and making tabs.

ILLUSTRATION: MAGAZINE COVER

FOR THE TEACHER

Lettering and images go hand-in-hand in most commercial art assignments, but while lettering can be purchased, ideas and original images have to come from the artist. The ability to draw should be stressed. Students need practice interpreting ideas and learning new ways to present them. Although commercial artists have "swipe files" or references where they can go to get "clip art" of people, buildings, trees, etc., their ability to make their own extraordinary interpretations of ordinary objects can be the basis of their success.

Remind students that although commercial artists often use artwork or photographs done by other artists as a *starting* point for illustration, it is unethical and illegal to faithfully reproduce artwork (and photographs are artwork) done by another person. If the photograph is taken by the artist or illustrator, it may be reproduced down to the last eyelash, as it is the artist's own artwork to begin with. See the opposite page for a student's rendering of an evolution from the original piece of art.

Give students options of materials to illustrate the cover of a magazine. They may design a cover for an existing magazine that they enjoy reading, or they may become the "cover illustrator" for a new magazine to be published. Their assignment is to make a colored cover with a masthead. Suggest they look at magazines on racks. Discuss which ones are eye-catching and why. Could it be that car magazine covers are so "busy" looking because they resemble the inside of a car? Why are pretty women on the covers of so many magazines for men and women? Do business magazines look business-like?

This assignment could be the culmination of a number of one- or two-day exercises in using a variety of media to do the same illustration. Remind students that mixed media often are used in illustrations. Although we teach "proper" ways to use materials, sometimes rules are made to be broken, and unlikely combinations of media can produce exciting results. The exercises could be made one/fourth the size of the finished cover to allow for experimentation. Ask the students to choose a subject such as a politician, rock star, or movie star, or an object such as a car, food, house, or cat, or some subject that is strongly newsworthy at that moment. They could draw this subject once on tracing paper, then each day interpret it quickly with a new medium. After five days they should know what medium will give the best results.

MATERIALS

Student Project 5.5: *Design a Magazine Cover*

Newsprint

Tracing paper

Drawing paper

Ink

Pen points

Brushes

Coloring media: acrylic or watercolor paint, colored pensils

Broad-nib and fine-line markers

Charcoal

Pencil

Pastels

Tim Smith's students use magazine photos as a starting point for various interpretations.

Student Project 5.5: DESIGN A MAGAZINE COVER

DIRECTIONS

1. Decide on an idea for a cover illustration. Look at magazines in a newsstand to see how covers are designed for different types of readers. They range from extremely complicated to simple and elegant, and usually feature an image on the cover to make you want to buy the magazine and see what is inside.

2. Draw a number of thumbnail sketches and decide on one image (such as a car, animal, scene, or person) that you will not tire of drawing and painting in a variety of media.

3. Draw the image on tracing paper the exact size that you want to have the finished cover. If you prefer, you may make the sketches one/fourth size to save time. To transfer the image a number of times, go over the lines of the tracing paper on the back with pencil,then place the tracing paper on top of drawing paper and retrace on the front of the original drawing.

4. Each day do a quick interpretation of this same subject in a different medium or combination of media. Some suggestions are:
 a.**Pen and ink:** cross-hatch to show differences in value; stipple; use a combination of ink wash and drawing or cross-hatching.
 b.**Acrylic or watercolor paint:** use diluted acrylic as if it were transparent watercolor, or paint with it straight from the tube to resemble opaque oil paint.
 c.**Charcoal:** use charcoal alone or in combination with white paint and red conté. Blend it with a tortillon, cotton ball, or your finger.
 d.**Marker:** apply broad-nib marker carefully in parallel strokes, or draw loosely with it, but avoid the appearance of scribbling. Experiment!
 e.**Collage:** make a collage of your own photographs. This could be redrawn or interpreted in a colored medium.

5. To do the final illustration, choose the medium that you think works best. This time design your cover exactly the way you want it to look on the newsstand, including the title, price, and any other information normally found on magazine covers that would relate to inside stories. You may have to place lettering on top of your image. Think about the color of lettering and where and how it will be placed. You may exactly duplicate the masthead of an existing magazine.

6. Make the illustration on a piece of good drawing paper that is at least two inches larger all the way around than the finished size of the art. Trim the edges later if necessary.

7. When finished, mount it on illustration board, then protect it by placing an overlay of acetate or tracing paper on top.

FURTHER SUGGESTIONS

1. Design a book jacket for a book you writing or illustrating. It will have the front cover, a title on the side (spine), and a back cover. Think about style of lettering and the fact that most people select books by looking at the side before pulling them out of a shelf to examine. Specify background and lettering colors.

2. Design a poster for a new movie or video—one that will make people want to see it. The illustration is very important and needs to give a strong message of the movie's content. The title will probably be short and to the point. Don't forget that it is also a major part of the illustration.

© 1990 by The Center for Applied Research in Education, Inc.

MAKING POSTERS

FOR THE TEACHER

The "Let's have a poster contest" syndrome is something with which most art teachers are well acquainted. Many of these competitions are worthwhile, and if they do not interfere with your curriculum, they may give a "real," meaningful assignment to the students. Avoid those competitions where the student is asked to copy work by another artist (such as cartoon characters). These do not promote originality and could be detrimental to what you are trying to teach. Schools are usually filled with posters that promote everything from school plays to student council elections. A few simple and effective methods of making posters should be taught to all art students and club members to visually enrich the school.

In the last century it has been recognized that, although posters were created for commerical purposes, many are fine works or art, and collectors vie for originals that were once given away. To introduce poster making, show students examples of posters made by Toulouse Lautrec, Erté, Alfonse Mucha, as well as those made by unknown artists. Point out how simple most posters are. The most eye-catching have broad areas of color and lettering that is large and clear. See below for some simple divisions of space based on well-known posters. Although students are encouraged to do original work, they can learn from seeing books and slides of posters.

MATERIALS

Student Project 5.6: *Poster Making*

Student Project 5.7: *Advertise Yourself*

Poster board

Fadeless paper

Construction paper

Long ruler

Rubber cement

Brushes

Tempera paint

Markers

Thumbnail sketches based on some well-known designs.

Student Project 5.6: POSTER MAKING

DIRECTIONS

The purpose of a poster is to advertise something. It is usually not expected to be a permanent, framed work of art. Begin with thumbnail sketches to try ideas. There are ways to work quickly for an eye-catching effect, yet get the message across creatively. What words will be on the poster? Can you think of a slogan or phrase that will emphasize the message? While the text is often the main element of design, it is also appropriate to have a drawing or silhouette that complements the text. People may see the image or background before they read the lettering.

Some pointers to consider when doing a poster:

1. The main element of the design should dominate the poster, with everything else being subordinate. One important message should be done in the largest print.

2. It should be easy to read in three seconds or less, with simple lettering, and enough space left around the design so that it is easily seen and understood.

3. The lettering should be the same size and color, and spaced as if you were pouring the same amount of water between them. Never split a display line or stack the letters.

4. Balance is an important consideration when designing a poster. Avoid a top-heavy effect if the major lettering is at the top of the poster by putting color or an image near the bottom to give "weight" and balance to the entire composition.

5. Vertical posters have better visual impact.

6. You might consider that a poster could have a top line, a waist line (between one third and one half way from the top), and a base line.

7. Keep it simple to make it eye-catching and interesting to look at. Comfortable margins should be left on the sides.

8. People should be able to tell at a glance what the poster is about: who? what? where? when? why?

LETTERING

1. It is probably not a good idea to use a "rainbow" of colors; stick to one color for the lettering.

2. Darker colors show up better from a distance. If you use yellow, outline it in a darker color.

3. The lettering should be appropriate to the message (as an extreme example, bubble letters are happy, not for death or dying).

4. Complex letters are difficult to read quickly, so keep the printing simple.

5. People read lower case typeface more easily than capital letters, so while the main message might be in capitals, the incidental information could be written in lower case.

6. Count the number of letters.

7. Measure the space to be filled

8. Use a long ruler and a pencil to lightly draw two parallel lines the height of the letters. Letters should be wide enough to be seen from a distance; at least 1/2 inch thick.

9. If centering the message, divide the letters in half and start in the middle to make sure there is room. *Lightly* draw the letters in pencil so you can correct any mistakes.

10. Go over the letters with marker or paint.

CUT-PAPER LETTERING

One of the easiest and most effective ways to make lettering of any size is to use cut-paper. Fadeless paper is bright and easily cut. Construction or drawing paper may also be used.

1. Cut a long strip the width of the letters, then cut them into equally sized pieces (except for W, M and I).

2. Be sure to keep the height of the letters the same, and cut out letters in the same style. a. For cutting letters with "holes" such as B, A, P, O, simply cut through to the interior opening. The letters will be glued down, so cuts to the interiors will not show.

3. Before gluing, lay the letters on the poster to check the fit. If the letters do not all fit on, stagger the letters above and below an imaginary line or even overlap them. Never allow them to run onto a new line. They could be used horizontally, diagonally, or vertically.

4. Letters may be most effectively glued by laying them face down on a newspaper and painting the backs all the way to the edges with rubber cement. If the poster is being made to last rather than just for two weeks, make a permanent bond by applying the cement to the poster surface too and allowing both surfaces to dry before applying the letters. Excess rubber cement may be removed by using an eraser or the tip of a finger.

Student Project 5.7: ADVERTISE YOURSELF

DIRECTIONS

The poster can be as simple or as complex as you wish. Just remember that it needs to be seen from a distance and be easily readable. The materials used may be the same that you use in other works, ranging from pastels, crayons, ink, acrylic, or poster paint, to cut-paper and collage.

Use your name as the featured person (recording star, great ballerina, an artist having your first one-person exhibition, or a politician running for office). Make a time and place where you will perform or be featured, and design a poster for the event.

1. On a piece of newsprint, make several small rectangles in rough proportion to the shape of the poster.

2. Before doing your design, decide what the main message or theme of the poster should be and write down what you want to say. It is worthwhile to spend time planning. Try for a slogan or play on words. Originality will attract attention to your message.

3. The largest letters should be the main message, with special information such as times, location, or costs grouped and set in smaller print. Make "dummy" letters on the thumbnail sketch by roughly indicating large writing and making wavy lines to represent small lettering. See if there is too much space left or not enough.

4. Work at finding a visual image that might improve the looks of the poster. Sometimes simply "breaking up" the background with a geometric shape behind the lettering is sufficient. Often there is an obvious image and it is up to you to come up with a new way to use it.

5. When you have chosen the best thumbnail sketch, decide how you will add the lettering and images. Be sure to allow enough space around the lettering for the message to be seen. You may use marker, poster paint, crayon, pastels, or cut-paper. Use your own original artwork rather than cutting out magazine pictures and pasting them on.

FURTHER SUGGESTIONS

1. With a small group, make an oversized poster to call attention to an event at school such as an athletic event, an art festival, a musical concert, or graduation. It could be as long as 30 feet and at least 36 inches wide. Let it be more than just letters, but bear in mind that if it is to be seen from afar, the lettering should be quite large. Letters could be painted or made from cut paper.

2. Make a poster to advertise a play being given by your school this year. Look at examples of posters in newspapers, video shops, and theatres. This poster could be reprinted at a print shop in two colors (using a colored ink on a colored background). Even a black and white poster can be made more interesting by adding color by hand after it has been printed.

3. Make posters to be reproduced on 8-1/2 by 11 inch paper and posted all over school. If you know in advance of a number of parties or other events, split into groups and have a number of students do one assignment. Choose the best one to reproduce.

Chapter 6: CERAMICS

OBJECTIVES

- To teach students traditional techniques of pinching, coiling, modeling, flattening, and burnishing clay to form practical or decorative sculpture
- To discuss traditional methods of working with clay that have evolved from various cultures around the world
- To familiarize students with the properties of clay and glazes
- To explain the materials and tools used in working with ceramics
- To help students vizualize the final form of an object through drawings

INTRODUCTION

Ceramics is an ancient art form that is continuously evolving. It is a craft in that it often involves making practical objects such as vessels. It also is considered a fine art, as those vessels become more decorative while remaining useful. Although most modern potters are trained in throwing pots on a wheel, many of them choose to hand-build to give an expressive, personal quality to their ceramics.

Many secondary schools have potter's wheels, but few students have the time and dedication necessary to learn to throw. It is best reserved for advanced students.

Many secondary students enter a ceramics course with feelings about clay, based on experience. Some may love it, while others are uncomfortable about their lack of skill. Get them excited about clay. Talk about it; show them slides, books, photographs, and movies. Allow each student to create a work of art without being told specifically how the finished product should look. Professional ceramics magazines are helpful to give students ideas. Also encourage them to go to ceramics exhibitions, or invite a professional potter to visit your classes.

All secondary art students should have the opportunity to experience making at least one ceramic project. An art 1 or design course may allow time for only one or two projects, but you will teach a life-long appreciation for this art form by helping students understand the ongoing tradition of ceramics. Learning to build by using the pinch, coil, and slab methods gives them a valuable introduction to three-dimensional art. A one-semester ceramics course will allow exploration of all three of those methods, perhaps including wheel-throwing. At the beginning of this chapter are helpful hints gleaned from several ceramics teachers.

Point out the different attitudes toward potters in various cultures. Teach appreciation for creativity, technique, and form. The Bauhaus concept that "form follows function" simply states what primitive potters everywhere have always known. Although modern potters often move beyond this concept, many continue to create the vessel form, even though it may be strangely shaped or colored.

Probably no other art form has been an integral part of almost every culture in the world throughout history. The durability of ceramics has helped archaeologists recreate cultures that have left no other record. Introduce students to the uses of ceramics in various cultures, ranging from Japanese tea bowls to Peruvian funerary urns. Students are fascinated with this history and like the idea that if their own work is not broken, it could endure for thousands of years.

GENERAL SUGGESTIONS FOR THE TEACHER

THE CERAMICS ROOM: Try to keep your room as dust-free as possible by having students wash down tables, and have the floor mopped at night.

1. **SAFETY NOTE:**The kiln should be in a separate room with an outside vent, or at least vented and isolated from the students by sliding mesh doors. You may prefer firing only at night to allow time for the room to be clear of odors during the day. Safety vents are available to attach to the bottom of the kiln.

2. Storage shelves ideally are in a closed room or ventilated cabinets.

3. Tools such as loops, knives, and kidney shaped scrapers should be kept clean. Check them out to students at the first of the hour, and don't accept them back until they are spotless and dry. If you have one or two really special tools, have the students leave "forfeits," keys or a pen, until the tools are returned.

4. Facilitate clean-up and handling by having students work on 12 inch squares of 3/8 inch thick masonite or heavy linoleum. Keep lots of sponges at the sink.

BEHAVIORAL EXPECTATIONS: Announce that if anyone throws clay, he or she will lose points on a grade and will be allowed to scrub down the room for an hour after school. It works!

CLEAN-UP: Each week designate one clean-up table to do extra chores such as sweeping and cleaning the sink and counter. Or divide the classroom into work areas, and rotate clean-up chores for various areas among tables.

Teaching Methods

1. Have many ceramic books and magazines for students to look at while planning their work. Assume that most of them have not seen many professionally created ceramics and need to realize the potential of the material and the wide variety of objects they can make.

2. Insist that students design their projects in advance. They may make a number of thumbnail sketches, then enlarge the design onto graph paper. Have them draw all views: bottom, top, and sides.

3. Announce at the beginning that you will not allow them to construct any projects to do with smoking. (This should take care of the immediate desire to make ashtrays or pipes.)

4. By stating at the beginning of the course that you will not fire a piece that is not of high quality, students will learn to take their time and work carefully.

5. Make test tiles of the clay you will use, and put glaze on top of each to show the effect of color on different clays. To make a test tile, roll out clay 1/4 inch thick and cut into 1 by 3 inch rectangles, circles, or equilateral triangles. Use a pencil to put a hole in them. Either hang them on cup hooks on a board, or string them together on jute, knotted between tiles. Write the name of the glaze on the back of the tile with slip or underglaze.

6. Teach students the vocabulary of ceramics from the very beginning. It might help to give them a vocabulary sheet.

GLAZING: Methods of glazing vary widely, with the determining factors being storage space, budget, training, and time. The common methods of applying glaze are brushing, pouring, dipping, and spraying. Before applying glaze to a bisque-fired pot, either use a wet sponge to dampen the pot, or pour warm water inside and outside. This will reduce the tendency for brush and glaze to stick and overload the surface in spots.

UNDERGLAZES: Underglazes can be painted directly onto leather-hard clay or bisque-fired clay. Painting on damp clay gives the students something to do while they are waiting for work to become bone dry. Light colors need more coats, as they tend to fade after the glaze is applied.

SLIP GLAZING: Some raw natural clays contain sufficient fluxes (low melting compounds) to function as glazes when applied to pots. Clay is thinned to the consistency of cream and applied to a pot. Sgraffito (scratching designs through the layer of slip) gives some beautiful effects.

COMMERCIALLY PREPARED GLAZES: Commercially prepared glazes are painted onto bisque-fired pieces. Multicolored glazes tend to lower the dignity of the work. Reds and oranges easily become overfired, turning brown or clear. Many of the commercial glazes, expecially the matte glazes, have a soft, lovely finish. Experiment with glazes on test tiles for best results.

GLAZE FORMULAS: To mix your own glazes, obtain a book with glaze formulas, or ask around among potters for glazes that would work well in a school. Purchase oxides and chemicals as dry powder and mix them by weight with an accurate scale. Store the dry chemicals in wide-mouthed food jars from your school cafeteria. Keep liquid glazes in glass jars; they will last indefinitely if well covered. Making your own glazes allows you to pour or dip pots into glazes for interesting effects.

SAFETY NOTE: Do not use glazes with lead in them.

NONGLAZE FINISHES: Many teachers prefer simply to leave a reddish clay in its natural state. It could be given a sheen by applying wax, polymer medium, or shoe polish. Spray paint can also be applied, using closely related colors, to give the effect of slightly uneven firing.

FIRING: Be sure the bottom has been wiped clean of glaze, and protect the kiln shelves by setting the work on stilts. Some potters dip the bottom of the pot in molten wax to prevent glaze from adhering. Always protect new shelves by painting a "kiln wash" on top of them. This whitewash keeps shelves from chipping off. Don't allow glazed pots to touch each other, or they will stick together.

Cones (small wedge shaped clay pieces) are purchased from manufacturers for firing. Although many kilns have a temperature gauge, most of them use a cone to activate the shutoff. When a temperature is reached that causes the cone to bend, you know the kiln has reached that temperature. The cone number is determined by the type of clay you are using.

AVERAGE FIRING TEMPERATURES OF CLAY: LARGE CONES

1700 to 1900 degrees F: Earthenware: Cone 06-04

1830 to 1873 degrees F: White talc: Cone 06

2070 to 2320 degrees F: Terracotta: Cone 01-10

2318 to 2426 degrees F: Stoneware: Cone 7 to 10

2390 to 2500 degrees F: Porcelain: Cone 10 to 12

REPAIRS: Yes, things do occasionally break, either in the firing or afterward. Greenware can occasionally be put together by using slip as a glue. If something breaks in the bisque-firing, but it was a clean break, the pieces can be glued together with white glue, and heavily glazed. The melted glaze sometimes holds things together. Cracks in bisque can be repaired by pounding down extra bisque pieces with a hammer to fine powder (grog). Mix it with glaze and rub it into the crack with the fingers. Wipe excess with a sponge.

If the fired piece broke into many pieces, leaving holes, repairs can be made with white glue, filling in holes with plaster of Paris. Smooth the plaster with sandpaper, and paint the entire piece with acrylic paint or spray paint.

GRADING: Because ceramics projects take so long and occasionally break after much hard work, many ceramics teachers grade as work progresses. One teacher grades one fourth of the way through the project, half-way through, three fourths through, and for the finished product. Another teacher suggests grades in points: idea 20; form, 20; construction, 20; decoration and glazing, 40. Criteria to consider are planning and good use of time, craftsmanship, following instructions, having the finished piece resemble the original idea, meeting a deadline, application of glaze, and appropriateness of decoration. You may wish to allow students to earn extra points for mixing clay by hand or performing other major chores.

Sketch of "July House" 14 × 9 × 9 inches by Mary Ann Kroeck. This slab built portrait of a home is complete with animals. Courtesy the artist.

Pinch Pot: THE JAPANESE TEA BOWL

FOR THE TEACHER

A pinch pot is relatively simple to make, and teaches students to control the clay as they work. Although any shape may be pinched from a ball of clay, making a tea bowl is a good opportunity to introduce the Japanese reverence toward pottery and potters.

Fired clay has been found in Japan that can be carbon-dated back to 8000–7500 B.C., but the tea bowl was not generally made until the sixteenth century. The tea ceremony is a social event of great cultural significance. A central part of the ceremony is passing the tea bowl from hand to hand to be examined on all sides and admired before using. In this culture, the bottom of the bowl has equal importance to the top. The bowls often are of unglazed, high-fired stoneware and always have a small foot (the rim on the base of the bowl). Raku (low-firing done in a pit) was introduced by the Japanese, and the smoke-caused imperfections are valued. The tea ceremony wares are rough, to symbolize solitude and remoteness. Many famous bowls have been honored by being given names based on characteristics of the bowl. Although most of the bowls are symmetrical, occasionally they are deliberately marred with paddle marks, or random marks are made by including straw in the firing.

The Japanese reverence for pottery is reserved not only for the work, but also for the potter. A number of Japanese potters are designated as "National Treasures." Japanese pottery is distinguished by a strong personal relationship between the potter and his work.

MATERIALS

One to two pounds of clay per student (about the size of a small orange)

Glazes

Knife for scoring

Flat sticks or rulers for paddling

Half-moon scrapers

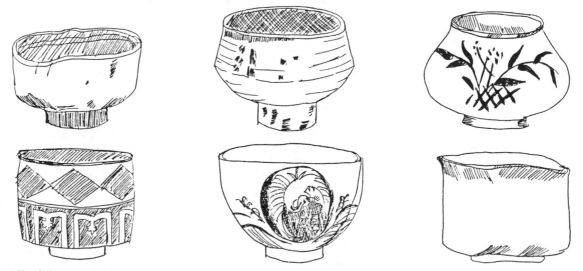

All of these are shapes of Japanese tea bowls. Each is individualized by glaze, design, shape or color.

Student Project 6.1: JAPANESE TEA BOWL

DIRECTIONS

A tea bowl is a shallow bowl without a handle that can comfortably be held in the palms of your hands. They are normally small, three to four inches high, as there are other, more efficient methods for forming larger vessels. They may be straight-sided, flared at the top, or even slightly irregular.

1. Wedge the clay either by kneading it on the table with your palms or by slapping it firmly between your palms or against a canvas-covered surface as you keep turning it around. Check for air bubbles by cutting it open with a wire or knife. The bubbles with be visible irregularities. Shape it into a ball.

2. Place the ball into the palm of your left hand, and use the thumb of your right (or dominant) hand to poke a hole in the middle, leaving at least 1/4 inch of clay at the bottom.

3. Keep the thumb and fingers of the right hand on the outside of the bowl to keep the walls' thickness even. Keep turning the bowl in your left hand, using the fingers and palm to maintain the shape. Use the thumb to pull clay toward the top of the bowl. Try to keep the sides almost vertical, since clay tends to flare out at the top. Avoid making the walls too thin, or the clay will sag. You may paddle the sides with a flat wooden stick to make them smooth. The paddling will also drive out air bubbles remaining in the clay.

4. If the pot becomes too large for the hand, place it on a decorating wheel or on a paper towel so it can be easily lifted off. If the walls are not high enough, add coils to build to the height you want.

5. When you are satisfied with the shape, allow the bowl to harden enough to support its own weight, and turn it over to apply the foot to the bottom.

6. Make the foot on the bottom of the bowl by rolling a piece of clay. Score (roughen) the bottom of the bowl where the foot will be applied, and score the roll of clay. Use slip (equal amounts of clay and water mixed until smooth) to attach the foot to the bowl. Use your finger to smooth it on.

7. When the bowl is leather hard (usually a day later), it may be burnished with the back of a spoon, a large smooth stone, or scraped with a metal scraper. The foot may be trimmed with a knife, scraper, or loop, until smooth and even. The outside of the bowl could also be scraped with a kidney-shaped tool.

8. It isn't necessary to smooth the bowl all over. Reinforce the rim by supporting the inside and outside of the bowl while you smooth it. If the rim is terribly uneven, cut it with scissors held horizontally in your right hand, keeping your elbow at the same level, and turning the bowl slowly with the left hand while cutting.

9. Possibilities for finishing are: Leave the bowl crude and simple; give it a sophisticated design based on nature, applied with a needle tool; make a geometric pattern or organic form such as a branch; press straw or the head of a screw to make an indentation in the surface.

10. Glazing is usually fairly natural for tea bowls. The inside and rim should be glazed, but the lower outside and foot are often left unglazed.

FURTHER SUGGESTIONS

1. Make contrasting pinch pots: smooth and rough, tall and squat, open and closed, symmetrical and lopsided.

2. Make a pinch pot form that is comfortable to hold, but any shape you wish. You could begin with a square, rectangular, or irregularly shaped piece of clay that resembles a stone.

3. Use your elbow instead of your thumb to make an indentation in the pot.

4. Make more than one pinch pot and join them together by scoring at the joints and adhering with slip.

5. Make almost closed pinch pots by leaving excess clay at the top of the pot. Insert a finger almost horizontally in the opening. Keep turning the pot while paddling to push the excess clay into a totally rounded form.

Coil built pot—student work.

COILED VESSEL

FOR THE TEACHER

Building with coils is the ancient method for making vessels ranging from tiny oil lamps to giant funerary urns. Coils can be the thickness of worms, snakes, or a person's arm. If possible, introduce coil building by showing a movie, *Hands of Maria*. Maria Martinez, an American Indian from the San Idlefonso Pueblo, became known internationally in the 1930s when she rediscovered the ancient method of reduction firing that causes red clay to turn black. She fired the pots in a wood bonfire in a shallow pit, with large pieces of metal placed on top to hold the heat in. After firing for a time, the metal is covered with manure to smother the fire, resulting in a reduction firing. When the pots are removed, they are black. This technique is used today by Maria's relatives and descendants. The decorations used by the American Indians are usually based on nature forms.

Do a demonstration for the students; show them how to roll out or coil the base, how to roll out coils and attach them with the fingers, the technique of paddling, and using a scraper to smooth the pot. Two variations in coil pots are shown below.

MATERIALS

Student Project 6.2: *The Coiled Pot*

Decorating wheel

Metal scraper

Paddle (flat stick 1 to 1 1/2 inches wide, 1/4 inch thick)

Knife for scoring

Clay

Slip

Underglazes

Brushes for applying underglaze and clear glaze

Colored glazes

Tagboard to make a template

Photo 6–1 Coil pot with three openings and coils showing, by a student of Steve Warren.

Photo 6–2 This Brazilian pot from the Amazon has a black glaze similar to that of the San Idlefonso Indians. Collection of the author.

114

Student Project 6.2: THE COILED POT

DIRECTIONS

The first coil project should be a minimum of 9 inches tall. It is extremely important to carefully wrap the clay at the end of each day to keep out air. If the clay begins to dry, place wet paper towels inside the plastic bag to remoisten the clay (not touching the piece itself).

1. Draw thumbnail sketches before beginning. Look through ceramic magazines to find pleasing shapes or use variations of a natural form such as a pear, egg, or gourd. When you have chosen the best drawing, enlarge it carefully, drawing side, bottom, and top views. Consider showing a finished top on your design to add a finishing touch. Although slight changes may happen, it is best to have a plan and stick to it.

2. Wedge at least 3 pounds of clay for a minimum of 15 minutes. If possible, work on a decorating wheel so you can turn the pot easily.

3. Roll some coils staring with fairly evenly sized pieces of clay. Place one on a piece of cloth to roll it out with your fingertips. Keep the coil moving, working from the center and going out to the edge. Then use the palms of your hands to make the coil as even as possible. Cut the coils diagonally on the ends. You may roll a number of coils at one time, but keep excess clay covered with a damp rag or plastic while you are working.

4. Begin the bottom of the pot with a tight coil, slab or pinch pot. To join one roll of clay to another, score both surfaces and coat with slip. Omitting this step may leave holes in the vessel when the clay shrinks while drying. Unless coils are smoothed together, they may fall apart when they dry.

5. When the bottom is the correct size, start adding coils vertically. Always make the first three coils straight up, as they will flare out naturally. If you go out too soon, the coils will have too much weight, causing the pot to fall. Place coils directly on top of one another for straight sides, or slightly to the outside for an outward curve, or slightly inside to curve inward. With practice you will find it fairly simple to control the shape.

6. When a coil ends, add a new coil of the same thickness, cutting the slant the opposite direction before scoring it and joining it with slip to the first coil.

7. A good working method is to place three coils on the pot, remembering to score and join them with slip. Then take the time to smooth the outside with your fingers and a scraper. Paddle before adding the next three coils. The paddling will force out any remaining air bubbles. The pot should be approximately 1/4 inch thick.

8. Refer to your original sketch to see if you are following your design. When the pot has reached a height of at least nine inches, finish the top by scraping it smooth, then smoothing with a damp sponge.

9. After the clay becomes leather hard, you may choose to finish it in the Indian method by burnishing with the back of a spoon or a large smooth stone.

10. You may incise the surface by using a sharp instrument. Either before or after the bisque firing, an underglaze may be painted on.

11. After the pot has dried until "chalky," it can be bisque-fired.

12. To prepare it for glazing, put the pot under a faucet to moisten with warm water.

FURTHER SUGGESTIONS:

1. Make a "hidden-coil" pot that is 12 inches high or 12 inches in diameter, leaving the coils showing either on the inside or the outside. This pot may be symmetrical or asymetrical. If you prefer, you may use the scraper and paddle and hide the coil construction on both sides.
2. Decorate the outside with coils that have pinched edges.

This student work resembles an opening cabbage. The edges have been pinched to give that effect.

Student work, coil built.

CONSTRUCTING WITH SLABS

FOR THE TEACHER

A basic method of constructing with clay is working with slabs. Many ceramic forms use combinations of methods such as slab building, coiling, and wheel throwing. Slabs are versatile because the clay is plastic enough to drape on top of or inside an existing form or to support its own weight when it has stiffened. Normally the larger the form, the thicker the clay should be. A form thicker than 2 inches should be hollowed to allow drying. Slabs can be used flat to make tiles or can be cut as thick as 1½ inches to stand without support. They can be rolled as thin as 1/4 inch and still be strong.

To use slabs for tiles or as flat works of art, remember that drying needs to be done slowly and evenly or the slabs will curl. The slabs dry from the outside edges in, so keep them moist around the edges until the center has had time to dry. Slabs should be rolled out on canvas or burlap for easy removal.

Constructing a box made of slabs teaches the technique of joining and controlling the clay and allows for individual interpretations of the box form. One art teacher builds environments such as a house in box forms and encourages her students to come up with their own individual interpretations.

MATERIALS

Student Project 6.3: *Constructing with Slabs*

3 to 4 pounds of clay per student

Rolling pins (brought from home) or 1 or 2 inch dowels cut 12 inches long

Battens: sticks 1/4 by 1¼ by 12 inches.

Rulers

Canvas or burlap: for rolling slabs

Knives, pointed

Slip

Wire screen (for adding texture to the surface)

Tagboard

Student Project 6.3: CONSTRUCTING WITH SLABS

DIRECTIONS

Decide in advance what your finished product will be. Almost any idea you have can be made with slabs. Some suggestions are planter boxes (the clay should be at least 1/2 inch thick for a planter), a replica of your own house, a tall rectangular vessel for flowers or weeds, a desktop holder for letters, or simply a decorative box for a desk or table. The use will help you decide on the size, shape, and thickness of the box. A slab-built lid could be added.

1. Make thumbnail sketches of the finished product. Choose the best one, enlarge it on paper, and use that as a pattern to make a tagboard model of your box. Tagboard resembles clay in that it is stiff enough to support itself and hold a shape. Cut out the pieces of tagboard and join them with masking tape. If the cardboard pieces fit together well, take them apart to use as patterns.

2. Place a piece of burlap or canvas on the table. Then place two flat sticks parallel and about 12 inches apart.

3. Place a ball of clay in the middle and flatten it evenly with a rolling pin. Use enough clay to avoid patching.

4. Lay the pattern on top. Cut straight edges with a knife. Set the slab aside to stiffen while you continue cutting the other pieces for the box. It is better to assemble the pieces in one working session, but remember to wrap them well if they must wait overnight.

5. When all the pieces are cut, score the edges that will be joined together. Use slip on the joints. For extra strength, score the corners inside and outside horizontally after the pieces are joined, then smooth them again. Use a scraper to clean up the edges. Strengthen the corners by rolling a thin coil and placing it on the inside of the box, smoothing it onto each wall with the thumb.

6. Decoration may be applied in a number of ways.
 a. Incise designs into the surface with a needle tool (or use a needle stuck into a cork). Color inside the designs with underglazes.
 b. Make thin "worms" of clay to apply as decoration; score and use slip before applying.
 c. Cut openings in the clay, carefully preserving the cut-out (positive) part to apply as positive shapes elsewhere on the form.
 d. Use various "found" objects as stamps.

FURTHER SUGGESTIONS

1. Make a 16 by 20 inch tile wall hanging by making a design on tagboard, cutting the tagboard into large "puzzle" pieces, then using that as a pattern for cutting out slab pieces. When the slabs have dried, glaze and assemble them on a piece of plywood of the same size, using thin-set adhesive or mastic and putting grout around the tile afterwards. This same technique could be used to make a Monumental Ceramic mural as a class project.

2. Make a draped slab by rolling out a thin slab and draping it over a papertowel-covered form such as a bowl. The slab may have wedge-shaped slices removed and "tucks" made to make it fit a curved form perfectly.

3. Press-mold slabs by forcing them into shaped containers such as bowls. If excess clay must be cut away to make a tuck, be sure to score and add slip to those areas.

© 1990 by The Center for Applied Research in Education, Inc.

CERAMIC SCULPTURE

FOR THE TEACHER

This is where it can all come together. Pinching, coiling, making slabs, carving away . . . all the techniques for forming clay may be used singly or in combination to make a piece of sculpture. It might be appropriate to explain to students that sculpture is generally considered a fine art, with no practical function other than to be seen and admired. Major exceptions to this definition may be found throughout history, with the Peruvian sculptural pot below left as an example of fine art that has a function. The pots made by the Naxco Indians in Peru illustrated people doing every imaginable activity, as well as wonderful animal- and bird-shaped pots. Most of these pots had a "stirrup" handle (hollow handle on top) that allowed them to be picked up and used.

Show students slides of sculpture from the Greeks, Romans, and Egyptians. Sculpture by Auguste Rodin exemplified motion in the human form through the unfinished quality and fresh way he applied clay to an armature. Discuss the sculpture by Jacques Lipschitz, Constantin Brancusi, or Umberto Boccione so students can see that successful sculpture does not have to be realistic.

If this is the first student project in ceramics, allow two days to show slides and demonstrate different sculpting techniques. Although it may be easier to give a specific assignment, let students surprise you with their creativity. Have them draw designs before beginning so they can decide which of several techniques to use.

By specifying that the sculpture must measure at least 8 inches in one direction, you will open the door for important pieces. If students wish to make a human form, they could consider making an environment for the figure such as that in the photo on next page.

Small forms may be carved or modeled from solid pieces of well-wedged clay. The clay may be formed by hand or cut away with a knife. When the piece is done, cut it open with a fine wire or knife, hollow out the inside until no area is thicker than 1 inch, then score and rejoin the cut edges with slip. Remember that a hollow piece of sculpture must have an outside opening (such as a hole in the bottom), or moist air trapped inside will cause the piece to explode when it is fired.

To avoid having to hollow out forms, build clay around armatures made of newspaper or paper towels and string. These may be removed before firing, or could be left inside to burn up in the firing.

MATERIALS

> Student Project 6.4: *Ceramic Sculpture*
>
> Newsprint
>
> Pencils
>
> Minimum of 3 pounds of clay per student (terracotta or white talc suggested)
>
> Canvas
>
> Decorating wheels
>
> Paper towels
>
> Tools: knives, wire, loops or spoons, paddles (or wooden rulers could be used)
>
> Dowels for rolling out
>
> Underglazes
>
> Clear glaze

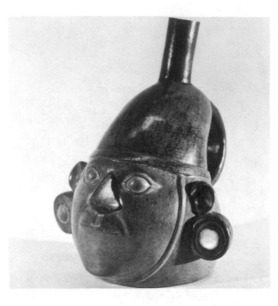

Photo 6–3 Jug—human head. Peruvian: North coast, 600-700 A.D. 18.4 cm. high. The Saint Louis Art Museum. Gift of J. Lionberger Davis.

Photo 6–4 Mary Ann Kroeck, "Five Weeks of Wheel of Fortune." Ceramic. Courtesy, the artist.

120

Student Project 6.4: CERAMIC SCULPTURE

DIRECTIONS

1. Draw at least two *good* ideas on newsprint (this may take more than two drawings). When you have decided on one, draw the front, side, and bottom views. This sculpture must be at least 8 inches in one direction. Some suggestions are animals, human form in an environment, pop art (such as food items), replica of the outside of your home or the inside of a corner of your own room. Your sculpture could also be abstract—simply a combination of shapes such as geometric or organic forms.

2. Wedge the clay thoroughly. Cut it open to make certain it has no air bubbles. Determine the method of construction you will use. Remember that you will have a fairly large piece of sculpture.

 - If the form will be rounded, coil building is probably best.
 - If you make people, simply shape the form with your fingers.
 - For straight sides, use slabs.
 - For an abstract form, you may want to model the solid form, then cut it in half and hollow out the insides so it will dry evenly.
 - Make one form using a combination of methods such as pinch, coil, and slab.

3. It may be necessary to allow the clay to stiffen when you are getting ready to combine the forms. Realize that this sculpture will not be created in just a few hours, and therefore the clay must be kept moist and well-wrapped between working sessions.

4. While you are working, think about the outside finish. If you are going to have a one-color finish or leave the clay unglazed, then consider how to show differences in value. The way light falls on a sculpture to show form is important when working with only one color. Variations in texture may make the surface more interesting.

5. If any areas are thicker than 1 to 1½ inches, hollow them out to avoid explosions. Allow the sculpture to dry for at least a week.

6. Underglazes may be put on before or after a bisque firing. If underglazes are used, clear glaze may be applied for the final finish.

7. When the sculpture is completed, look at it carefully and decide whether to mount it on a piece of wood. Some pieces need this finishing touch, while others are complete "as is."

FURTHER SUGGESTIONS

1. Make a "set" of three similar forms in different sizes to group together on a base.
2. See Chapter 2 on three-dimensional design for instructions for small ceramic figures.
3. Make a class "banquet" by assigning realistic food for each student to construct. Divide the class into groups to make different courses such as hors d'oeuvres, main course, and dessert.
4. Invent a container or server for a particular food item. These cannot be ordinary containers, but should reflect in some way what food will be contained.

THROWING ON THE WHEEL

FOR THE TEACHER

Although many secondary teachers feel that throwing on the wheel takes students too much time to master, others allow their students to do it often and see them through the difficult first stages to teach them mastery in throwing.

Few schools have enough wheels for everyone in the class to throw, so it may be necessary to set up a schedule or allow students to throw only if they have completed other assignments and have time to learn. Many students are willing to come in and practice after school and become quite successful in the art of throwing.

Some potters have difficulty accepting the perfection of form achieved by throwing a pot on the wheel; after it is thrown, they deliberately flaw it by flattening one side, or making an indentation.

There are as many methods of throwing as there are people who throw, and all potters have personal techniques. The steps given here work for me and were passed down from teachers who learned from other teachers. The tradition goes on. The photos below are of examples of well-thrown clay pots.

MATERIALS

Student Project 6.5: *Throwing on the Wheel*

Wheel for throwing (may be electric or kick)

2 or 3 pounds of well-wedged clay

Water in container

Slop container

Natural sponge

Large sponge for clean-up

Piano wire with toggles at each end
(for removing pot from wheel)

Loop tools (for finishing bottom of pot)

Plaster bat or piece of masonite

Photo 6–5 Wheel-thrown pot by Steve Warren. Collection of the author.

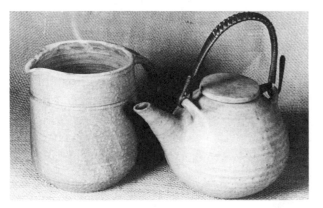

Photo 6–6 Teapot and pitcher by Jan Sultz. Collection of the author.

122

Student Project 6.5: THROWING ON THE WHEEL

DIRECTIONS

1. Clay must be especially well wedged for throwing on the wheel. An air bubble may keep you from ever getting it properly centered. Before throwing clay, wedge it for at least 15 minutes.

2. Seat yourself in front of the wheel with your lap well protected by an apron or cloth. The wheel must be completely dry. Throw the ball of clay onto the middle of the wheel with considerable force.

3. Dip your right or dominant hand in water, remembering that both hands must be kept wet, or they will drag the clay. Also remember that if you use too much water, the clay will become soggy. Use your sponge from time to time to clean excess water from the wheel and from the inside of the pot.

4. Start the wheel, lean forward, and place the left hand at a slight angle and cupped around the ball of clay. Place the fingers of the right hand loosely over the first finger of the left so that the ball is almost enclosed by both hands. You must control the clay. It wants to control you! By bracing your elbows on your legs, pushing down, and not allowing your arms to move, the clay can be centered on the wheel. Watch your hands. Are they staying in the same place? Use a thumb and lightly touch the top of the ball. Does the mark you made with your thumb continue to stay in the center? When you hands don't move at all and the ball of clay has lost its wobbly appearance, it is ready to open.

5. Place your right fingers almost vertically over the left fingers, with the right fingertips almost touching the wheel, allowing the left hand to control the pot. Place your right thumb in the middle, beginning to push down to the bottom of the pot (leaving 1/2 inch of clay between your thumb and the wheel). If the pot begins to wobble, take the thumb out and use both hands to contain the ball of clay and make it even again.

6. If the pot is stable as it continues to go around, enlarge the center. While bracing with the left hand, turn the right hand around to face the left hand, and put two fingers in the pot. Squeeze against the left hand, enlarging the opening, but still keeping the sides of the pot vertical. Remove the right hand and stabilize the pot again, making sure it is even. Look on the inside for air bubbles (they look like diagonal streaks). Use a needle to prick them.

7. Before pulling the clay upward, open the bottom of the bowl to the size it will be when finished. Once the clay is pulled up, it is too late to do this. To add a professional finish to the inside bottom, align the first three fingers of the right hand so that the middle finger is the same length as the others. Hold the fingers straight on the bottom as the pot goes around to make a circular pattern. If you prefer, use a natural (elephant ear) sponge to gently smooth the inside bottom

8. At this point decide about the shape of the pot. It can be drawn up vertically for a pitcher or vase or flared slightly to become a bowl. The angle of your hands determines the shape. One hand supports the inside while the fingers of the other hand gently pull the clay up on the outside. The two hands are separated only by a thin wall of clay, and they work together to form and maintain the shape of the pot. Some potters prefer to support the pot on the inside with the entire hand while pulling the clay up with a knuckle or metal rib. If too much pressure is exerted, or if the fingers aren't wet enough, distortion can quickly happen. If you sense you are losing control, gently place both hands on the outside and stabilize the pot again.

9. The quality of a pot is often judged by its weight in proportion to its size. If a large pot is lighter in weight than you would expect, it must have thin walls and bottom. The walls shouldn't be much thicker than 1/4 inch.

© 1990 by The Center for Applied Research in Education, Inc.

10. When the pot is the height desired, unless you have been extremely skilled, it will be necessary to cut off the top evenly. This can be done in one of two ways:
 a. Brace the elbows well, and hold a wire taut with your hands about 3 inches apart. Spin the pot slowly, and hold the wire in place at the lowest level of the rim. As the pot goes around, the excess will be sliced off. Remove it with thumb and forefinger.
 b. Use a needle tool and hold it horizontally (again bracing your elbows) and as the pot goes around let the needle slice off the top. Use the needle tool to remove the excess clay.

11. Use a sponge or your index finger and thumb to finish the rim.

12. To cut the pot from the wheel, spin the wheel slowly and hold the piano wire flat on the wheel and pull it under the pot toward yourself. If time permits, let the pot set on the wheel for an hour or so after it is cut, as it is preferable to let the clay stiffen somewhat before moving.

13. To remove the pot, place a plaster bat or a piece of masonite in front of the pot, level with the wheel. Slosh water on the wheel in front of the pot, and gently shove the pot from behind, touching only the bottom and gliding it across the wheel onto the bat.

14. To finish the bottom of the pot, allow the pot to stiffen overnight until it is leather hard. Put the pot upside down on the wheel, revolving the wheel slowly to make sure the pot is centered. Hold it in place with small wads of clay. Use the loop tool to even off the bottom and sides of the bottom. Finish the piece flat by simply trimming off excess clay. If the pot is thick on the inside, it can be made more attractive by trimming the bottom. Make a "foot" by leaving a rim around the outside of the bottom and an indentation in the middle.

15. Most thrown pots are glazed after a bisque-firing by dipping or pouring glazes.

FURTHER SUGGESTIONS

1. Make a pitcher by making a basically vertical form, then using a finger to make a pouring spout. Make a "pulled" handle by holding a cone of clay in one hand. Gently stroke the clay inside your other (dampened) hand, pulling it until it forms a long cone, thin at one end. When it is the length you wish, cut it from the original cone, and put the upper end of the cone on a table, allowing the entire "handle" to hang down until it has become firmer, then attach it to the pitcher with slip. Sometimes the thumb marks that are used to attach it to the pitcher are allowed to show.

2. Combine a thrown form with a slab form (for example, put a rounded top on a hand-made slab). Or join together several thrown forms to make a piece of sculpture.

3. Decorate a thrown form by using a needle while the pot is revolving to make perfectly incised lines.

Chapter 7: SCULPTURE

OBJECTIVES

- To develop students' ability to visualize a three-dimensional object
- To examine the potential and limitation of a variety of manufactured and natural sculptural materials
- To explain proper safety procedures while using sculpture equipment
- To teach the two forms of sculpture: additive and subtractive
- To emphasize that when one-color materials are used, surface treatment and value differences are important considerations
- To teach the history of sculpture while analyzing work of contemporary artists

INTRODUCTION

Creating sculpture is a recommended experience for all art students. It helps the ability to visualize and strengthens abstract reasoning. Students who have drawn and painted successfully often have difficulty analyzing how an object in-the-round will look. Sculpture doesn't always offer "safe" projects with predictable results and is a little threatening to some students. Pushing art students to take risks is also part of teaching them art.

While secondary students are often most comfortable while doing realistic work, lack of skill and practice may limit how realistic their work can be. Often they need guidance to accept that some materials limit the amount of realism they can depict. Seeing pictures of abstract sculpture helps them realize that it often has as strong an impact as realistic sculpture. Sometimes eliminating unnecessary detail to achieve simplicity in form is more important than depicting reality.

Although experienced artists are always trying to extend the limits of materials, students need to begin by understanding basic procedures. An important lesson to be learned in sculpture is that the material often dictates what may be done with it. In other words, the material must have a means of support. Flimsy cardboard can only be made so large until it collapses from its own weight. Thus large plaster casts often need supporting rods, and large clay portraits are made on armatures.

As paintings often become sculptural, with attached three-dimensional forms, so sculptures often are becoming more painterly. Sculptors are breaking with the tradition of one-color, one-material sculpture. Many are using materials such as glass, plastic, stainless steel, aluminum, fiberglass, museum board, and bronze in combinations, often painting all or parts of these materials. See, for example, "The Lamp," by "painter" Frank Stella.

Materials that are practical, relatively inexpensive and easy for secondary students to use are clay, plaster, papier mâché, plaster-impregnated sculpture tape, cardboard, foam core, wood, stone, and metal. The materials for carving (wood, stone, and plaster) often are available at little or no cost simply by going to building suppliers and manufacturers. School supply companies also sell stones such as alabaster or soapstone. Your school store may be willing to stock and sell these to students for you. Other materials that may be purchased for carving are sculptor's wax, plastic foam blocks, and fire-brick (soft carving bricks).

If a semester-long three-dimensional course is not possible, almost any project could be taken from this chapter and used in a general art course. There is not space to cover the unlimited possibilities for using the

125

materials available, but basic procedures have been given in other chapters for using them. It is a natural extension to apply larger sculptural projects to some of those techniques.

SAFETY NOTES: *In working with some materials or techniques, review safety procedures and insist that students practice them. Teach students how to cut safely with a utility knife. If there is the slightest possibility of something getting into the eyes, the students must wear plastic safety goggles or glasses. With sculptural carving, safe techniques must be followed to avoid serious injury.*

Photo 7–1 Frank Stella, "The Lamp." 1987. 264.8 x 191.8 x 181.6 cm. The Saint Louis Art Museum. Purchase funds given by the Schoenberg Foundation, Inc. This wall-hung sculpture demonstrates that sculpture can be "painterly." It could be the inspiration for a sculpture of foam core painted with acrylics.

MONUMENTAL CARDBOARD SCULPTURE (Group Project)

FOR THE TEACHER

The beauty of this project is that it will cost almost nothing, involves an entire class, and helps students become acquainted with each other and responsible for what is being done. There has to be give and take, and after you have finished, you will have a surprisingly cohesive class. It is a good first project for the year because it shouldn't take more than a few days to do, it gets artwork out into a gallery or hallway right away (get approval first, of course), and uses up all the cardboard in which your new materials were delivered. It may not be beautiful to look at, but it will be interesting and *large*!

Decide where this monumental sculpture will be built, remembering that you will need to work on it for a number of days and that people need to have room to walk all around it. Assemble all the materials you have on hand and decide if you need more. Merchants often will save boxes for you. Much of the preliminary work can be done in the classroom. Have students decide what portion they will work on. It may be necessary to assign groups to make smaller parts of the whole, but get them all involved! This assemblage should be left on exhibit until it is falling apart or the boxes are being used as trash bins.

MATERIALS

Student Project 6.1: *Monumental Cardboard Sculpture*

Sheet cardboard of all sizes, weights, and textures (cut up the cardboard boxes that materials come in, using a paper cutter)

Flexible corrugated cardboard that has the corrugated side exposed (may be purchased by the roll)

White glue

Jute or heavy twine

Brad fasteners

Utility or X-acto knives

Heavy scissors

Student Project 7.1: MONUMENTAL CARDBOARD SCULPTURE

DIRECTIONS

This cardboard sculpture will be composed of many "units" made by various people in the class. It should go clear to the ceiling, if possible, or have some of the units suspended from the ceiling to meet the floor structure (like stalactites and stalagmites). Because it will be made from unpainted tan cardboard, the only way to make it interesting is to create forms, shadows, and textures that give variety and make it interesting to view from all sides. Some of the units could be whole cardboard boxes with shapes cut out of the sides to create shadows.

Don't be concerned if not everyone thinks your sculpture is as interesting as you do. Sculptors often express themselves in work that is not universally beloved. People have laughed at the work of Richard Serra, Andy Warhol, and Pablo Picasso, but the artists were comfortable that what they created was art.

It will probably be easiest to work with a small group to make forms. Don't concern yourself yet with how the whole sculpture will look when it is put together. Simply do good workmanship on your portion.

1. Think of ways to assemble some of the pieces you have. Could you make forms such as triangles or pyramids in different sizes? Two surfaces could be fastened together with staples or brad fasteners. Gluing takes a little more time, but is sometimes the only solution. You can make slots to join two pieces. Don't use masking tape on the outside because it does not hold well for very long.

2. After some of the forms are completed, take them to the "site" and begin experimenting with assembling them into a sculpture. You may stack forms, hang them from the ceiling, or use heavy twine to tie them together.

3. Walk around the sculpture and view it from all sides to make sure that it looks finished, meaning that if you do one more thing you may ruin it. One side may be more complicated and clearly the "center of interest," but the other sides should also be interesting to look at. Does it look unified, like one large piece of sculpture? Could some of the forms be repeated in smaller or larger sizes to unify the project? If flexible corrugated roll cardboard is available, it can be twisted and wrapped around some of the forms. Heavy jute twine could also be strung in and around forms (this could be rewound and used again when the sculpture is taken apart).

4. Check for sturdiness. Precariously balanced forms will probably fall. Give them extra stability by attaching them to nearby forms, by tying them to a ceiling grid, or by putting a ladder in the middle of the sculpture to offer support and stability.

FURTHER SUGGESTIONS

1. Invite all art classes to do drawing, paintings, or photographs of the sculpture (to immortalize it.) To emphasize shadows, floodlights could be turned on during drawing sessions.

2. Use small units such as cubes, pyramids, or styrofoam packing components to make a "maquette" for a monumental structure.

3. Make an assemblage of quite different materials such as metal, wood, or plastic.

© 1990 by The Center for Applied Research in Education, Inc.

CARDBOARD MAQUETTE FOR A MONUMENTAL SCULPTURE

FOR THE TEACHER

In the past, leaders and famous persons were immortalized by having their likenesses made in bronze and placed in plazas. The Italian condottiere (military leaders) of the fourteenth to sixteenth centuries were depicted larger than life, seated on their horses. Students can generally understand contemporary monumentality in sculpture if you suggest they think of sculpture found inside shopping malls or in plazas outside buildings.

Many of today's monumental sculptures are first interpreted in three-dimensional cardboard maquettes, then enlarged in steel or bronze by workers rather than by the artist. Ernest Trova, Richard Serra, and Louise Nevelson all design work to be constructed by craftspersons.

This project is to make a maquette for an imaginary "commission." The student should decide in advance where it will be installed because the site might determine the appearance of the project. Students will learn that materials have some limitations. They will need to measure carefully and score the material to bend it.

Some famous installations are the Picasso "head" in Chicago which is several stories tall, the arch in St. Louis, which is taller than the Washington Monument, Richard Serra's sculptures in numerous cities, and Jean Dubuffet's sculpture in Chicago. This project could be enriched by showing slides or pictures of some of the monuments found around the world. Examples would be the Arc de Triomphe in Paris, the Obelisk in Paris, and the pyramids and Sphinx in Egypt. Discuss whether they are appropriate for the time they were commissioned and if they have withstood the test of time—are they still as good as when they were installed? See right for an example of a monumental sculpture.

MATERIALS

Student Project 7.2: *Maquette for Monumental Sculpture*

Rulers

Compasses

Chipboard or 6 ply posterboard, 22 by 28 inches

Straight pins

Glue

Masking tape

Metal straight edges

Utility or X-acto knives

Newsprint

Pencils

Photo 7–2 Richard Serra, "Twain." 1982. Weathering steel. St. Louis, Missouri. Commissioned by the National Endowment for the Arts, St. Louis Ambassadors, Inc., Missouri Arts Council, and numerous St. Louis corporations, Eero Saarinen's "Gateway to the West" (the arch) is in the background.

Student Project 7.2: MAQUETTE FOR MONUMENTAL SCULPTURE

DIRECTIONS

This sculpture is made from cardboard, which somewhat limits what you can do with it. Think of it as sheet steel $1/2$ inch thick and 22 by 28 feet. (This was all the steel you could afford, so you will use only one piece.) You can see that it would be difficult to do something complex such as a realistic portrait. It could be "welded," and some precast round forms could be purchased, but basically you will be working with flat planes joined together (in this case, with glue, tabs, and tape.)

Think about where your monument is going to be located and what material will be used. Although some outdoor sculpture is painted, much of it is left the natural color such as bronze, steel, or brass. If this is to be in a plaza or the city center, it may have to be as attractive from above as from street level. Will it be surrounded by water? Could it even be the centerpiece in a fountain?

1. On newsprint, sketch a number of quick ideas. Decide the height and the size of the base. Use rulers and compasses to make accurate geometric forms.

2. If you wish to form columns, score cardboard in lengthwise lines $1/2$ inch apart on the inside of the column so the cardboard will be more flexible.

3. To join two edges together, make "tabs" where one edge will go under another. Glue the two edges with white glue, and hold them together with straight pins until the glue has dried. You may cut slots to enable you to join two pieces together. Two methods of joining edges are shown. Masking tape could be used inside, but it should not be visible.

4. If you wish to add color, apply poster paint or spray paint when the entire project is completed.

FURTHER SUGGESTIONS

1. Make a small variation of this sculpture by using $1/4$ to $1/2$ inch thick slabs made of clay. Join them with slip (thinned clay that acts as glue).

2. If a band-saw is available, or you take an industrial art class, this cardboard maquette could be interpreted in masonite or clear plastic. Because these components cannot easily be glued, you may choose to join them with slots. (Use cardboard of the same thickness and construct a mock-up to make sure it works.)

3. Foam core is a relatively new material that is excellent for sculpting flat forms. It is sturdy and does not soften as cardboard does when it is painted. Cut similar shapes from a piece, leaving them white, or painting them with latex house paint or acrylic paint. Add sand to the paint for texture.

4. Use 6-ply tag board to create very large sculptures. The board is thin enough to curve naturally, and can be formed into a variety of shapes. For strength, cover the board with two layers of plaster sculpture tape before painting with latex house paint.

5. This could be a metal "bas-relief" for the side of a building.

© 1990 by The Center for Applied Research in Education, Inc.

Edges can be joined by scoring and holding together with brads, by making slots, or by stapling.

EXERCISES WITH CERAMIC CLAY

FOR THE TEACHER

For this project, it is not necessary to wedge the clay, as students will reuse the same ball of clay for each sculpture, and it will not be fired. It is more fun to do this if the students don't know what to expect in advance. After each interpretation, have the students place the sculpture on a table and discuss similarities and differences. For example, the interpretations for "angry" will mostly have points and rough edges. Occasionally one "angry" sculpture will be perfectly smooth, even totally rounded. If time allows, it is interesting to encourage students to discuss how they feel when they experience these emotions.

When this project is completed, most of the students will be proud of what they have done. Suggest that they decide which of their forms appealed to them the most, and reproduce it the next day with the same clay. Before making this piece to be fired or cast, they must wedge the clay to eliminate air bubbles. If it is to be smooth, then it should be perfectly smooth. Walk around and talk with them about looking at the sculpture from all sides, seeing if there is a "center of interest," and giving suggestions about variety or repetition of form. DON'T TOUCH THEIR WORK: simply talk with them. If something is "ruined," you don't want the students to blame you for it.

MATERIALS

Student Project 7.3: *Exercises in Clay*

1 to 2 pounds of terra cotta clay or white talc (or whatever you have) per student (at least the size of a grapefruit)

Student Project 7.3: EXERCISES IN CLAY

DIRECTIONS

1. Make the clay into a ball. Interpret the word "calm" in 10 minutes. Place all the sculptures on a table to discuss. Point out similarities. What do they have in common? Are any totally different from the others? Take your sculpture and make it into a ball again.

2. Interpret the word "angry" in 10 minutes. Place it on the table to talk about it.

3. The third sculpture is "love." No lips, no hearts, no people kissing; simply a symbol for love to be sculpted in 10 minutes. Again, place it on the table. Wide variations will occur this time. Why?

4. This time sculpt any word that depicts any emotion. Think of a word that describes a state of being (such as happy, crazy, sad). Try to guess what emotion the sculpture depicts. The guesses will be surprisingly close.

5. Now think of which form was most appealing to you. Before recreating it, it will be necessary to wedge the clay to eliminate air bubbles.

6. If this project is going to be fired, it will have to be scooped out from the bottom to about $\frac{1}{2}$ inch thickness. The clay should stiffen before it is hollowed out. It is possible to fire clay that is 1 inch thick, but it takes much longer to dry.

The piece should be fired. It does not have to be glazed, but may look good with shoe polish rubbed on it. If the shoe polish is too thick, thin it with turpentine so it will stay only in the grooves. The sculpture could be sprayed with successive coats of aerosol matte paint to resemble stone (gray, tan, white, black). Put paste wax on top of the paint or polish, and buff the piece lightly.

FURTHER SUGGESTION

1. Draw the same interpretations (calm, anger, love) with paint on paper. Notice similarities between your sculpture and the paintings.

CASTING WITH PLASTER

FOR THE TEACHER

Two schools of thought exist on using plaster in a sculpture class. One holds that it is a messy, almost uncontrollable, but necessary evil, and the other that it is a useful material in its own right. In truth it probably is a little of each. Students enjoy the directness and action involved in working with this material and feel the pride of creation. They especially love to make castings of their own hands or feet.

The simple sculptural clay form can be cast successfully. The clay model should not have undercuts. (In a plaster casting of a nose, the nostrils would be considered undercuts, as they would prevent the mold from being pulled straight off.) The principle is to divide the clay model in half all the way around so the two pieces of the plaster mold are easily pulled apart. Although skilled cast-makers make as many divisions as necessary, the first student cast should have no more than three divisions.

Clay and plaster are incompatible materials, although they are often used together in the same studio. If clay has bits of plaster in it, the absorbent plaster will quickly dry the clay surrounding it and can cause the piece to explode when fired.

MATERIALS

Student Project 7.4: *Casting with Plaster*

Clay: 1 to 3 pounds per student

Plaster: approximately 3 pounds per student (this can be inexpensively purchased from building suppliers in 100 pound bags)

Heavy acetate; may be used for shims

Aluminum frozen food containers: to cut up and use for shims

Flexible plastic buckets: to mix plaster

Aluminum pie tins: to make "plaster bats" from leftover plaster

Cardboard milk cartons with tops cut off, to pour excess plaster into — these square forms could be carved later.

Plastic gallon milk cartons

Petroleum jelly

Large pieces of cardboard to place the clay on while casting, so it can be moved easily

Metal hammer and chisel or screwdriver, to force the mold apart

Tempera paint: may be added to hydrostone or plaster to "marbleize" the casting

Finishing materials for the cast piece: instant tea or coffee, shoe polish, charcoal, ink, varnish, linseed oil, spray paint (in related colors)

Sandpaper

Student Project 7.4: CASTING WITH PLASTER

DIRECTIONS

1. Make a shape of clay that is relatively simple, but interesting. It can have planes (flat surfaces), edges, rounded areas, and even holes. As you are forming the clay, think about how it can be cast. It will have to be sectioned to be molded in a two-part mold. You must be able to pull those two parts straight out to remove them from the mold. Openings that go inside something (such as nostrils in a nose) are called undercuts and would break off it you tried to cast them. If you make a hole going completely through the form, a piece of shim must be put in the middle of it to allow the mold to be pulled away.

2. When the sculpture is completed, use a sharp pencil to make a thin line where the shims will be put to divide the mold. It is possible to have as many as three divisions, but more than that makes it difficult to put the mold back together.

3. Use scissors to cut the shims (pieces of aluminum or acetate) into 1 by 3 inch pieces. Push each shim down into the clay sculpture to a depth of 1 inch, overlapping them to leave a continuous "crown" that is 2 inches above the clay.

4. Use petroleum jelly or vegetable oil to lightly coat the piece of sculpture and the shims. This acts as a "release" to keep the plaster from sticking to the clay and shims. Place the sculpture on a square of cardboard at least 6 inches larger all around than the sculpture.

5. Several people can make plaster molds at the same time, if they work carefully as teams. When the plaster is at the right stage for making the mold, you often have less than 1 minute to work, so it is good to have a partner who will help you.

6. Make plaster of Paris as follows:
 Put warm water into a plastic container such as a bucket. Plaster is normally used in proportions of *two parts plaster to one part water*. A half-full bucket of water is enough for two sculptures of 6 to 8 inches. Add plaster slowly to *warm* water. Don't start stirring until the plaster has mounded in the center to break the surface of the water and has formed a "mountain peak." Put your hand to the bottom of the bucket and use your fingers to gently mix the plaster and water. Stirring vigorously will form unwanted bubbles. Remove your hand from time to time, and when the skin on your hand cannot be seen because the plaster is the consistency of thick cream, it is almost ready. When the plaster is no longer shiny and your hand leaves a path as it is stirred, it is ready to make the mold.

7. Take a handful of plaster and place or "throw" it on the mold. Continue covering with plaster, making sure not to cover the tops of the shims. The plaster should be at least 1 to 2 inches thick all the way around.

8. Clean as much of the plaster as possible out of the bucket, and put the excess in milk cartons or use it to make plaster bats. DO NOT POUR EXCESS PLASTER DOWN THE SINK. IT WILL STOP IT UP! When the plaster has dried in the buckets, tap the bottom of the buckets over a wastebasket and flex it, and the plaster will flake off.

9. The plaster will get quite warm while it is "setting up" because this is a chemical reaction. Allow the mold to set overnight.

10. Use a knife or chisel and metal hammer to force the two halves of the mold apart. Remove the clay, inspect the mold for holes, dry the mold with a paper towel, and remove any of the color left by the clay. Mix a small amount of plaster and fill in any holes.

11. With petroleum jelly, coat the inside of the mold, including the surfaces formed by shims. Put the halves of the mold back together, then cement them together by mixing a small amount of plaster to generously cover the outside of the mold along the crack. Allow this to set overnight.

12. Cut the top half off of a plastic gallon milk carton. Place the mold upside down inside the carton, placing crumpled newspaper around it so the opening is level. Mix the plaster to pour into the mold. For a marbled effect, add tempera paint to half the plaster, and pour the two colors of plaster in together, stirring slightly. Allow the piece to set overnight, then gently pry the mold apart to avoid damaging the cast sculpture. The mold may be reused a number of times.

13. Dry the casting, using fine sandpaper to smooth off the casting seam or other rough surfaces. After the sculpture has hardened it can be finished by staining it, spraying with clear shellac, or combining stains such as shoe polish and charcoal. Metallic powder sprinkled into a wet lacquer will make the piece resemble bronze.

FURTHER SUGGESTIONS:

1. Make a cast of your own hand or foot, by casting only half at a time, allowing the plaster to set, and then completing the other half of the mold the next day. Use oil to keep the plaster from sticking to your skin.

Clay model with shims inserted.

"Foot Hand Tree," cast plaster.

CARVING PLASTER

FOR THE TEACHER

For carving, plaster can be mixed with vermiculite (purchased at garden shops) and poured into cardboard milk cartons to harden. This makes it lighter weight than pure plaster, and it can be carved with a knife and filed smooth with sandpaper or a rasp. If students have carved with soap they may already be aware that if you try to take away too much of the material at one time, you can end up with "soap powder" (or in this case, building material).

The subtractive method of sculpture can result in many "mistakes," and it is important for you to be there to help students make decisions on the next step after things don't go quite as they envisioned. You might suggest that they "take-away" from a drawing or a small cube of clay to get the idea of subtractive sculpture.

To set the mood for carving from a rectangular form, students might like to know that Michelangelo spoke of freeing the human forms that were imprisoned in the marble he carved. He felt they were inside there, just waiting to be discovered.

SAFETY NOTE: *Students should always wear safety goggles when carving or using a rasp, as stray particles can get into the eye.*

MATERIALS

Student Project 7.5: *Carving Plaster*

Milk cartons—quart or half gallon (cardboard preferred)

Newspaper

Plaster

Vermiculite

Paring knives, spoons, or melon-ballers for removing plaster

Rounded files or rasps

Sandpaper

Polymer medium

Smocks

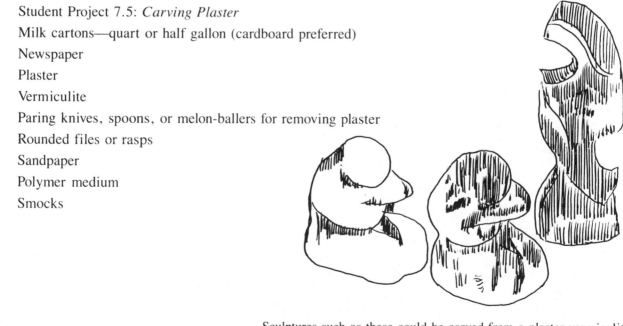

Sculptures such as these could be carved from a plaster-vermiculite combination.

Student Project 7.5: CARVING PLASTER

DIRECTIONS

1. Mix plaster until it is the consistency of cream. Add vermiculite (approximately two cups per quart). Pour into the carton, tapping it gently on the table to eliminate air bubbles. Allow the plaster to harden overnight.

2. Peel the carton from the hardened form.

3. Work on newspaper, and use a rasp or knife to take away plaster from the outside. Carving takes patience, and trying to take away large amounts may break the form. Try to make curves or twisting forms, to avoid a stiff-appearing sculpture. Even though sculptural carving is done with hard materials, most sculptors try to suggest movement.

4. Keep turning the sculpture, making it interesting from all sides. Stand back and carefully look at the work, asking a friend to turn it for you. Generally sculpture is tapered inward at the bottom to suggest a finished piece.

5. When you are satisfied that if you take away any more material, the piece will be ruined, use sandpaper to smooth the plaster. Begin with coarse sandpaper, then use fine sandpaper to finish it totally. The sanding could be done outside, although a newspaper contains most of the dust.

6. Coat the finished piece with thinned polymer medium for a glossy finish or spray it with shellac.

FURTHER SUGGESTIONS

1. This same type of carving can be done on firebrick or some forms of styrofoam or feather rock (sometimes called lavastone) with a rasp.

2. Use a rasp to shape a styrofoam packing form into sculpture. (Do this outside or in a well-ventilated room.) Coat it with gesso, allow it to dry, then paint with acrylic or latex house paint.

Although the firebrick limits the size of a sculpture, it is a wonderful, easily handled material.

138

STONE CARVING

FOR THE TEACHER

To do sculptural carving an investment in tools is necessary. (A list of tools and materials will follow.) Carving in stone is time consuming but satisfying for high school students. It develops flexibility, imagination, and abstract analysis, while honing visualization skills. A large piece of stone (the size of a round loaf of bread) will take at least six weeks to carve, but students will have something of quality to display for the rest of their lives.

The stones best suited for secondary students are soft and relatively easy to carve. Limestone, alabaster, soapstone (steatite), and serpentine come in a variety of shapes and sizes. These stones can be obtained from art supply stores, industrial cut-stone companies, stone-cutters, or garden nurseries, or they can be found by the side of the road. If students are getting *free* limestone from a huge pile by the side of the road, suggest that they hold it at chest height and let it drop to test it for fractures. One of my students *purchased* green stone (serpentine, which fractures easily), then dropped it to test it!

Stones that are easily carved are also easily broken. Remain in the room while students are carving so if a piece breaks you can discuss options. Broken pieces can be developed individually to be mounted together (witness the Henry Moore sculptures that are often in several pieces). They can also be repaired by drilling a ³⁄₈ inch hole in each part and inserting a dowel or metal rod (such as a heavy nail with the end cut off) with epoxy glue on the nail as well as the two surfaces to be joined. Joints can be almost perfectly filled with stone dust mixed with white glue.

The stone's shape limits what can be done, and the students may have to study it for a time before deciding what to do. Drawings can be made, or a sketch can be made by forming a piece of clay roughly the same shape as the stone and subtracting clay. A stone has a high point and a low point, and normally sculpture leaves the high points in place. Often no particular subject seems to present itself, and the student decides to do an abstraction, simply shaping and smoothing the stone, perhaps making planes on edges, and giving movement to the form to draw the eyes around to all sides. Interestingly, many of these sculptures come to resemble a human or animal form, even though that was the furthest thing from the student's mind when he or she began carving.

Before students begin, discuss Eskimo sculptors who work with almost no tools but a knife, a bow drill, and their hands. They polish their sculpture by letting it soak in seal oil for a few days, then use oil combined with fine stone dust and bare hands to smooth their work. Eskimo sculpture almost always tells a story and is often simplified to the point of abstraction. Students may choose to sculpt a soapstone animal in the manner of Eskimo carvers. In fact, since your students may not have the skill to make details on their first piece, encourage them instead to simplify forms. They may choose not to "finish" the entire piece. Many sculptors deliberately leave some surfaces textured. On a Michelangelo sculpture of the Virgin and Child in Bruges, Belgium, the face of the infant is the only highly polished area on the artwork. The artist can thus call attention to portions of a sculpture by how it is finished.

Let students know that the tendency of most people when they see a sculpture is to want to touch it and rub it. For this reason, it is desirable to give a smooth finish to a piece. People are rarely moved to touch something they know will not feel good.

SAFETY NOTES: *Students must always wear safety goggles when carving to avoid stray particles. Stand while carving, with the stone on a sandbag or soft towel. If they are dry-sanding, wear mouth and nose mask to avoid breathing particles of stone. Remind them to always keep chisels pointed away from the*

body, turning the stone so they are always aiming toward the side. As always when students are using cutting or power tools, an adult must supervise.

TOOLS AND MATERIALS USED IN STONE SCULPTURE

Bush hammer: a metal hammer with a toothed surface for rounding surfaces

Face shield: plastic shield to protect face from flying chips

Hacksaw:a saw with a thin blade used for cutting stone

Hand-drill: a hand-operated drill for making openings

Pointing chisel: used for preliminary carving

Rasp: a file that comes in a variety of surfaces and sizes for finishing stone

Rifflers: small, shaped files for hard-to-get-at places

Safety goggles: plastic goggles worn when carving to protect eyes

Sandbags: canvas bags filled with sand to hold the sculpture in place (rolled or wadded towels also work)

Soft iron carving hammers: used with carving chisels

Stone chisels: straight-edged chisels made of metal

Toothed chisels: chisels that come in various widths with jagged edges

Wet-and-dry sandpaper: sandpaper that is dipped in water for finishing stone; begin with 160 and finish with 600 (the numbers refer to the number of grits per square inch)

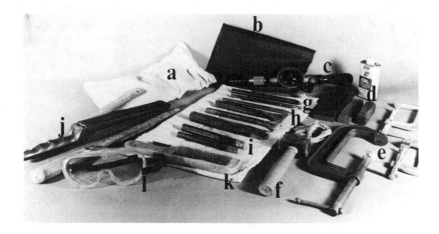

Photo 7–3 The tools of stone carving: (a) sandbag, (b) wet n' dry sandpaper, (c) hand drill, (d) sharpening stones and oil, (e) C-clamps, (f) stone hammer, (g) pointing tools, (h) toothed chisels, (i) chisels, (j) rasps and files, (k) file card–for cleaning files, (l) safety goggles.

Student Project 7.6: STONE CARVING

Study the stone, then make sketches of various ways to carve it. It might help to shape a small piece of clay in proportion to the stone and "take away" from it to get ideas. Making decisions is often the most difficult part of carving. Sometimes you may spend a day just making decisions, then carve for six days straight.

HELPFUL HINTS

1. When carving, always hold the chisel at an angle. If you hit the chisel at a right angle to the stone, you may "bruise" the stone; it may not break at that moment, but it could later on.

2. Work over the entire surface. Don't attempt to complete one area before going to the next, or you may be disappointed in the result. Just as you draw or paint over the entire picture plane before refining, you sculpt over all the piece before finishing any one area.

3. Remove as much of the material as you can with tools such as a saw, drill, pointer, or toothed chisels, then refine and gradually erase your tool marks by the use of flat chisels, rasps, rifflers, and wet-and-dry sandpaper.

4. To make a deep indentation (such as a neck), use a hacksaw to cut to the desired depth, then chisel toward the saw cut from each direction to avoid bruising the stone. Save these cuts until last, as they will make the piece more delicate.

5. To make a single deep indentation or opening, use a hand-drill to drill to the desired depth, then chisel toward the hole.

6. Be open to change. Sometimes the material will not do what you want it to but dictates what you may do with it.

DIRECTIONS

1. Begin roughing out the sculpture with the "point." Place the tip against the stone at an angle, then tap it with the stone hammer, watching the point where it touches the stone and guiding it down or sideways as you hammer. The point and hammer become extensions of your hands as you work.

2. With the point, make a number of parallel groves, which should be shallow at the start but become deeper at the finish of the stroke. Then cross-hatch with the chisel, just as in drawing, at angles to the grooves. This creates an interesting texture, which may be left in some places.

3. In a one-color material, the depth of the carving and the shadows created will make the sculpture interesting.

4. Rough out the basic shape with the pointer, than refine the surface with the toothed chisels. Begin with the coarsest toothed chisels and finish with the finest.

5. To round large areas and remove excess material, tap gently with a bush hammer.

6. To remove marks made by the toothed chisels, first use flat chisels, then a stone rasp for smoothing.

7. When the stone is shaped, and has been smoothed as much as possible, begin polishing.

8. If the stone is large and you have an outside work area, use an electric drill with a circular sanding disk for preliminary finishing. This creates enormous amounts of dust, so it should not be done inside. Wear a mask to avoid breathing in dust.

9. Use wet-and-dry sandpaper for finishing stone. Work from coarse (160 grit) to medium (400 grit) to smooth sandpaper (600 grit). When the stone is wet, you can see what it will look like when the finish is done.

10. Small pieces of stone such as soapstone can be polished on a jeweler's wheel with emery for rough finishing, tripoli for polishing, and then rouge for the final finish.

11. Rub paste wax on the surface to bring out a glow.

12. Mounting gives stability to a piece of sculpture and protects table surfaces. Wood or a contrasting stone such as onyx could make a good base. Drill holes slightly larger than the screw in the bottom of the sculpture and the exact size of the screw in the base. Use a counter-sink drill bit to make a recessed hole in the bottom of the base so the screw will not scratch surfaces. Fill the hole in the sculpture with wood chips and white glue and allow it to dry before screwing the base onto the sculpture.

The front and back views of this 2 × 6 × 16 inch stone show the rhythmic movement possible. Student work.

WOOD SCULPTURE

FOR THE TEACHER

In a semester course in sculpture, students would probably have time to do *either* a wood *or* stone sculpture. The two techniques take approximately the same length of time. The finishing can be done at home to save class time.

Work closely with the students, questioning them, pointing out good things that are happening, and giving suggestions. Remind students that wooden cigar store Indians appeared rigid because the carvers seldom attempted to make curving graceful lines or give "life" by movement.

Wood can be purchased or acquired from manufacturers. Kiln-dried lumber is desirable because it has already lost its moisture. Woods which may be used are classified as hardwood or softwood. Hardwoods generally are trees that have leaves, such as mahogany, birch, cherry, hickory, ebony, maple, walnut, ash, oak, and elm. They are preferable for sculpture because they are generally heavier, harder, denser, less porous, less likely to shrink, and more durable than softwood. Softwoods such as pine, balsa, soft maple, fir, cedar, and redwood generally have needles rather than leaves. These splinter easily while carving and do not have the close grain of the hardwoods.

Many well-known sculptors worked in wood as well as in clay or stone. Henry Moore was a virtuoso sculptor in all media, and his wood sculptures are particularly good examples to show that simplification is often appropriate. Constantin Brancusi was another artist who made fascinating wood sculptures. The photo below shows a mixed-media sculpture, with roughly finished wood an important part of the whole.

SAFETY NOTE: *Students must be supervised by an adult whenever they are using cutting or power tools.*

TOOLS AND MATERIALS FOR WOOD SCULPTURE

> Cutting tools: gauges, chisels, knives, and parting tools
> Abrasive tools: rasps, rifflers, sandpaper and steel wool
> Holding tools: vises and clamps or V-boards
> Wood: a piece at least 6 inches square. Could be long and thin
> Finish: varnish, oil, pastewax, stain, or shoe polish
> C-clamps

Photo 7–4 Constantin Brancusi, "Mademoiselle Pogany III." 1933. Polished bronze. 17½" high, wooden base 37⅝" high, overall, 5'4" high. Photo by David Gulick. Brancusi also created simplified forms in cast brass and carved stone. This sculpture incorporates all three media, with each important. Private collection.

143

Student Project 7.7: WOOD CARVING

DIRECTIONS

Designing in wood holds an exciting challenge. Use as much of the material as possible, while removing enough of it to define your sculpture. Make a number of drawings (from all sides) before beginning to sculpt. As you work, you will probably make changes in your original design.

Don't attempt to develop one area of the wood completely, work first on one area, then another, to achieve overall unity.

1. Keep your tools sharp by using oil on a sharpening stone, and be careful to aim them away from your body.

2. Devise a way to hold the wood in place without it slipping each time you hit it, or you will be constantly wasting your effort. Each stroke should count.

 a. Use a C-clamp attached to the edge of a table as a stop.

 b. V-board made of two 2 by 4 by 12 inch pieces of wood at right angles, screwed onto a 30 inch square piece of plywood. The V-board can be clamped to a table, pushed against a wall, or sat upon to hold it in place.

 c. A wood vise would also hold the work firmly, but you can't keep turning it, and the sculpture often becomes one-sided.

 d. Sand bags or a towel.

 e. Place one side against a wall.

3. Basically the right (or dominant) hand is producing a forward thrust of the cutting edge, while the left hand controls the thrust of the chisel. Hold the chisel at an angle loosely in the left hand, with the bevel (slanted edge) flat against the wood. Make a slice cut by holding the mallet in the right hand and hitting the end of the chisel with enough force to drive it into the wood. If you are doing this correctly, "with" the grain, the chisel will naturally rise to the surface and the chips will be smooth on the bottom. Many sculptors prefer to leave the surface caused by the chisel marks unfinished.

4. Constantly reassess what you are doing. Perhaps your original idea can be refined. Normally the material will force you to make some changes. Be receptive to changes if they add to your original idea. Sometimes you need to spend a day looking and thinking, then work for five or six days to make necessary changes. If you need to make a deep cut into the piece, it may help to use an electric drill to make a hole or two the depth you want, then chisel toward the hole, constantly turning the piece. (Always use power tools with great caution and adult supervision.) When you are afraid that any changes may "ruin" the form, it probably is time to stop removing wood and begin finishing the piece.

5. After the form is as complete as you can get it with cutting tools, use finishing tools to refine it. Use the rasps first, working from coarsest to finest. Sandpaper is used the same way, working from coarse to very fine, until the wood has attained a glow and is smooth all over. To smooth with a wood rasp, grasp the rasp at both ends and smooth the wood all over. To get into hard-to-reach areas, use small rifflers, pointed files, or electric drill accessories.

6. When the wood is so smooth that nothing further can be done, dip your hand in water and wet the entire surface. When it is dry, you will find that the water has "raised" the grain, and it needs further sanding with superfine sandpaper. Do this at least twice before finishing. People will instinctively want to touch a smooth wood piece.

7. The final finish is necessary to protect wood from dirt. The trend is to leave the material as natural looking as possible, and this can be achieved with paste wax or linseed oil. Other possible finishes are enamel, shellac, varnish, oil and wax emulsion, stain, and lacquer. Simply follow directions on the container.

8. When it is finished, you may want to put your piece on a base to achieve both physical and visual balance. The base should never dominate the sculpture it supports, and it should be finished to enhance the sculpture.

FURTHER SUGGESTIONS

1. Incorporate a "found" piece of another type of material such as metal into your design.

2. Find scraps of wood, assemble them, and carve some to enhance your design. (Study the witty sculptures of Marisol Escobar.)

Student wood carving. The bark was left in place.

A 4 × 4 × 24 inch piece of wood challenged the imaginative student who carved this.

Chapter 8: CRAFTS

OBJECTIVES

- To teach the relationship between traditional and contemporary crafts
- To analyze the application of design elements and principles in the creation of crafts
- To recognize the timelessness and universal appeal of crafts from all over the world
- To encourage finding new applications for traditional crafts techniques

INTRODUCTION

Everything old is new again! Handicrafts such as pottery and clothing have been in continuous production in some parts of the world almost since the beginning of civilization. Revivals of ancient crafts continue to occur in the modern world.

Most cultures have traditionally had forms of ceramics, needlework, weaving, cloth dyeing, metal work, paper cutting, and doll making. Some regions have practiced unique crafts that today are appreciated world-wide: examples include batik, tapa cloth, molas, pysanky eggs, featherwork, and quilting. Modern adaptations of these techniques may not have practical applications, but are appreciated simply because they are handmade.

Introduce craft projects with discussions of historical techniques. If your personal specialty is weaving, jewelry, ceramics, basket making, or one of the "major" crafts, share your expertise with your students. Take this opportunity to teach students about recognizing quality and timelessness. Some crafts have surges of popularity. Anyone who teaches crafts needs to keep up with changes in the field to avoid the trite, ordinary, or "cute." Constantly examine crafts at museums, shops, galleries, and fairs. When you see something wonderful, think how to adapt it to a class project, often using quite different materials (such as substituting paper for cloth molas, as described in Chapter 1, or making "tapa cloth" from brown paper grocery bags).

PAPER MAKING

FOR THE TEACHER

The invention of handmade paper in 105 A.D. is credited to the Chinese. Ancient methods of making pulp often consisted of boiling vegetable fibers with lye. Today handmade paper is often considered an art form, with examples of cast and manipulated paper seen in galleries.

Paper can be made in the classroom by a variety of methods:

SCREENING: The traditional method of dipping a screen deckle into pulp-filled water and lifting it straight up to leave pulp on the surface of the screen. Some artists make paper without deckles by lowering small (approximately 8 by 8 inch) pieces of screenwire into a vat and overlapping the resulting "free-form" pieces together on felt to make large sheets of paper. Screening pulp may be pressed into molds such as in the example below.

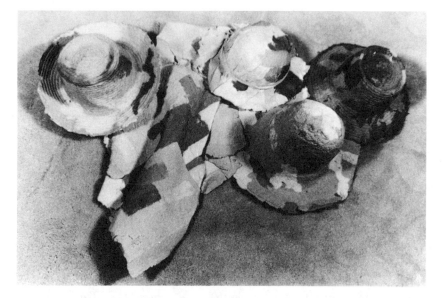

Photo 8–1 Elizabeth Concannon, "The Gang's All Here." This handmade cast-paper sculpture reminded the artist of the warmth of a hat and coat rack seen in a hallway. Courtesy, the artist.

PATTY CAKING: Pulp filled water is strained through a sieve, and the resulting pulp pressed into molds.

POURING: Pulp is poured from a container onto a screen to make large forms or "paintings." Shaped paper is made by pouring into shaped styrofoam or foam core on top of a screen.

FURTHER SUGGESTIONS: Large plain sheets of hand-made paper can be lovely, but may be boring. Sew on it with fine copper or brass wires, even stitch it on a machine. Incorporate natural materials such as sticks, string, or grasses into the paper to create more interesting art.

Organizational tips

1. Have students do the preparation. Tear linters in class, then grind the pre-soaked fibers in a blender at home. Only three or four small (1½ by 1½ inches square) pieces of linter should be ground in a quart

147

of water before emptying the water through a sieve and grinding the next batch. It is possible to prepare a gallon of pulp in less than half an hour. You can also grind large quantities by using an 18 inch paint mixing extension on the end of an electric drill.

2. Keep wet pulp in plastic ice-cream cartons. A handful of pulp in a dishpan full of water is adequate to make a few sheets of paper approximately 4 by 6 inches.

3. Students could work in groups of four to prepare the materials for a vat of pulp from which to make their paper.

4. You can either set up one corner of the room for paper making, with small groups working, or you can use the entire room for paper making for a short period of time. Secondary students begin to use their imaginations only after understanding the basic process, so allow them enough time for experimentation.

5. Dyes can be added to slurry vats for intense colors. To keep odor under control, add 1 cup of alcohol to the vat. At the end of a few days, use the sieve to remove slurry from a vat, saving the pulp by patting it into tennis-size balls to dry, and changing the water.

6. The vats could contain any of the following materials:

 a. Cotton linter: may be mixed with colored construction paper, or paper scrap from a print shop. A handful of iris leaf pulp added to this makes an Oriental paper. A handful of yellow paper pulp and crumpled dried ginko leaves gives an interestingly textured paper. Any dried flower petals may be used in the pulp or carefully placed on finished paper. These may be purchased from art supply stores.

 b. *National Geographic* magazines ground up make a thin grayish paper. A handful of linter will add strength.

 c. Paper dress patterns can be ground up. Many words survive the grinding, and you will still be able to read them when the paper is finished.

 d. Create mystery slurry by putting all the pulp that would be thrown away in a small plastic tub, then regrind it with linter, adding color, and making paper.

7. Because paper making uses large quantities of water, protect the floor around the slurry table with layers of newspaper to absorb the water. Put down fresh paper as needed. Keep sponges and a damp-mop or two available for clean-up.

SAFETY NOTE. *When grinding paper, keep the area around the blender free of water by frequent sponging.*

MATERIALS

Student Project 8.1: *Paper Making*

Deckles: frames may be made of wood or by using butcher trays. You need two frames of the same size — one with wire stretched across the opening, the other to use on top of it.

Materials for pulp: cotton linters, old *National Geographics*, construction paper, old paper dress patterns, fibers (such as dried iris or gladiola leaves) that have been boiled. Have a "paper-saver" box for wasted drawing paper to recycle.

Additives for paper: embroidery or colored thread, dried ginko leaves, dried iris or gladiola leaves that have been boiled until they disintegrate, colored scrap paper from a print shop, construction paper, sesame seeds, dried rose petals, dried chrysanthymum petals

Vats: square dish pans or other tubs; for large screens, black plastic tubs used for draining grease from cars may be purchased from hardware stores

Size: paper used for print making or writing, may be sized with LePage's glue, spray starch, commercial fixative, 1½ cup water to ½ box cornstarch, or 1½ cups water to 1 envelope of Knox gelatin

Large sieves

Plastic ice cream tubs (or pickle tubs from your cafeteria or local fast-food vendor)

Wooden screens: old, torn screens students bring from home

Screenwire: should be metal—plastic screenwire is not heavy enough

Duct tape: to tape screenwire onto butcher trays

Blender: for grinding fibers (or you can grind them in large quantities by soaking them and using a long electric drill paint-mixing extension. To avoid burning out electrical appliances while grinding fibers, pre-soak the fibers before grinding and work with small quantities of fiber in large amounts of water.)

Sponges: small and inexpensive—cut them in half to use for couching

Felt: white is preferred, as other colors have dyes that run and may affect the paper; rug remnants, old blankets, heavy cotton sheets, or Pellon may also be used for removing excess water

Plastic storage trays: these are good for standing on the post of felt and paper to squeeze out water

Small plastic containers for the middle of the work tables

Mops for clean-up

Wooden boards at least the size of the felt (for squeezing out water), 12 by 16 inches

Newspaper: to absorb water from floor

Iron: to dry paper placed between sheets of newsprint (if desired)

The materials of paper makings—deckles, felts, sponge, vats, blender, cotton linters.

Student Project 8.1: PAPER MAKING

DIRECTIONS

1. To make paper, fill the vats to within 2 inches of the top with water, then add one or two handfuls of pulp. Before dipping the deckles, always stir the slurry with your hand so the pulp is floating throughout the water.

2. Place the screen deckle and open deckle together convex side up, with the open deckle on top. Hold the deckles vertically and dip them down the side of the tub. Turn them horizontally (flat) on the bottom, and lift them straight up.

3. Continue holding the deckles over the tub; shake them forward and backward, then from side to side to blend the fibers and drain excess water. Use one hand to remove excess fiber from the deckles, then carry the deckles to a piece of felt.

4. Remove the open deckle and turn the screen deckle with the paper upside down onto the felt. Use a sponge to gently push on the inside of the screen to release the paper. This step is called couching, which in French literally means to "lay down." When the paper is on the felt, put another piece of felt on top of it.

5. Although you can now squeeze water from the paper by applying pressure, it is easier to make several sheets of paper and squeeze all of them at once. An alternating stack of felt and paper is a "post."

6. To remove water, place a post of paper between two boards (inside a plastic tray on the floor) and apply pressure by standing on the board. The paper is delicate, so do this gently.

7. To remove the paper from the felt, roll back the top felt with both hands, then use your fingertips to handle the paper. If you try to hold it between thumbs and fingers, it may tear. Carry it to a screen and gently lay it down to dry. To dry many pieces of paper, stack the screens on top of each other, holding them apart with sponges in between or put each screen on a shelf or a drying rack.

 Another method of drying is to place the damp paper between two sheets of clean newsprint and iron it dry. It can also drain dry on clean newsprint on top of a stack of newspaper.

8. Experiment with variations in paper making:

 a. To make paper with a different color on each side, make two different-colored sheets of paper and lay one on top of the first before placing the felt on top.

 b. Place slurry and water in squeeze bottles and "trail" colored slurry on top of the paper on the screen before you take it away from the vat.

 c. Dip a string into a vat with slurry such as iris leaves (or ground up blue jeans); when you lift out the string, the slurry will hang from it. Lay that on top of a piece of paper before squeezing out water, and it become part of the paper.

 d. Lay small strips of scrap paper or string onto wet pulp before squeezing it.

 e. Add rose petals or other dried flowers to the sheet of paper before squeezing.

 f. Prepare a colored sheet of paper and place it on the felt. Then make a different color of paper and pour water onto your screen to create a natural "hole" in the paper before taking it away from the vat. Place this paper onto the first sheet of paper before squeezing out excess water.

 g. Stretch pantyhose over the bottom of a large plastic bottle (cut 2 inches deep) and hold it with a rubber band. When it is dipped into the slurry and drained, the result is a round piece of paper. An embroidery hoop with hose on it gives the same effect.

h. Use an upper deckle with a high rim around it that will contain slurry (use 2 by 2 inch wood and make a frame, tacking screenwire on the bottom). Place several handfuls of pulp inside the rim of the deckle, then lower the screen into a vat of plain water so the pulp floats around and settles evenly.

FURTHER SUGGESTIONS

1. Make paper masks by pressing paper pulp inside "sculpt-tape" masks lined with plastic wrap (see directions for making masks in this chapter). The paper shrinks in two days and is easily removed.

2. "Cast" paper into any kind of container or shape such as the textured trays used by bakeries for cookies or cakes. Many different shapes of molded plastic are used as make-up containers. Start saving these to make cast-paper sculpture. Cut shallow bottoms from textured trays, and lay them next to each other; when you cast the paper, a larger textured sheet is created.

3. Make a plaster mold by pouring plaster into a plastic or clay vessel. These can be reused many times. The plaster absorbs the water from the paper, and you can make containers of paper. Impress natural items into the paper, allowing them to stick out on the rim.

4. Cast paper on top of seashells to create an interesting surface.

5. To make large, shaped paper, cut shapes in ½ inch thick styrofoam or foam core, place it on top of a large screen, and pour slurry through the screen into a large plastic tub. Allow the paper to dry on the screen, or simply turn the screen over onto a large piece of felt and cast several shapes that are alike.

Sketch of "Eye in the Desert," paper cast pot by Carolyn Uhley. This quiet work is made dynamic by the addition of grains extending from the sides. Courtesy the artist.

MARBLING

FOR THE TEACHER

Marbling (or marbleizing) is another ancient craft that has seen a recent revival. It originated in eighth-century Japan, traveled to Persia and Turkey, and was done in Europe in the fifteenth century. The high point of marbling in Europe was during the Art Nouveau period. Marbling was first brought to America in 1750 as end papers in fine books. Today's uses, in addition to matting and framing a sheet of marbled paper "as is," include: covering wooden boxes, pencil holders, or lampshades; pasting small pieces on notepaper or cards; using as end sheets or covers in bookbinding; and laminating as bookmarks. Students in one school recently raised funds by selling notepaper made from marbled paper. Artists also make beautiful marbleized silk scarves.

The traditional method of marbling was done by floating thinned oil paints on water and laying a piece of paper on the pattern to make a "print." Modern craftsman Jim Reed works with gouache paints on alum-soaked paper with wonderful results, and he shared his expertise with my classes. Acrylic paint thinned with water, floated on a surface of carrageenan, is a satisfactory substitute for gouache. The paints adhere to paper better if the paper has been sponged first with alum solution. Another method utilizes liquid starch as a solution for floating thinned acrylic paint. Experimentation shows that untreated construction paper absorbs the paint well.

Always experiment with the paints before introducing students to the technique. There are no easy formulas for proportions of paint to water, and trial and error are necessary to get each type of paint to the correct thickness. If the paint forms thick blobs and does not spread on the surface, it is too thick. Sometimes it takes the addition of paint to the tank of carrageenan for it to work the way it should.

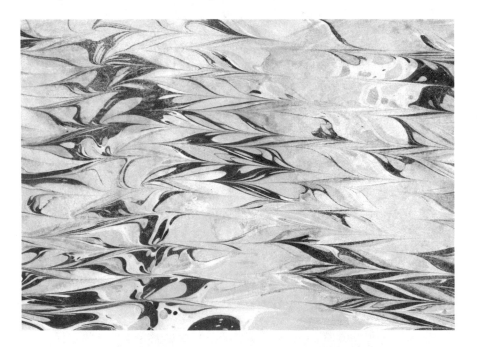

Photo 8–1 "Flame" marbling pattern.

152

MATERIALS

Student Project 8.2: *Marbling*

Gallon plastic milk containers for mixing and storing carrageenan solution and for rinse water

Alum: Aluminum sulfate, available from same supplier listed below

Carrageenan: the powder to make this solution may be purchased from Colophon Hand Bookbindery, Seattle, Washington. One pound is sufficient for hundreds of sheets of 10 by 14 inch paper. To mix, add one tablespoon of carrageenan to one quart of water in a blender. Agitate for one minute and empty into a gallon plastic jug. After preparing 3 quarts add another quart of water to the gallon jug and shake to mix. Let stand 1 to 2 days to age. Do not save for longer than a few weeks, as old carrageenan smells unpleasant. Note: distilled water may work better for some areas of the country; liquid starch makes a similar solution to use with acrylic paints.

Sheet plastic or butcher paper for protecting tables

Smocks: old shirts worn backward work well

Pint containers such as tempera jars, for mixing acrylic paints

Sulfite drawing paper or light-colored construction paper, cut to fit inside the tray (with $\frac{1}{2}$ inch to spare)

Each table should have the following materials:

Tank (tray): 3 to 4 inches deep; could be photo trays or plastic storage trays—not metal

Rimmed cookie sheets: approximately the same width as the tank

Muffin tin or baby food jars to contain acrylic paint colors

Rake: make of $\frac{1}{2}$ inch square balsa wood, the width of the tank, with corsage pins or long nails inserted at $1\frac{1}{2}$ inch intervals

Combs: made like rakes, with pins or nails at $\frac{1}{4}$ to $\frac{1}{2}$ inch intervals

"Shoebox kits," one per table, containing: broomstraws, drinking straws, 6 to 8 watercolor brushes, pencil, cotton balls and eye-makeup remover or baby oil

Newspaper strips approximately 3 by 15 inches

Newspaper pages cut in half to hold wet prints

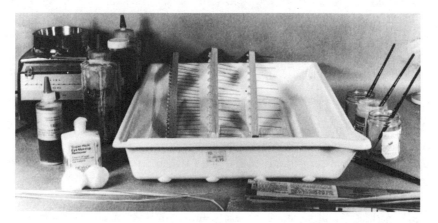

Photo 8–2

Student Project 8.2: MARBLING

DIRECTIONS

1. Before beginning, write your name in pencil on the back of the paper since it is easy to confuse your work with someone else's.

2. Skim off excess paint and clean the surface of carrageenan in the tank by holding a strip of newspaper vertically, taut between your hands. Draw the lower edge along the top of the solution and throw the paper away. It may be necessary to do this a number of times.

3. Plan a color scheme, using from 3 to 6 colors. Stir the paint in the jar with a brush before dropping it onto the carrageenan. Hold the brush about 6 inches from the surface of the tank. Put the brush back into the jar and add new colors to the surface. Manipulate the color to achieve a variety of patterns. At any point you may stop changing the pattern and make a "print."

BASIC PATTERN: There is a "basic" pattern from which several variations are made. Begin with the pebble pattern (see below). Then draw the rake vertically down and back the length of the tray, then draw it the width of the tray of one side to the other. After this draw the comb the length and width of the tray.

PEBBLE PATTERN: Hold a watercolor brush well above the surface and spatter paint on the surface of solution by tapping the brush lightly on the opposite forefinger. Three to five colors work well. The paint spreads in circles of different sizes and the print is made without changing the natural shapes that form.

FEATHER PATTERN: After creating a pebble pattern, pull the rake the length of the tray. Move the rake sideways $1/8$ inch and pull it back to the starting point.

COMB MARBLEIZED PATTERN: After making the feather pattern, pull the comb the length of the tray and back. Then draw the comb the width of the tray.

SNAIL PATTERN: Dip a broomstraw into the surface and make small side by side spirals.

DIAGONAL PATTERN: After making the basic pattern, hold the rake and comb together and draw them the length of the tray, while going in a side-to-side motion.

HOLE PATTERN: Create any pattern listed above. Then gently dip an oil-tipped broomstraw (use a drop of oil on a cotton ball to apply the oil) into a chosen area of paint. The resulting hole, created as the paint pulls away from the oil, prints on the paper as white. Another broomstraw may be used to change the shape of the hole by pulling away from the hole into the painted surface or by pulling paint into the opening. (These look like flowers.) Stems and leaves may be created by drawing the oil-tipped straw through the surface.

FRIED EGG PATTERN: Make a hole as above. Then use a drinking straw to carry a drop or so of paint from the paint container and drop it into the opening created by the oil. (Retain the paint by holding your finger on the end.) More than one color may be dropped in the middle of a previous one to create concentric circles of color.

4. For best results, sponge the paper with an alum solution before printing. Make a print simply by holding a piece of paper from diagonally opposite corners, slightly curving the center. Let the center touch the surface first, then drop the corners. This will help prevent white spots on the paper from trapped air bubbles.

5. After the print is made, hold a cookie sheet tilted at one end of the tank. Remove the print and place it color side up on the cookie sheet so excess solution drains back into the tank. Carry the cookie sheet with the print to the sink, and rinse by gently pouring water from a gallon jug of water. (A

© 1990 by The Center for Applied Research in Education, Inc.

faucet usually has too much force and could rinse away the colors.) Allow the print to drip over the sink until no more water runs off.

6. Place the print on newspaper and carry it to a drying rack or to a place on the floor where it can dry for an hour or so.

FURTHER SUGGESTIONS

1. Marbling with pastels: use a knife to scrape different colors of chalk onto the surface of water. Use a broomstraw or wooden end of a brush to swirl it around into a pattern, and lay a piece of paper on the surface to make a print. Spray with fixative to make permanent.

2. Accordion-fold drawing paper to make a "Haiku" book for poetry. Cover two slightly larger pieces of cardboard with marbleized paper and glue them onto the ends of the accordion fold. Place tape between the cover and the paper to tie the book together.

3. Make a small "gift-bag" from a sheet of marbleized paper.

4. Find animals or people in the pattern and define them with black marker or pen and ink. These are quite dramatic.

5. Combine marbleized paper in a collage with other materials.

6. Use it as a base for printmaking with a strong linocut or woodcut.

A marbelized bag such as this is easily
made from a sheet of marbled paper.

MASK MAKING

FOR THE TEACHER

Modern masks do not always have ritual associations as in other cultures, but they continue to be appreciated as works of art to hang or to wear. The history of masks is an important part of presenting a project like this to students. This project could degenerate into the ordinary without considerable guidance and background information.

Do research on masks from Africa, Brazil, the South Seas, the Tlinglit Indians, and Chinese or Japanese theater masks. Find pictures of modern uses for masks such as parades or the theater and hang examples to inspire the students when they are making and decorating their masks. See photos 8-3 and 8-4 for a variety of examples of masks.

Making masks of forms created on their own faces is exciting for students. The creation of the forms, while an interesting activity, is not the primary purpose of making masks. Stimulating imaginations, fostering the steps beyond, will lead to the creation of a work of art.

Working with plaster-impregnated gauze (sculpture-tape) gives reasonable facsimiles of the model's face. I recommend making faces on half the students one day, the other half the next day. Have the students cut sculpt-tape strips the day before they are needed. On the day of the actual mask making, there is no time to cut.

Some students may be wary of having their faces covered. Ask them to tell you privately so you can be near the student. Tell the students to take good care of their partners. It may help to have music in the background. Have them wear older clothes on the mask making day.

MATERIALS

Student Project 8.3: *Mask Making*

Phillips screwdriver

Old shirts or smocks

Scissors

Plastic containers half full of warm water

Newspaper to cover tables

Plaster-impregnated gauze (sometimes called sculpture-tape) cut into approximately 1 by 3 inch strips

Plastic kitchen wrap for protecting face

Electric drill for drilling holes to attach hair or string for hanging

Tempera or acrylic paint for decorating

Decorating supplies such as feathers, bells, raffia, sequins, ribbons, yarn

White latex house paint: to provide a base on the plaster to prevent absorption of paint

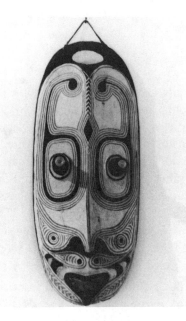

Photo 8–3 Mask. New Guinea: Korogo Village. 17″ x 12″. Courtesy, the Coyote's Paw Gallery, St. Louis, Missouri.

Photo 8–4 The bright and colorful decorative designs on these Chinese clay masks would be effective on a smooth surface, even painted on to a mask made of tagboard.

Student Project 8.3: MASK MAKING

DIRECTIONS

The sculpture-tape you will be using is the same that surgeons sometimes use to set a broken arm or leg. When you put it on your face, you will not be able to move for approximately 20 minutes until it has "set up." The tape has the chemical Gypsum (plaster of Paris) in it. Adding water causes a chemical reaction that will warm the plaster just before it sets. Your nostrils will be left uncovered, but the rest of your face, including your eyes, will be covered with plastic wrap. You will always be in control of how long the mask stays on your face, so if for any reason you are uncomfortable, you can easily remove it yourself.

You will have a partner with whom you take turns making masks.

1. Spend one day cutting sculpture-tape into approximately 200 1 by 3 inch strips. Do this over newspaper, as the plaster sifts out. Wrap your strips into a package of paper and put your name on it. Cut more than you think you will need, as the mask needs several layers of tape and you won't have time to cut it while you are working.

2. Before beginning, cover the table or floor with several layers of newspaper. Have the "patient" lie down. Take two 24 inch pieces of plastic wrap and place one across the tip of the nose, covering the hair and touching the table on both sides. Place the other one directly under the nose, covering the mouth and upper lip, and tuck it under the chin. Allow only the nostrils to be uncovered.

3. Dip a piece of tape in the container of warm water, hold it over the container, and draw it between two fingers to get rid of excess water. Open it flat.

4. Apply one layer of tape over the entire face, beginning at the eyes, across the nose, and almost to the ears. If you want to leave openings for eyes or mouth, do not put tape across them (even though they are covered by plastic wrap). Shape the tape to the contour of the face as you go, smoothing it well under the chin and bringing it high across the head from ear to ear, making sure the outside edges have a smooth contour and sufficient layers for strength. It is hard to change them after they have dried. Neatness counts!

5. Apply a second coat, remembering to use both hands to shape it. You may be tempted to continue applying tape to the central portion of the face, but a good mask needs at least four smooth layers everywhere. Take the time to straighten out the pieces so there are no folds. Look carefully at your work, trying to envision how it will look when it is finished.

6. To strengthen the nose, when the nose and the upper lip are almost hardened, cut a piece of tape $3/4$ by 3 inches. Fold it to $1/4$ inch wide and place it vertically from the bridge of the nose down between the nostrils onto the upper lip. Two pieces of this strengthen the mask. Do this carefully so your friend can breathe. Place more tape across the nose and upper lip to hide the ends of the vertical tape.

7. When you have finished, pour the water off the top of the bowl. Take some of the plaster that has settled to the bottom of the bowl and smooth it on the outside of the mask, then wipe out the bowl with paper towels. Plaster can ruin plumbing. If you do pour some down the drain accidently, flush it with running water.

8. Wait a few minutes until the mask has hardened, then allow the "patient" to remove it. Place it on a piece of newsprint with the student's name.

9. After the mask has hardened for an hour, poke holes with a Phillips screw driver about 1 inch from the outer edge slightly above eye level for attaching strings for hanging. When it is firm, hold it to the light to see if there are thin portions, adding sculpture-tape there or to edges if needed.

10. The masks will be dry enough in a day to paint. The creative finish of a mask is all important. It may be finished in a plain color with designs painted on later. Although they could simply be thought of as a surface for a painting, facial features lend themselves to a different type of decoration. Look at examples of masks in library books. Think of their uses, for pageants, plays, parades, religious ceremonies, and disguises for parties. Look around your home or a store for things that could be added to your mask.

 a. Use varnish, white shellac, polymer medium, polyurethane or white latex housepaint on the inside and outside of the mask to prevent the plaster from soaking up paint.

 b. The surface can be made completely smooth by using layers of modeling paste and thinned acrylic gel, sanding between coats.

 c. Plaster of Paris can be mixed and smoothed onto the surface, then sanded for an even surface.

 d. The surface can be made to appear like metal by sprinkling metallic powder onto a wet shellac surface.

 e. Heavy cardboard additions can be added to the mask using sculpture-tape.

 f. "Hair" may be added using metallic pot scrubbers, yarn, ribbons, or raffia.

FURTHER SUGGESTIONS

1. Varnish the plaster mask and then use it as a base to make any number of cast-paper masks. See the section on making paper in this chapter. Place the paper pulp inside the mask, as it will shrink as it dries.

2. Make a papier-mâché mask on top of this form. To protect the plaster mask, cover it first with plastic wrap. Use small pieces (2 by 2 inches) torn from brown paper grocery bags to form this mask (the feathery edges blend smoothly). You could decorate it in abstract or realistic designs, restricting yourself to three to five colors.

3. Make a "direct-clay" mask. Coat another students' face with petroleum jelly. Roll a slab of clay ¼ inch thick and cut it larger than the face. Make an opening that will fit under the nostrils, then lift the slab and make it fit the face by patting and molding. Take it off the face and place it on a prepared mound of newspaper (taped together to maintain its shape). Refine it by adding eyes, mouth, or other features (or cutting holes for eyes or mouth). Use a pencil to make holes in front of the ears for hanging it. Paint on details with underglaze before firing, then apply a clear glaze for a final firing.

4. Make a papier mâché mask on a mold made of clay. Cover the clay with plastic wrap or petroleum jelly to facilitate easy removal of the mask. Keep the clay moist and reuse it for as many replicas as you wish.

These papier mâché masks were formed on shapes made of clay. Paint with acrylic paint, and a coating of polymer medium.

BATIK

FOR THE TEACHER

Because cloth disintegrates over time, it is often difficult to trace the origin of fabric design. Examples of batik show it was made in China as early as the eighth century A.D. Batik remains a traditional art form in Indonesia, and it was at the height of fashion in Germany at the end of the nineteenth century. In Africa, in place of the traditional batik wax-resist, a resist is made of cassava flour paste.

Creating batik offers students a chance to learn about applied design. Students may already have done some variation of batik either on paper or cloth, as ink-washed crayon-resist looks similar. The traditional Indonesian resist method of drawing on cloth with hot wax is as easy as any method and gives lovely results.

Although I have been very specific in "safety hints," I have taught batik to large classes of secondary students, and to children as young as five with no mishaps because of safety precautions and frequent reminders to the students.

HELPFUL HINTS

DIRECTIONS: Post student's directions near the work area to remind students of the sequential procedure. It is far more exciting to talk with them about their designs and color schemes than to answer the same procedural questions repeatedly.

COLOR SCHEMES: The first color should be light, and you rarely need more than three colors. Although color schemes are important in batik, making the dyes double strength allows almost any color to cover another. Not all decisions have to be made beforehand; some can be worked out as you go along. Some of the most successful color schemes use closely related colors such as orange, red, and magenta, or light blue, aqua, and dark green. Dyes of a complementary color can be painted on, but it is better not to dip the cloth in complementary colors, as the result is often "muddy" looking.

DYE MIXING: Mix the dyes in gallon jugs and label them. Two tablespoons of salt may be added to a gallon of dye to intensify the color. Either set up a "dye table" and leave the dyes in trays or, if that is not feasible, keep the dye in gallon jugs and pour it into trays as needed. The dyes can be reused indefinitely unless you wish to "fix" the dyes (e.g. for clothing).

DYE FIXING: Fixing is done with washing soda or a powder that comes with the dyes. Adding fixer deactivates the dye after an hour, but does result in permanent, intense colors. A number of pieces of cloth may be dyed and fixed in a tray at the same time. Add the fixing powder and stir it to dissolve. When the cloth is in the dye, lift it out and move it around to distribute dye evenly. After fixing, rinse the cloth until the running water is clear.

THE DYE BATH: Several pieces of cloth can be in the dye bath at the same time. If they are the same size as the dye container, they can lie flat.

DRYING THE CLOTH: Set up a station in the room to dry cloth. Either hang it on a line with newspapers underneath to catch drips or lay it in a drying rack on a clean sheet of newsprint on top of newspapers.

SAFETY NOTES: *Wear gloves when mixing dyes and avoid getting them on your hands.*

Never leave the room when you are using hot wax. Wax is best heated in a temperature-controlled container such as a crockpot or electric skillet to about 200 degrees. Above 325 degrees paraffin may give off toxic fumes. It can be melted in a double boiler on a hot plate or in a tall container placed in a pot of boiling

water. In case of fire, do not add water, as it would cause the wax to splash. Instead, keep a lid near the wax source to smother the fire. If wax is spilled on a burner, turn off the burner and use baking soda. If hot wax is spilled on skin, immerse the burned area in cold water.

MATERIALS

Student Project 8.4: *Batik*

Cloth: 100% cotton, rayon, or silk (washed in hot water to remove sizing, then ironed)

Wax: paraffin or a blend of paraffin and beeswax. The higher the content of beeswax, the less crackling will be achieved. Economy batik wax has 82% paraffin and 18% synthetic beeswax. If you mix your own, the proportions are one part beeswax to four parts paraffin.

Crockpots or electric skillets for heating wax

Dyes: cold water fiber-reactive dyes (procion)

Plastic milk jugs for storing dye

Funnels

Brushes: bristle or bamboo, for applying wax; allow to soften by leaving in wax until the heat melts the wax in them. Don't try to clean them; reserve them for batik.

Pipe cleaners: may be bent into designs and used to stamp wax onto the cloth

Rubber gloves: used when dipping the cloth into the dyebath

Dye vats: polystyrene trays or plastic dish pans

Steam or dry iron

Newspaper

Newsprint

Tjanting needles (nice if you can get them, but not necessary)

Assorted metal items for dipping into wax and printing onto cloth (such as tin cans, metal cookie cutters, long screws, heavy wire bent into designs on one end)

Candy thermometer

Photo 8–5 This silk scarf is orange, red and brown. Even though the vivid colors and patterns are not natural to elephants, there is no doubt what they are.

Student Project 8.4: BATIK

DIRECTIONS

Material such as molten wax is difficult to control, so be prepared for mistakes to happen and call them happy accidents. Accept the likelihood that you will drip wax where you don't want it. You will be the only one to know it is a "mistake." Learn to apply the wax just inside the lines, because it spreads when it is hot. Practice will improve your control, so begin working on areas that are not quite so important until you get the "feel" of applying wax. You may practice briefly on paper.

1. Make several rectangular thumbnails sketches (have your teacher approve one). Intricate patterns such as stripes, dots, and wavy lines are especially effective. The outside shape of something determines what it is, and pattern makes it more interesting. Realistic color is not important in something as exotic as batik.

2. Enlarge the design on paper to the exact size of the cloth, leaving a 1- inch border.

3. Outline the design on the paper with magic marker.

4. Place the cloth on top of the design, and outline the design on the cloth *lightly* in *pencil*.

5. Choose the color scheme. In general, work from light to dark colors and rarely use more than four. White is always one of the colors, since the cloth is white in the beginning. Use colors that are analogous on the color wheel such as yellow, orange, and red, and the dye will cover easily. If you must have a complementary color it should be painted on and allowed to dry before the first dyebath, then waxed so it will remain that color.

6. Wax the areas on the design to *remain* white. If you are using a brush, allow it to stay in the hot wax until the bristles have softened. If using a tjanting, dip it frequently to keep the wax hot enough to penetrate. As you carry wax from the container to the cloth, hold a tissue under the tjanting or brush to avoid dripping wax. The wax needs to be hot enough to penetrate the cloth, making the cloth appear translucent. If it appears whitish, the wax has cooled on the brush. If the wax is visible only on the front surface of the cloth, the cloth will still take dye underneath. Turn the cloth over, and where it has not penetrated, apply wax to the back. It is not necessary to crumple the waxed cloth to obtain the traditional crackle design; handling it while waxing and dyeing will give all the crackle needed.

7. When the wax on the cloth has cooled, dip it in the lightest color dye (yellow, light blue, pink, light orange, or tan). For light values, leave the cloth in the dye four to five minutes. If the dye is too intense, rinse it in cold water to make it lighter. For normal intensity, leave it in the dye 30 to 50 minutes. Cloth will dry lighter than it appears when wet. Although the color may be lighter in areas when the cloth is dry, usually the darkest colors cover evenly.

8. After removing the cloth from the dyebath, let it dry before applying the next coat of wax.

9. When the cloth is dried, wax the areas to remain that color (such as yellow), then dip it in the next dyebath. Realize that if you dip yellow cloth into blue dye, the result will be green rather than blue, as each dye is affected by the previous color used.

10. If more colors are desired, allow the cloth to dry, then wax the colors to remain before redyeing it.

11. Remove the wax by placing the cloth between two sheets of clean white newsprint and ironing it on a flat surface covered with newspapers, changing the newsprint often until no more wax comes off the cloth.

a. If some areas are lighter than others because no wax is on them, you may even out the coloring by waxing those areas and then ironing out the wax.

b. Wax can be completely removed by dipping the cloth in cleaning fluid, but this is not recommended at school.

c. If the batik is a garment, the excess wax may be boiled out (make sure the cloth has been fixed).

12. Finish the piece of cloth in some way. You can hem the sides and ends and suspend it from two sticks. You can also quilt it on a machine by using old sheeting, with cotton batting in between, and then stretching it on a piece of cardboard or wooden frame.

FURTHER SUGGESTIONS

1. Make a soft sculpture from the batik by making a paper pattern, cutting out and batiking the pieces separately, then sewing them together and stuffing them. On a small scale, batik foods or animals could be a class theme. Several people could work together to make an oversized soft sculpture.

2. Batik T-shirts. Make sure they are 100% cotton. Wash in hot water to remove sizing. Place waxed paper on top of newspaper inside the shirt to prevent the wax from going through. To make the color permanent, fix the tee-shirts. Save up a number of shirts to be fixed in a given color at the same time.

3. Make paper batiks by painting wax on paper and brushing dye on top. Gently crumple before painting to obtain "batik" texture. Use same ironing method to remove wax as used with cloth batiks.

This traditional blue and white Chinese batik uses geometric design and forms from nature. Collection of the author.

TIE-DYING

FOR THE TEACHER

Tie-dyeing is a natural follow-through when you are doing batik. The dyes are being used, and students can easily prepare cloth for tie-dyeing while waiting for their batik that is in the dye bath. The basic difference between tie-dyeing cloth that will be displayed and tie-dyeing cloth that will be worn, such as a T-shirt, is that the dye must be fixed to keep its intensity. The patterns in tie-dye result from several different methods of blocking out the dye. Before doing something like a T-shirt, have students practice various ways to make designs with tie-dye on scrap fabric or old sheets. One hundred percent cotton T-shirts dye best, but they must be washed in hot water to remove the sizing. Tie-dye wall hangings are also lovely to see, and can be made on cotton, rayon, silk, or velvet.

MATERIALS

Student Project 8.5: *Tie-Dyeing*

Dye: household dyes or cold-water dyes (to use cold-water dyes, the ties must be exceptionally tight or tied with waxed thread).

Fixer

Tanks: deep dishpans or plastic trays

Variety of materials for tying cloth: thick and thin rubber bands, needle and thread, string, waxed dental floss, wire, nylon rope, masking tape, fishing line, carpet and button hold thread

Clamps of various types for holding folds: bulldog clamps, clothespins, paper clips, bobby pins, and C-clamps

Miscellaneous items to tie into cloth: marbles, buttons, popcorn kernels, rubber washer, or plastic beads

Wooden blocks (any dimension): when the wood is clamped over the cloth and the cloth is put in dye, the area covered with wood remains white

Photo 8-6 A running stitch, pulled up tightly, created these patterns.

Student Project 8.5: TIE-DYEING

DIRECTIONS

1. Before dyeing a T-shirt or decorative hanging, practice dyeing a variety of designs on a scrap of fabric or old sheet.

2. Although the random pattern of tie-dye is interesting, you might prefer to plan ahead by making a design on a piece of newsprint. Some variations that could be done with tie-dye are:

 a. Put marbles inside the cloth and hold them in place with tight rubber bands or thread.

 b. For a T-shirt, hold the middle of the front of the T-shirt between two fingers, letting the rest of it dangle. Starting one inch from the middle, wind string down until the entire front is tied. Do the same procedure on the back. For variation, string could be tied in individual knots 1 inch apart.

 c. Stitch circles with small stitches, pulled up tight. The stitching gives an entirely different effect than tying does. Diamond patterns, squares and lines can all be made with running stitches pulled up tightly before dyeing. Folding fabric and whip stitching tightly on top of the fold makes vertical lines that look like fish ribs.

 d. To get different colors, dip the center of a circle into a different color dye that will cover the first color.

 e. Folding and dyeing gives distinct patterns. Accordion folds can be stitched together loosely or tightly for different effects. Practice with rice paper or paper towels to see that each type of fold makes a different pattern.

 f. Using two identical blocks of wood or heavy plastic, fold fabric and place it between the wood, clamping it together tightly with a C-clamp.

 g. To make a spiral pattern, soak the cloth in washing soda, and while wet, pinch a small amount between thumb and forefinger, and twist, pleating to make a swirl. Tie to hold in place while it remains flat. To dye, use concentrated dye (3 to 4 tablespoons of dye per cup of water), and use a dispenser (such as a hair dye applicator) to make the design, going from the center to the outside, as if cutting a piece of pie.

3. After tying the cloth, place it in the dye. If it is to be worn, the cloth must be fixed, or the dye will fade.

4. Rinse the fabric after dyeing, but leave it tied until it has dried. The fiber-reactive cold-water dyes tend to bleed when they are only partially dry.

FURTHER SUGGESTIONS

1. Rice paper, paper towels, or similar paper can be folded into various shapes and dipped and dyed for very interesting patterns. Try accordion folds or triangular folds, dipping them into a succession of colors.

2. Combine tie-dye with batik by using wax to block out batik areas, and tying borders.

3. Make tie-dyed squares to use in patchwork for clothing or wall hangings.

SOFT SCULPTURE

FOR THE TEACHER

The art form of soft sculpture became popular in the 1960s when artists constructed sculpture of fabrics, vinyl, and stitched and stuffed forms. Claes Oldenburg created such sculptures as "Soft Giant Drum Set," "Soft Toilet," and "Telephone" of canvas, vinyl, kapok, and wood. Other artists, such as Clare Zeisler, created large sculptural forms by joining many yarn-wrapped strands together to be self-supporting. Although George Segal's ghostly figures made of plastic gauze were not soft to the touch, they reflected the breaking away from traditional sculptural materials.

Soft sculpture today continues these traditions, with artists creating artwork through interpretation of their own unique visions. Holly Hughes, an Arizona painter-photographer-weaver-sculptor, creates soft sculpture "from brocade and bottle caps." Her "Piano Player" demonstrates some of the variety of materials used in her sculptures, which are distinguished by their humor and imaginative use of materials (see photo at left.) The photo at right shows a detail from another artist's fond portrait of her grandmother.

To do soft sculpture with your classes all you need is a large bin of fabric and a collection of "trash," such as buttons, metal scraps, sewing trim, and so on. Although abstract designs could be created, students will probably have better luck if they try to interpret something realistic. Have them look through grocery, toy, appliance, and department stores for forms they could interpret in another material.

MATERIALS

Student Project 8.6: *Soft Sculpture*

Fabric of all sizes, kinds, and textures

Metal scrap: buttons, shotgun shells, old spoons

Needles and thread

Yarn

Safety Pins (to hold things in place until you sew them)

Scissors

Materials for stuffing: cotton batting, shredded foam, old hose, even lint from a dryer.

Photo 8–7 Holly Hughes, detail from "Piano Player." 8′ x 81″. Mixed media. Courtesy, the artist.

Photo 8–8 Judy Lehmer, detail from "Grandma Cochran." Life-size soft sculpture. Courtesy, the artist.

167

Student Project 8.6: SOFT SCULPTURE

DIRECTIONS

Choose some realistic item to make into soft sculpture. The artwork could hang on a wall or be free standing. The size of the original object is not important because you will either enlarge or reduce it.

1. Let yourself go when you are making a list of possible subjects for a soft-sculpture. You may wish to interpret something you have drawn or photographed. Go to various stores and see if there is something that it would be fun to try to make realistically. Do library research for an idea, or base your subject on a famous painting.

2. Make thumbnail sketches of your subject and decide how large it will be. If you have a general idea for a color scheme, it may help your search for materials. If you are working very large, you will need a wide variety of materials. Consider using *anything*.

3. Decide what portions of your design will be stuffed. Make patterns before cutting fabric to make sure things fit together. Attach them by sewing or gluing. Hold metal pieces that don't have holes by putting nylon net on top of them and sewing that down. There are no rights and wrongs, and you must use your imagination.

4. Finish the edges of a wall sculpture so it can be hung, using a thin board through the top and bottom to keep it straight. If a piece of sculpture is be free standing, it should be stuffed tightly enough to support itself. It may need a stick armature inside to keep it from sagging.

FURTHER SUGGESTIONS

1. Work with a group to make a large batik soft sculpture (such as a model of your school or car).

2. Two or three people could work together to make a large piece for a school wall, as long as they agree on a general concept.

Chapter 9: PRINTMAKING

OBJECTIVES

- To teach a variety of techniques used in printmaking
- To acquaint students with the history of printmaking
- To teach the application of the elements and principles of design in printmaking
- To encourage students to create designs or motifs that express personal interests
- To explain the visual differences between the techniques of relief, intaglio, planographic, and stencil printing

INTRODUCTION

Most students already have tried one or more methods of "printing." They may have made potato stamps, rubbings on a penny, or linocuts in earlier art classes. Spend a week or so drawing to give students some ideas to work with. Encourage them to build on prior artistic experiences or ideas.

To help students recognize varieties of printmaking, photocopy reproductions utilizing various printmaking techniques from books. Most prints are based on the engraved line or carved shape. Because first attempts in printing are likely to be in one color, value differences also need to be considered. A one-color print is an effective introduction to printmaking, as it reinforces the concept that most prints are approximately half white and half black.

Although it is tempting to teach students many printmaking methods, allow time for students to explore one method fully. Take time to talk with students about the print—about whether printing it differently could give a totally different image, or whether this print could be a starting point for another type of print. Prints aren't *sacred*. A student could improve a print by using a different method of printing on top of the first or applying colored pencils, paint, or ink on the print. Artists such as Andy Warhol sometimes hand-colored finished prints so there were many variations.

In addition to their primary artistic medium, many artists have chosen to express themselves through printmaking. Since the time of Rembrandt, many painters have been tempted to interpret their unique visions through printmaking. A few well-known printmakers are Francisco Goya, Rembrandt, Albrecht Dürer, Pablo Picasso, Robert Motherwell, Kathe Kollwitz, Jim Dine, and Robert Indiana.

A variety of methods of reproducing art are lumped into the word "printmaking." These methods of printing are all appropriate to the classroom:

1. *The intaglio print* may be made with a collagraph, drypoint, or etched metal plate.
2. *The relief print*, where the highlights are printed, is common in the classroom as students work with stamps, wood cuts, or linocuts.
3. *The planographic print* such as lithography can be taught through the paper lithography method.
4. *The monoprint* is also an old printmaking method that is currently enjoying a revival and that has no limitations except the artist's imagination.
5. *The stencil form* done through silk screening is also applicable to the classroom.

General printmaking instructions are at the end of this chapter.

BRAYER PRINTING

FOR THE TEACHER

Students may have already used a brayer to apply ink to a linocut. They may even have inadvertently made a brayer print while they were spreading ink evenly on the brayer. Let them explore making prints on large sheets of paper, using only the brayer as a printing tool. Even "unsuccessful" brayer prints could be cut or torn into collages or used as a background for a linoprint later. Many of these prints, in their simplicity, are wonderful works of art.

Conserve ink by having a different color of ink at each working table. If students share brayers and don't have to clean up when they go change colors, you may get more interesting effects for less money and mess than if they have to clean brayers and inking plates each time they change colors. Obviously at the end of a working session they all need to share equally in clean-up rather than only the part they think they used.

MATERIALS

Students Project 9.1: *Brayer Prints*

Inking plates: sheet glass, heavy plastic or aluminum cookie sheets

Newspaper

Paper: newsprint, drawing paper, and white or tan butcher or roll paper

Ink: water-based ink

Brayers: soft rubber; hard rubber rollers tend to warp and apply ink unevenly

Print dryers: drying rack or line with clothespins

Student Project 9.1: BRAYER PRINTING

DIRECTIONS

The only limitations in brayer printing are the width of the brayer and the amount of ink it can hold at one time. The variations caused when the brayer runs out of ink are an interesting result of this method. Don't throw prints away until you have had a time to think about them for a while. You may use "ruined" prints in collages later.

1. Squirt a 2 inch line of ink onto the inking surface (such as glass). Use the brayer to spread the ink around evenly. The ink should be thin enough to make a "tacky" sound when the brayer goes through it.

2. A variety of effects can be made with a brayer:

 a. Continuous line made until it runs out of ink

 b. Series of interrupted marks made by inking one side of the brayer

 c. Circular effects made by holding one end of the brayer in place while swirling the other end

 d. Small marks made by printing with the end of the brayer

 e. Plaid made by criss-crossing lines

 f. A pattern made by drawing on the inked brayer with a pencil to interrupt the ink line.

3. When you begin, experiment to see what different colors look like together and how you can vary lines. When interesting compositions occur, try not to lose the spontaneity by overworking. Learn to recognize when you have created a work of art by leaving some areas unprinted or by repeating patterns or colors.

4. You may find that although the entire composition is not perfect, a portion of it is interesting. Perhaps you should cut away parts of the composition that do not contribute to it. Place finished prints on a drying rack, and come back and analyze them later.

FURTHER SUGGESTIONS

1. Keep all the brayer prints and use some of them later as a basis for another form of printmaking such as linocuts or drawing.

2. Work in groups of six to print *huge* brayer prints on long sheets of roll paper 36 inches wide. Spread the roll paper in a hallway with newspaper underneath the edges, and allow each person to be responsible for one color. Remember to vary the types of marks you make. Discuss before you begin the effect that you are after. Stop from time to time and analyze it. Don't be afraid to speak up and give your opinion.

3. Use scissors or X-acto knife to cut out a few of the brayer lines that didn't quite work. Make a collage on another sheet of paper using these throw-aways. After cutting them, see if some of the negative shapes can also be used in your collage. Emphasize an area by adding charcoal, ink, marker, or an otherwise textured surface.

4. Color on top of the brayer prints with cray-pas.

5. Make a city-scape with the brayer, using sponges to print trees and 2 or 3 colors of cray-pas for details.

6. Cut corrugated cardboard into 1½ by 3 inch strips and use them for printing "line" into a brayer print by dipping them into ink on the printing plate and using them as stamps.

THE COLLAGRAPH

FOR THE TEACHER

Artists who worked in collage, such as Pablo Picasso, Georges Braque, Kurt Schwitters, Paul Klee, and American painter Arthur Dove, paved the way for printing from a collaged "plate." The word "collagraph" is a combination of the words "to glue" (French) and "graphic" (English). Collagraphs became popular in the 1950s when permanent acrylic glues came onto the market.

The collagraph is a good introductory process for secondary students because there are so many ways to make one. Being able to draw well is not a prerequisite for success. The resulting print can be totally abstract or realistic. Almost anything can be used to build up the plate. Collect materials in the art room, and announce well in advance that collages will be made so that students can bring in a wide variety of materials for selection.

Two approaches to making a collagraph will be given, one without a printing press and the other with a printing press. Exposing students to printmaking doesn't require an elaborate setup. Cardboard, string, glue, and tempera will make adequate prints.

The chief difference between a hand-printed and a press-printed collagraph is that the plate for the printing press needs to be considerably sturdier to withstand the pressure. Either plate can be printed many times, so experimentation is encouraged. There are almost no limits to the things that can be applied to a plate, but a plate for the printing press should be kept as thin as possible.

MATERIALS FOR A CARDBOARD COLLAGRAPH WITHOUT A PRESS

Student Project 9.2: *The Cardboard Collagraph*

Tagboard or posterboard: at least 9 by 12 inch plate

Scissors or X-acto knives

White glue

Water-based ink or tempera

Brayers

Varnish or shellac

Linseed oil (linseed should be used only to thin oil-based paints)

Variety of materials to add texture: cotton cloth, lace, needlepoint cloth, mylar, Mystic tape

Pickers: small squares of matboard folded in half to pick up clean paper when hands are dirty

Photo 9–1 Student collagraph. 14″ x 18″. This was printed in gray with only the figure printed in black.

MATERIALS FOR A COLLAGRAPH WITH A PRINTING PRESS

Student Project 9.3: *Collograph With a Printing Press*

Plate for print: untempered masonite $1/16$ to $1/4$ inch thick (beveled by sanding the edges), matboard, 6 ply posterboard, or thin litho plate (scraps obtained from a printer or newspaper)

Cloth: organza (when put on a surface, it holds the ink and gives a variety of values, depending on how many coats of polymer medium are added), corduroy, canvas, cotton cloth, taffeta, cheesecloth (or tarlatan)

Glue: thin white glue or polymer medium; may also be used to make texture and line

Gesso: can be used to attach materials or applied thickly to make textures

Modeling paste or marble dust: may be added to polymer medium to make texture and pattern

Needlepoint cloth, lace, rickrack, cording, almost any sewing trim

Flat materials: tissue paper, aluminum foil, tagboard, thick water color paper

Mylar: shiny metal-like plastic; can be used for a clean white surface as it wipes completely clean

Tapes of various kinds: masking tape, Mystic cloth tapes

Mat knife: for scoring masonite before breaking it

Old telephone books

Student Project 9.2: THE CARDBOARD COLLAGRAPH

DIRECTIONS

A collograph can depict a realistic form such as a person or an abstract arrangement of shape and line. Variety in texture is an important part of making a collagraph. Leave a portion undecorated, or cover with plastic, mylar, or aluminum foil.

1. Use posterboard as the base for your collagraph. The outside shape can be any configuration, such as a rectangle or square.

2. The cardboard, cloth, or other items that will be glued to the cardboard should be as thin as possible, yet varied enough to be interesting. If you use only cardboard to make your design, it will be relatively smooth. Other additions to the surface could be tapes of various kinds such as masking tape, mylar, or Mystic tape.

3. When the plate is completed, spray or paint it with shellac or varnish and allow it to dry completely before printing.

 a. Apply the ink or tempera with a brayer.

 b. Paint the ink on with a brush.

 c. "Card" on the ink, using a small piece of matboard as if it were a brush. To highlight some areas, use newsprint or a telephone page to wipe them clean. Keep the paper flat to avoid taking ink out of depressions.

5. Print by placing paper on top of the plate. Apply pressure to the back of the paper by using the back of a spoon, a baren, or your hand.

6. Experiment with printing by using more or less ink, wiping the plate, adding more than one color to the plate either with a brush, or using a rainbow roll.

7. When the prints are dry, sign and number your edition and mat your best two prints.

Student Project 9.3: COLLAGRAPH WITH A PRINTING PRESS

DIRECTIONS

1. Prepare the plate carefully to prevent the corners from coming up when it is printed. If the plate is thicker than $1/16$ inch, sand the edges at an angle to avoid cutting the blankets. Try to keep the plate as thin as possible. Many materials absorb too much paint and can dominate the composition (fill in holes with coats of polymer medium if necessary). Here are some considerations for preparing the plate:

 a. To glue something that normally resists glue, such as mylar or plastic, rough up the back of it first, or coat the back of slightly crumpled aluminum foil with gesso and let it dry before gluing down (it tends to flatten out in the printing).

 b. Organza holds the ink well and can be glued on the plate as a base. Different values can be obtained by coating it from two to ten times with polymer medium, allowing each coat to dry before applying the next. You could block out areas with tape to make designs.

 c. Use a mat or X-acto knife to (carefully!) cut through layers of matboard or masonite. A rough layer will hold the ink and give variety to the surface.

 d. Make a design using only a variety of tapes. Mylar tape wipes completely clean, while cloth or masking tapes hold ink differently.

 e. Cloth glued to the background could be heavily coated with polymer medium to prevent it from soaking up too much ink as you print.

 f. Gesso can be used as a glue or to make designs. If you press materials such as plant life or coins into it when it is wet, it will retain the shape when it dries. It also can be drawn into.

 g. Cardboard of various weights and textures can be cut to any shape you desire. Corrugated cardboard, with its ridges, can be very effective.

2. When everything is well glued down and the edges are smooth, apply an ink-resistant finish such as acrylic spray, shellac, or varnish on the front and sides. If using a matboard plate, varnish the back also, so it can be easily cleaned without disintegrating.

3. To print in the intaglio (pronounced intallyo) method, dampen the printing paper. When the plate is dry, apply ink by "carding," daubing, or painting it on. To make sure it is in all the crevices, make a tennis ball-sized wad of tarlatan and wipe the ink into the plate in a figure-eight motion.

4. Wipe the plate by using a page from the telephone book (keep it flat). To leave some areas completely white, wipe with the side of your hand.

5. Place the plate on the bed of the press on top of a sheet of newsprint. Put the textured side of the printing paper next to the plate, and place a sheet or newsprint on top of that. Place the blankets carefully, and run the plate through in an even motion. If the plate is not as dark as you would like, leave the paper in place under the roller, increase the pressure, and run the plate back through.

6. Remove the paper and dry it flat. If you are printing an edition, simply repeat the process again. To experiment with color, follow general directions at the end of chapter.

7. When the prints are dry, sign them (again, see general directions) and mat at least two.

175

FURTHER SUGGESTIONS

1. Make an embossing of your collagraph before applying any ink to it by wetting paper and running it through the press on top of the plate. If you wish, ink and wipe one or two small areas and emboss the rest of the print.

2. If your plate has sufficient texture, make a paper casting of it.

3. Mount the plate and exhibit it next to the print. Sometimes the plates become more interesting after the ink builds up from printing.

4. Make combination prints by cutting holes and inserting etching plates or linocuts directly into the opening (easy in matboard) or by printing on top of the finished collagraph with another form of print such as a woodcut or linocut.

THE PAINTED MONOPRINT

FOR THE TEACHER

The monoprint (or monotype) may be made with or without a printing press. This one-of-a-kind print can be made through a variety of methods. Inking a collagraph differently each time it is printed creates monoprints. A brayer print is unique and therefore considered a monoprint.

Some monoprints are paintings made on a hard surface such as metal or glass, printed by pressing paper on top of it. This type of monoprint differs from other techniques in that there seldom are pronounced lines or contours and no grainy textures. It is a combination of drawing, painting, and printmaking. Its very nature encourages spontaneity and recognition of the "happy accident."

The monotype was first invented by Giovanni Benedetto Castiglione of Genoa in 1640. Edgar Degas rediscovered it and made 400 monotypes between 1874 and 1893. Twentieth century artists such as Maurice Prendergast, Mary Cassatt, Camille Pisarro, Henri Matisse, Marc Chagall, Pablo Picasso, John Sloan, Milton Avery, Mark Tobey, Naum Gabo, and Morris Graves have used this technique.

Unlike linocuts or etchings, the surface of the hard plate does not physically change, allowing the plate to be used over and over with totally different designs. The usual medium for monoprinting is oil paint (which allows for infinite changes, as it dries so slowly). For classroom use, tempera mixed with vaseline can give much the same effect. Printing ink may be used, but the print must be pulled before it dries.

Students should first do a drawing, then place the glass or plastic plate on top of the drawing, taping them at the top. The design is then printed directly onto the plate. Each print will give different results, and changes may be made by adding a color, misting the surface with water, or sprinkling drops of mineral spirits on the surface.

MATERIALS

Student Project 9.4: *The Monoprint*

Plate: glass or clear plastic (plexiglass)

Paint: oil paint, or tempera mixed with vaseline; tempera can also be combined with media-mixer; water-based ink works well on plexiglass

Brushes: various sizes

Paper: white drawing paper or colored construction paper

Solvent: if needed for cleaning up after oil paints—kerosene, mineral spirits (avoid contact or fumes)

Cotton swabs

Markers

Paper towels

Spray bottle with water

Mineral spirits

Colored drawing pencils (optional)

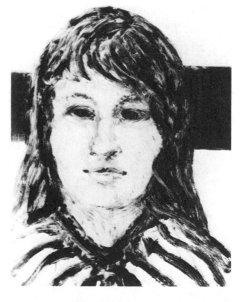

Photo 9–2 Annette Ellis, "Striped." 15″ x 19″. Monoprint made on clear plastic with etching ink. Courtesy, the artist.

177

Student Project 9.4: THE MONOPRINT

DIRECTIONS

The monoprint will be different each time you print it, even if you use the same design several times. Remember, the design will print backwards.

1. Draw a design on paper the same size as the clear plate. Tape the plate and drawing together, and use oil paint or tempera mixed with vaseline to paint your design onto the plate. Apply the paint thickly. Although certainly brushstrokes will vary, a stippling method (loading the brush and dabbing it on) of applying paint is effective.

2. While the paint is still wet, place a piece of paper on it, and rub the back of the paper with your hand or a baren. Analyze the print and decide what might improve it. After it is dry you may draw on it with colored pencils or pastels.

3. Some alternate methods are:

 a. Use your fingertips, palms, or sides of hands as your working tools.

 b. Mist water over the image. If it is a water-based medium, it will make a considerably "looser" image.

 c. If using a water-based medium, add drops of mineral spirits to the painting. The interaction of the solvent with watercolor will cause a marbled effect. Add more than one color and add more mineral spirits. Use a cotton swab or paper towel to create "holes" in the print.

 d. Place the paper on top of the painted glass, then bring the paint onto the paper by rubbing the back of the paper with a fingertip or cross hatching with a pencil to make value differences. Make as complete a drawing as possible in a short time to adequately fill the paper.

4. When the print is dry, sign and mat it.

FURTHER SUGGESTIONS

1. Reserve several "prints," and make a linocut of the same drawing that was used for the monoprint. Print the linocut on top of the monoprint.

2. Fingerpaint a monoprint with tempera and media mixer.

3. Make a monoprint and draw into it with marker to introduce a linear quality.

RELIEF PRINTING

FOR THE TEACHER

Relief printing is the oldest and most traditional of all printmaking processes. Woodcutting as an art form originated in Germany and became widely disseminated when woodcutters realized that the same printing press that was invented for movable type could also be used for printing woodcuts.

Albrecht Dürer was the first artist to do significant woodcuts, most of which were of religious or moralistic subjects. Expressionists such as Edvard Munch, Emil Nolde, Ernst Kirchner, and Emile Gauguin exploited the grain of the wood. In Japan the Ukiyo-E print (the pageant of passing life), so popular in the seventeenth century, was based on popular figures of the time such as theatrical artists and warriors.

The best-known modern form of relief printing is the linocut, which evolved some time after the woodcut became popular in Europe and the East. Because of its smooth texture, linoleum does not have the innately interesting character of wood, but it allows the artist great freedom of expression. Pablo Picasso was one of the most famous practitioners of linoleum cutting and often made reduction prints (discussed in this chapter).

Wood and linoleum are the major materials used for relief printing, but any material that is hard enough to be inked can be printed. Metal will accept ink very well and can be combined with other materials for relief prints.

Students must be taught safe procedures for using sharp cutting tools. Their hands must be held behind the cutting tool so *when* it slips (and it will!), their hand is not cut. Keep a supply of bandages on hand, and tell them what to do if they do cut themselves (apply pressure with a paper towel until bleeding stops, clean, see nurse). Bench hooks will aid greatly in preventing cuts.

Introduce students to linoleum printing by doing a small one-color print. Students can learn to ink properly, do chine collé, and mix ink colors (make it a "given" that color may not be used straight from the tube without mixing). If they make enough prints, encourage them to draw on them with colored chalks or tear them up for collage. They could also do multiple printings from the plate on one large piece of paper.

The reduction print (or "lost block," as the English call it) allows printing in multiple colors with the same block. It does not vary significantly from normal linocutting except that when the student is finished, the surface of the block has been cut away.

Challenge students to avoid ordinary subject matter such as symbols for musical groups or their own initials. Expand their visual literacy by showing them Japanese woodcuts and modern prints. Encourage them to work with simplified shapes and interesting subjects. Although they should not copy existing artwork (and photographs *are* artwork), sometimes they can get ideas from looking through magazines such as *National Geographic*. Explain the difference between research and using someone else's original composition.

Students could make embossments with their linocuts by running the uninked plate through a press with dampened paper on top.

MATERIALS NEEDED

Student Project 9.5: *The Reduction Linocut*

Battleship linoleum (8 to 12 inches square preferred)

Water-based printing ink

Brayers

Linoleum cutting tools: V-gouge, U-gouge, knife, chisel

Glass or plexiglass for rolling out

Drawing paper

Photo 9–3 Student linocut. This lion was printed on a large grocery bag.

Photo 9–4 Printing equipment for linocuts: (a) brayers, (b) bench hook, (c) baren, (d) cutting tools, (e) plate (wood or linoleum).

Student Project 9.5: THE REDUCTION LINOCUT

DIRECTIONS

The reduction print needs to be planned carefully. The background will be the lightest color. Each time you remove portions of the linoleum, you will print in a new, darker color. Begin with at least 10 to 12 prints, as you usually "lose" one each time you add a new color. Do not worry too much about realistic colors, but do try to use at least four different colors. Your first color could be made from the uncut block.

Register the block each time you print by visually lining the block onto the paper, flipping over the block and paper, and burnishing the back of the paper. Don't throw away any disasters; often these have a charm of their own, or at least can be drawn on or used in a collage.

1. Make a number of thumbnail sketches in proportion to the printing plate. Choose one, and make a design with pencil on tracing paper the exact size of the linoleum block. Transfer the design by placing the tracing paper face down on the plate and drawing on the back of it (remember it will print backward).

2. The first reduction will not be extensive. Cut away the outlines of most things in the picture; decide what things will be left white, and cut away those areas entirely. Remember that each time you add a new color, you are covering up the underneath color.

3. Cut away more of the plate and print in a second color. The most effective prints repeat colors in more than one area. Continue to cut away and print in successive colors.

4. Mat and sign the print as discussed previously. If each print is different, you may prefer to put AP in the middle (artist's proof).

FURTHER SUGGESTIONS

1. Print two prints at each state of the reduction print on separate pieces of paper. Mount each set together.

2. Use the same techniques as in linocutting to do a woodcut on ¼ inch plywood or a section of plank. The grain in wood could become an integral part of the design, as in the works of Edvard Munch.

INTAGLIO PRINTMAKING—DRYPOINT

FOR THE TEACHER

Intaglio printing is the opposite of relief printing in that the incised lines below the surface of the plate hold the ink while the *surface* is wiped clean. Intaglio printmaking is done on a printing press because of the pressure needed to force dampened paper into the incised lines. Because of the intense pressure, the plate is usually made of heavy plastic or metal.

Decorative engraving and illustration were originally done by hand, with practitioners laboriously carving lines into metal. Around 1500, an armor decorator accidently discovered the process of etching into a metal plate. In the seventeenth century Rembrandt created wonderful prints that demonstrate his command of chiaroscuro, the lively contrasts of dark and light. Spaniard Francisco Goya was another major painter who became equally famous as a printmaker. His aquatints are rich and velvety.

Drypoint is a good introduction to the intaglio process of inking and printing with a press. The drypoint technique of scratching a design into a plate forms burrs that hold the ink, giving a fuzzy look to the lines.

Drypoint may be done on thick acetate or on $1/4$ inch thick sheet plastic. For best results, have the students spend at least a week making a number of different drawings to choose from. To do the drypoint, have them tape the plastic plate on top of the drawing and scratch the design in the plastic with a sharp tool.

Before beginning the print, have the etching paper ready, leaving at least a 2 inch border all the way around the plate. Immerse the paper in water to remove the sizing (the time varies with the type of paper); when it is thoroughly soaked, place it between blotters and press (or roll with a rolling pin) to remove excess water. If the paper is properly prepared, no shiny spots can be seen. Refer to information at the end of the chapter before beginning to print.

MATERIALS

Student Project 9.6: *Intaglio Printing-Drypoint*

Plastic plate, 5 by 7 by $1/4$ inches or heavy acetate (any size or shape), or old x-ray plates work well. (Remove the emulsion from x-rays in a solution of household bleach and water.)

Thinner for etching ink: "Easy Wipe compound" is recommended, available from etching suppliers

Oil-based ink: black, brown or sepia, reddish brown—any color

Tarlatan

Paper towels or telephone book pages

Printing press (or an old-fashioned wringer)

Etching paper

Tray to soak etching paper (such as kitty-litter trays or wallpaper trays)

Blotters

"Cards" ($1^{1}/_{2}$ by 3 inch pieces of matboard for applying ink)

Newsprint

Mineral spirits or kerosene (always stored in metal cans)

Cotton Gloves: for holding the plate while applying ink and wiping

Photo 9–5 The etching press. To print, place items on the etching press bed in this order: 1) newsprint, 2) plate, face up, 3) printing paper, 4) newsprint, 5) sizing catcher, 6) hard blanket, 7) soft blanket.

Student Project 9.6: INTAGLIO PRINTING— DRYPOINT

DIRECTIONS

1. Prepare the plate by beveling the edges to a 45-degree angle to prevent tearing the paper or the blanket.

2. Choose a detailed drawing to make the print more interesting. Place the plastic plate on top of the drawing and tape it to hold it in place. Cross-hatch with the etching needle to show differences in value.

3. Before printing, place a clean plate of the same thickness on the etching press and run it through once or twice to check the pressure of the press.

4. Thin the oil-based ink with Easy Wipe or stand oil. Use a spatula or card to mix the ink. Card the ink onto the plate. To work the ink into the incised lines, make a figure-eight motion with a generous wad of tarlatan flattened on one side.

5. Use a *flat* paper towel or telephone book page to remove the ink from the plate's surface; crumpled paper removes ink from the crevices as well. Be sure to wipe the plate's edges.

6. Place the plate inked side up on a piece of newsprint on the bed of the press. Put the dampened etching paper on top, and newsprint on top of that. Sizing catcher and blankets go on top. Run the plate through the press. You may make a "ghost" image on a second piece of paper without re–inking, but freshly inking the plate for each print is preferable.

7. Remove the plate and release the pressure on the press. At the end of the printing session, use mineral spirits or kerosene to clean the surface and back of the plate. Store the plate between two sheets of newsprint.

8. Sign and mat at least two prints. Number all the prints.

INTAGLIO PRINTING ON A METAL PLATE

FOR THE TEACHER

The difference between this medium and drypoint is that lines are needled rather than scratched into the surface of the plate. The use of acid deepens the lines. It is rare for a plate to be ready to print after one time in the acid bath. Making trial proofs and re-etching is usually necessary to make the plate interesting.

Although copper was the traditional etching medium because of the ability to get fine detail, zinc plates are adequate and less expensive. The plates may be purchased to size or cut with a bandsaw or hacksaw. School industrial arts departments often have a machine that can easily chop metal plates. The students must bevel the edges of the plate to a 45-degree angle with a file or scraper to avoid cutting the etching paper and the blankets.

SAFETY NOTE: *Supervise all cutting and have students wear goggles and masks to avoid problems from flying particles. Although etching a metal plate is done with acid, following proper safety procedures almost eliminates danger. The diluted acid is quite weak, and if students are cautioned to wash it off if they accidentally get any on themselves, there will be no harm. When mixing the acid, remember to pour the acid into the water (I always remember this by thinking of* A and W *root beer). Keep it in photographic or glass trays, covered when not in use. When diluting the acid, always wear safety goggles.*

When using solvents to clean up, mineral spirits are recommended for ink and etching grounds. Stop out varnish must be removed with alcohol. Work in a well-ventilated area or, if necessary, send students outside to clean plates.

MATERIALS

Student Project 9.7: *Etching a Metal Plate*

Etching plates: zinc, 2 by 3 inch or 4 by 6 inch (may be purchased with back already covered with an acid-resistant material)

Nitric acid: use one part acid to eight parts water

Photographic or glass trays to hold acid

Etching paper

Liquid universal etching ground, soft ground, or hard ground

Spray enamel

Miscellaneous materials for soft ground: plant life, net, rubber gloves, tarlatan

Mineral spirits or kerosene: will remove ink and universal ground

Alcohol: will remove stop-out varnish

Stop-out varnish: purchase, or make by mixing equal parts of powdered resin to isopropyl alcohol

Tray for soaking paper

Etching paper

Scraper

Burnisher

Paper towels or telephone book pages

Scouring powder such as Bon-Ami

Hot plate

Brayer

Photo 9–6 Student etching. 3½″ x 5″. Needled hard ground, with the darker areas made in aquatint. Florissant High School.

Student Project 9.7: ETCHING A METAL PLATE

DIRECTIONS

1. On a piece of tracing paper draw around the outside of the printing plate and draw your design on the paper. Your design will be transferred to the plate after it is prepared.

2. After beveling the edges of the plate and rounding the corners, use cleansing powder, paper towels, and water to scour the plate. If the plate is totally clean, the water will form a solid sheet when it is run on the plate. If it "crawls" from the edges, then oil is still on the plate. Clean those areas again.

3. Apply universal etching ground to the plate, following directions on the can. This liquid is relatively trouble-free and allows you to scratch (needle) gently through the ground to allow the acid to reach the plate.

4. Transfer the design to the plate. Vary the width of the lines by using etching tools with different points. Tools may be a nail, a needle stuck into a cork, or even a pencil point. To create dark tones, needle lines closely together or do cross hatching.

5. Everything that is not covered with a resistant material will be etched. Cover accidental scratches and exposed edges with stop-out varnish.

6. Gently slide the plate into the acid bath, image side up. Watch for bubbles to form on the edges of the etched line, which show that the acid is working. Brush away bubbles with a feather or brush. If you have used soft ground, be careful not to touch the plate with the brush, as it will mar the delicate surface. Generally the plate should stay in the acid a minimum of ten minutes, depending on how fast the acid is working. The longer the plate is in the acid, the deeper the "bite."

SAFETY NOTE: *Wear gloves to put the plate in or take the plate out. Avoid getting acid on hands and clothing. This weak solution will not damage the skin if it is washed off quickly, but it can damage clothing.*

7. Rinse the plate in water and dry it. The etching ground must be removed before you can ink the plate. Use a toothbrush and mineral spirits to clean the plate.

8. Put approximately 1 tablespoon of ink on a piece of glass and combine it with a thinner such as Easy Wipe. Apply the ink to the plate with the end of a 1 inch-wide piece of cardboard. Use tarlatan in a figure-eight motion to fill the etched lines with ink.

9. When finished, use a flat paper towel or telephone page to wipe excess ink from the surface while leaving it in the etched lines. The wipe of the plate can give character to a print. You do not want to wipe ink off the surface of the plate entirely, but leave traces of the ink. Use the edge of the palm to wipe the ink from places where you want a bright white.

10. Before printing, place a clean plate of the same thickness on the etching press and run it through once or twice to check the pressure of the press. The print is the first "state." Look at it carefully, trying changes with tracing paper or directly on the proof before making changes on the plate.

11. Other methods of etching could be combined with the hard ground method. The plate may be totally covered with a different type of ground, such as soft ground or aquatint, to achieve textural effects of velvety grays and blacks.

12. Although major changes are not recommended, the scraper and burnisher may be used to alter the surface. The burnisher can be used to polish an aquatint surface so it does not print as darkly as the unpolished surface would.

AQUATINT: To achieve different values of black to white, cover the plate evenly with minute dots. This traditionally was done with powdered resin on a heated plate, but modern printers often use spray paint. Lay the plate on a newspaper and spray the paint can back and forth in an even motion, beginning and ending beyond the plate so it does not become thicker on the edges. Allow the paint to dry. Use stop-out varnish to block out the edges and areas that are to remain totally white. Immerse the plate in acid for only one minute or so for a very light value. Stop out the area to remain light. Continue stopping out and biting areas until all the desired values have been achieved. For totally black areas, carefully stop out everything that is not to be black, and leave it in the acid longer. Tickle the plate often to eliminate bubbles. You don't need to clean the plate until you are completely finished with the etching, but you may want to clean the plate and make a proof about midway through the process to see how things are going.

SOFT GROUND: Rub a ball of soft ground over a heated plate, then even it out with a brayer. When the plate has cooled, almost any texture impressed into the soft ground will etch. Some of the most successful textures are net, fingerprints with rubber gloves, plants, lace, and of course drawing with a pencil. A plywood bridge can support your hand above the plate while drawing on soft ground. The plate is sensitive to anything, and care must be taken to apply stop-out to any area that you do not want to etch. When the plate is put in the acid bath, look carefully for bubbles coming from areas not to be etched. If necessary, remove the plate from the bath and apply stop-out varnish to those areas.

HARD GROUND: is applied and used in the same manner, but is not as sensitive to a variety of materials as soft ground. It may be used in place of universal liquid etching ground.

DEEP ETCH: Deep etch is used to make differences in depth in large areas. These broadly etched areas do not hold ink well, but edges that are created by these different depths hold ink and create strong, dramatic lines. Use universal etching ground or stop-out to protect any areas that you do not wish to have deep-etched.

nter for Applied Research in Education, Inc.

SILK SCREEN PRINTING (SERIGRAPHY)

FOR THE TEACHER

Silk screen is a form of stenciling, using silk (or nylon) that has been stretched over a wooden frame. A stencil is applied to the screen by a variety of means, such as cut or torn newsprint, stencil film, or a photographic process, Ink is forced through the silk with a squeegee, leaving a thin layer of ink on paper or cloth.

Although the serigraphy (silk screen) method originated in England in 1907, a group of New York artists popularized the technique in the 1930s and 40s. The modern T-shirt has familiarized students with the silk screen process. Some well-known serigraphers are Andy Warhol, Victor Vasarely, and Robert Indiana.

If you have never done silk screen, I recommend using torn or cut paper stencils before teaching more complex techniques. Printing silk screen is a matter of remembering which ink and solvent to use to allow the blockout (stencil) to remain in the screen. If you use a water-soluble film, you must print with oil-based inks, and if you use a solvent-adhered film, you may print with water-soluble inks.

Although there is an initial investment for materials and ink, screens may be used indefinitely if they are well cleaned. The screens may be purchased completely assembled, or formed from small box lids with silk or organdy stretched over an opening cut in the flat part of the lid.

After years of teaching students to do screen printing, I have learned some shortcuts for classroom work. Elaborate equipment and major preparations are not necessary for printing in school. The idea is to get the image onto the screen, print it as many times as desired, and clean the screen so the next student can use it. Awarding an extra 30 points for a clean screen is a marvelous incentive for students to do it right.

STENCILS

A. *PAPER BLOCKOUT:* either water-based or oil-based ink may be used. To make a plain background, cut a square or irregular shape in newsprint. Tape this to the underside of the frame on two sides. The first time the ink is squeegeed through the silk, the ink will hold the paper onto the frame. For classroom work newsprint stencils are adequate for all but very detailed designs.

B. *STENCIL FILM:* may be soluble in water or adhering solvent: use the ink that will *not* dissolve the blockout. These films are adhered to a waxed backing that allows you to use an X-acto knife to cut fine details with sharp edges. Put the stencil under the screen, adhere it to the screen with a special solution, then peel off the backing. These films may be used with water-based inks. When using adhering solvents, do it in the open air or well ventilated rooms.

C. *WATER SOLUBLE BLOCKOUT:* Le Page's glue or blockout must be used with oil based ink. This simple water-based material may be used to brush on designs.

D. *TUSCHE:* A painterly effect may be accomplished with a greasy substance called "tusche." Apply it with a brush and allow it to dry. Then card water-based glue on and allow it to dry. Remove the tusche with solvent, leaving openings through which the oil-based ink is screened.

MATERIALS

Student Project 9.8: *Silk Screen Printing*

Matboard cut into 2-inch widths for scooping out ink and cleaning the screen

Solvent-resistant tape: 2 inches wide, used on inside screen and inside of the frame

Silk screen frames: baseboards or hinges aren't necessary for classroom use

Multifilament polyester screen fabric (other fabrics that could be used are nylon organdy or silk)

Masking tape

Staple gun and staples

Silk screen glue or water-soluble blockout

Drawing paper or colored fadeless paper (to give a two-color print the easy way)

Silk screen paints: special textile screen print ink is available

Student work. Photo silk screen. 8″ x 10″.

Student Project 9.8: SILK SCREEN PRINTING

DIRECTIONS

1. Make thumbnail sketches in proportion to the screen. Choose the one you like best and make a paper stencil, cut stencil film, or use a screen block-out such as LePage's glue.

2. Transfer your design to the screen and select an ink color.

3. Line up your paper evenly with the corner of the table so it is straight, then lay the screen on top of the paper. Hold the screen firmly in place and pull the squeegee. This avoids the problem of print registration, although registration may be necessary for two or more colors. It is useful to have a partner to take away the printed paper and place down a new sheet.

4. Apply the ink by spreading a generous amount at one end of the screen. Then pull the squeegee the length of the screen, forcing a small amount of ink through the screen onto the paper. For best results, pull the squeegee twice. Work quickly, or the ink will dry in the screen. If it does dry, squeegeeing ink back and forth over the area sometimes opens the screen mesh. If a "leak" of ink occurs when you don't want it, lift the screen and have a partner put a piece of masking tape or paper over the bottom on that portion of the screen. Make a minimum of ten prints. The actual printing is so easy that you might as well make enough to trade with friends or give to family and teachers (or even sell).

5. Put the clean prints somewhere to dry for a few hours before stacking them together.

6. It is possible to change colors midway through inking by using a card to scrape off the first color, then adding the next color. You may even like the streaks you get until the second color has permeated the screen.

7. When the edition is finished, clean the screen carefully so the next person can use it. The screen is clean if, after it has been dried, you hold it to the light and none of the mesh is blocked. The silk stains and the color of many images will be left on the screen.

WATER-BASED INKS: place the screen under running water. A solvent-based stencil must be removed with a solvent such as lacquer thinner or the adhering liquid.

OIL-BASED INKS: Place a pad of newspaper under the screen. Remove any paper stencil that is on the bottom. Put another open sheet of newspaper next to the table to throw away used paper towels. Use a small card to scrape excess ink from the inside of the screen and the squeegee, and put the excess ink back into the can. Pour approximately ¼ cup of mineral spirits onto the screen. Use a paper towel to first wipe the squeegee, then to spread around the spirits on the screen. Push ink through to the newspaper underneath. Take away that first layer of newspaper, and continue scrubbing with the towel. Add more spirits if necessary, and keep changing the newspaper until no more ink comes onto it. Remove a photo stencil with warm water and a brush. If the screen is still clogged, take it outside and clean with lacquer thinner and a brush (this is only as a last resort).

8. Sign the edition and mat at least two of the prints.

FURTHER SUGGESTIONS:

1. Print a T-shirt by first washing it well in hot water to remove sizing. Place a thick pad of newspaper covered with newsprint or wax paper inside the T-shirt to prevent the design from going through to the back of the shirt. Use textile ink or acrylic paint. Squeegee several times to make sure enough

ink will penetrate the cloth. Allow the shirt to dry. Iron between two sheets of newsprint to "set" the design. This can also be done with photo silk screen.

2. Do a two-color print by making a stencil similar to the first, but with less detail. Registration is important and may best be accomplished by screening onto a clear piece of plastic and lining the original prints up exactly. "Printing guides" that fit onto the bottom of each print and onto pins put on the board may be purchased from graphic suppliers and will help with registration.

Student Notes 9.1: GENERAL DIRECTIONS ABOUT PRINTING

KEEPING PAPER CLEAN

When you are printing, take care to keep your printing paper clean. Pickers (small, folded pieces of cardboard) allow you to handle the paper by the corners even if your hands are dirty. Another option is to have partners print together, one with clean hands, one with dirty hands. The clean-handed person is in charge of bringing in clean paper and remove prints and placing them where they will be dried. It is also a good idea to apply ink at one table and print at another table.

INKING THE PLATE

RELIEF INKING: inking the surface of the plate with a brayer

INTAGLIO INKING: covering the entire surface with ink using a dauber, or brush, and forcing the ink into crevices with a wad of tarlatan

COMBINATION INKING: inking the plate and wiping it (the intaglio wipe), then relief (surface) inking in a different color

COLOR PRINTING:

 a. Cut a plate apart and ink portions separately, or apply color by hand and wipe to blend it. A la poupeé (with the "dolly") inking can be done in small areas.

 b. *Rainbow roll*: 2 or 3 separate colors can be put on the inking glass, and the brayer rolled through them, then the multi-colored brayer is rolled on a plate.

 c. *Viscosity printing*: (done only with oil-based inks); thick color can be applied to the plate and wiped off, leaving color in the recessed areas. Color thinned with "plate" or "stand" oil is applied to the surface with a roller. As many as three layers of ink can be applied by varying the viscosity of the ink and by alternating "dry" ink with "runny" ink.

 d. *Chine collé*: literally, "Chinese paper-tearing;" fadeless colored paper or rice paper is backed with a thin coat of library paste and placed with the colored side next to the inked plate. When the printing paper is placed on top of that and run through the press, the paper is glued to the printing paper, with the image printed on top of the color.

 e. *Blended wipe*: Colors are applied separately, then carefully blended with cheesecloth wipe.

REGISTRATION: Printing in exactly the same place on a sheet of paper is not necessary for a one-color print. However, it may be desired for silk screen, linocuts, woodcuts, or collagraphs. Make 1 by 2 inch rectangles of matboard. Place a sheet of paper on a table or board and tape three of these rectangles in line with the paper's edge, one on each side of the lower left corner, and one at the upper left side. By always putting a new sheet of paper in line with these, once you have lined up the plate again you will be able to print in the same place. It is sometimes useful to print on a transparent piece of plastic, placing the paper under it to determine registration for a second color.

WIPING THE PLATE: If a highlight is desired, wipe the plate with a piece of newsprint (old telephone pages are wonderful for this). For intaglio printing or collagraph printing, how the plate is wiped is very important.

DAMPENING ETCHING PAPER: For intaglio printing, damp paper is necessary. An inexpensive American proofing paper is adequate for classroom work. Watercolor paper may also be used. Tear the paper to a size that will allow at least a 3-inch border, then place it into a tray of water to soak (roll the paper into a loose tube if you do not have a large enough tray for it to lay flat). Some fine papers need to soak as long as an hour. Most inexpensive papers take only a minute or two. Remove the paper from the water and put it between two blotters. Use a rolling pin to roll on the outside of a blotter to remove all moisture. The paper should not have any shiny spots (which indicates wetness). Collagraphic printing can be done with wet or dry paper but is more effective with dampened paper. Many sheets may be prepared in advance by alternating wet and dry sheets of paper and placing them inside a plastic bag to moisten overnight.

PRINTING

WITHOUT A PRESS: Place the paper on top of the plate and apply pressure. Use a Japanese "baren" (a smooth flat round surface of 3 to 4 inches) or the back of a wooden spoon to rub on the back of the paper. Or place a second piece of paper on top of the first (to protect the back from dirt) and rub with your hand. Another method is to place the plate and paper on the floor with a piece of plywood on top. Apply pressure by standing on the plywood.

WITH A PRESS:

a. Place a piece of newsprint on the bed of the press before putting the plate on top of it, face up.

b. The blankets from the press should be put on in this order (from the plate): (1) sizing catcher (2) the softest blanket (3) the pusher. These blankets force the wet paper into the crevices of an inked plate. Test the pressure of the press by running an uninked plate of the same thickness as the one to be printed. You should be able to "feel" when the plate goes under the roller, or it will not force the paper into the deepest grooves.

c. Place a piece of printing paper on top of the plate. For intaglio printing, use dampened paper. Put a sheet of newsprint on top of the printing paper, then lay the blankets smoothly in place. When using a long sheet of printing paper, it is possible to run it through the press and let it stay in place for a peek to see if it is necessary to run the plate back through the press a second time.

DRYING THE PRINT:

a. Dry paper: Simply place the papers on a drying rack or hang them from a line with clothspins.

b. Wet paper: The paper tends to buckle as it dries, but can be flattened later by placement under weights. Or, staple the edges to a piece of wallboard with the staples several inches apart, or tape it with brown tape onto a piece of masonite.

SIGNING THE PRINT: You're teaching a lifelong appreciation for original art when you explain what the penciled numbers and letters mean in a print signed by the artist. Insist the students sign all their prints in an edition. There is always a number or "AP" for artist's proof, title, and signature. Signing prints is a relatively modern innovation, as printmaking has become more commercial.

a. The artist's signature is always in the right hand corner directly under the print.

b. A number is either in the left-hand side or in the center. A number with a slash following it indicates the number of that particular print and the number of prints in the edition: for example, 1/25 means that it is the first print of 25. A number of 50/250 says that the edition was 250 and the print is the fiftieth. Traditionally the seventh print of an *etching* was desirable because it was felt the plate was

sufficiently inked in at that time. A late print in the edition of a drypoint was not desirable because the burrs formed by drypoint would have been broken down.

c. The title is either on the left-hand side or in the middle.

d. It is not necessary to actually print an entire edition at once, as long as the numbering system allows for the eventual number of the edition and you are able to repeat the standard print from the edition when you do it later. Some unscrupulous artists say they have a totally new edition when the paper used for a second printing of an edition is different from that for the first.

MATTING THE PRINT

The edges of a print normally show when the print is matted, with approximately a $\frac{1}{4}$ inch space between the edge of the print and the mat on the sides, and room for the signature at the bottom. The print is properly matted with a hinged mat on a board so the mat can be lifted and the edges of the print examined. See figure for proper "hanging" of a print on the mat.

A properly hung print is suspended with special acid-free tape on matboard, underneath a mat. One should be able to lift the mat to check for clean edges on the print.

Chapter 10: PHOTOGRAPHY

- To teach photographic composition using the elements and principles of design
- To explain the basic parts of the camera, and how each control affects the appearance of the photograph
- To help students reach an understanding of film developing, processing, and presentation
- To discuss the history of photography and introduce work by major photographers
- To introduce non-darkroom activities that do not require a camera

INTRODUCTION

Students love photography! It is immediate and somehow seems more personal to them than some other art forms. They have grown up looking at photographs and taking snapshots, and they want to learn more about it. The first few processes in this chapter do not require an enlarger or a camera, but introduce the student to the art of exposing and developing photo-sensitive paper. Many of these activities stand alone as art projects, and are also ideal introductory projects in a photography course.

The history of photography is interesting to students. Many of them have old family photographs and cameras and will enjoy learning about them. Have an "old camera day," when students bring in family photographs and old cameras. Encourage them to bring the oldest photos and cameras they can find, but accept their own baby photos. At least they have looked through their family albums and talked about photography with parents and grandparents. This is also a good opportunity for them to reproduce the old family photos. Compare old cameras with a new Single Lens Reflex (SLR) camera and show them similarities and differences.

When talking about composition, show them slides and reproductions of photography. Subscribe to photography magazines such as *Darkroom Photography, American Photographer, Modern Photographer* or *Popular Photography*. Many "slick" magazines are illustrated by wonderful photographers. Students may have old *Sierra* and *Audubon* calendars they would be willing to bring in. Have books for students to browse through on great photographers such as Ansel Adams, Bernice Abbott, Edward Weston, Jerry Uelsman, Edward Steichen, Alfred Stieglitz, Julia Margaret Cameron, Matthew Brady, André Kertesz, Manuel Bravo, and many, many others. Your school library may be willing to buy such books as the U.N. *Family of Man* (and *Women* and *Children*) series and *Joy of Photography*. Encourage students to visit museums and photography exhibits.

A required notebook with examples from magazines or personal albums forces students to look critically at photographs. If you request such examples as stop action, rhythm, and abstraction, students begin looking critically at their own photographs.

Use a variety of methods to teach technical information. Show tapes, slides and film strips that deal with complicated procedures such as developing film or printing in the darkroom. If you have a textbook, prepare study sheets that help students select the most pertinent information.

It isn't enough to simply deluge students with information; give them opportunities to apply things they have learned. They will be taking pictures long before you have really taught them everything they should know about composition, developing and printing. It is a process of building skills over a period of time by repetition and practice.

Exhibit their work. Although occasionally you must select only a few photos, it is important that all students see their work displayed together. They learn by comparing and examining photographs.

Even though students may have their own 35mm "point and shoot" or automatic exposure cameras, it is also suggested that the school have manual single lens reflex cameras available for their use. It is important to teach them the functions of camera controls and how they affect the appearance of the photographs. With as few as three cameras, a shooting schedule could be set up for a class that would give all students the opportunity to take many photos.

Ideally you have enough cameras and enlargers that every student is busy every day. In reality this isn't likely to happen, which is why there are a number of non-darkroom activities in this chapter that could be requirements for the course. Assignments in photography, as in any art class, are those that the teacher feels comfortable explaining. The accompanying list of assignments may be helpful.

PHOTO ASSIGNMENTS

Hands	Cornered	School Life	Groups in uniform
Faces	Nature	Machinery	Black on black (use gray exposure card or palm for light
Line	Pattern	High contrast	meter reading)
Shape	Texture	Close-ups	White on white (use gray card or palm)
Value	Children	Parts of cars	Subject in focus, everything else out of focus
Weird	Abstract	Reflections	School building (strong light and shadow)
Humor	Animals	Stop action	Food (make it good enought to eat)
Flash	Sunset	Blurred action	Nighttime existing light
Water	Rhythm	In the park	Everything in focus (use f16 or f22)
Space	Flowers	Downtown	Panned photo (1/30 sec. following action)
Boats	Framed	Architecture	Photojournalism (tell a story in one picture)
Trees	Sports	Strong emotion	Music (instruments, musicians)
			I'm just crazy about _____
			Double exposure
			Family Portrait
			Silhouette (backlighting)

SPECIAL LIGHTING ASSIGNMENTS

Portraits: group, individual, one light source • Glassware: use black background • Product photography: to sell something • Portrait: window side lighting • Hands: use lighting for drama • Self portrait in costume

NON-DARKROOM ASSIGNMENTS

Photomontage collage • Toned photograph • Hand-colored: colored pencil, dyes • Blue prints made from Kodalith or black and white drawings reproduced on copy machine transparency • Reticulation of film (deliberate mistreatment) • Paint on back of Kodalith with acrylic paint

DARKROOM SPECIAL ASSIGNMENTS

Print negative combined with photogram • Sandwich two negatives together to print • Make a "paper negative" by putting a wet print on top of unexposed wet paper and exposing through the print • Photogram • Distort a print by tilting the easel or arching the paper over a paper towel roll (tape the paper in place) • Kodalith (make positive, negative, and line print by sandwiching and offsetting the positive and negative)

NON-DARKROOM WRITING ASSIGNMENTS

Cut out examples of one type of photography and mount on posterboard for classroom use • Do a research paper on photographic composition • Write a research paper on one photographer or group of photographers • Illustrate one of your photographs with an original poem (invite an English teacher in to discuss poetry writing)

 Make a darkroom. A dark closet or small storage room could serve as a temporary darkroom using a table for trays, and putting developed photographs in a "holding tray" filled with water, washing them later in

a sink in the art room. The entire art room can be made into a darkroom by blocking out light with heavy black plastic. It can be put up and taken down easily by stapling 1 inch pieces of velcro around the windows and on the plastic about 4 inches apart. Safe lights may be purchased, or $7\frac{1}{2}$ watt red bulbs may be used instead, provided they are not too near the paper.

A darkroom ideally would have enough enlargers for half of the class. Vertical dividers between enlargers will allow you to put them fairly close together and not have the light from one affect the enlarger next to it. Darkrooms should have a dry area and a wet area, with the enlarger(s) on the dry side and the chemicals on the wet side. Counter or table space for one or two sets of developing trays (three trays to a set), one or two sinks, and adequate ventilation will make the darkroom comfortable. Be willing to sacrifice working space to make a light trap so you and students can enter and leave the room without having to worry about light exposing prints as you go in and out of the room.

The least expensive way to furnish film for students is to bulk-load film. The film comes in one hundred foot rolls for rolling into individual film cassettes.

About seven weeks into a course, try to take students on a photography field trip somewhere in the community. Because of limited cameras, I take only two classes at a time. If you have only one photography class, consider combining with a drawing class to fill the bus. I do not give assignments in advance, but spend time discussing composition and showing good photographs. Students are encouraged to borrow cameras, or share if necessary. Occasionally students are allowed to check a camera out overnight for a special occasion. These photographs taken away from school are a refreshing change.

GENERAL MATERIALS LIST

Read the list of supplies needed before starting any photography project. Most of these supplies may be bought in a photo shop. Always try something unfamiliar before demonstrating it to students. Go through the steps first to see if you are missing something vital.

Developing trays, 5 by 7, 8 by 10, or 11 by 14 inches

Tongs: set of three for each set of trays

Gallon or quart jars for mixing chemicals

Equipment for film developing: tanks, reels, thermometers, light-tight bag, beverage can opener, scissors, funnel

Chemicals for film developing: D-76, stop bath, fixer, hypo-clear, photo-flo

Chemicals for printing: developer, stop bath, fixer

Enlargers and other darkroom supplies: easel, scissors, 8 by 10 inch black cardboard, negative carrier, sponges, timer, sheet glass—11 by 14 inches, paper towels

Mounting equipment: press, tacking iron, mount board, mounting tissue, paper cutter

Bulk film loader, film and reusable cassettes (students could purchase film)

Resin coated paper (students could purchase their own packages)

Special lighting equipment (optional): photofloods, reflectors and stands, 18% gray card, tripods and cable releases

Student Project sheets

Student Notes

Student Notes 10.1: COMPOSITION

After you have taken a photography class, you may never again develop your own film, print pictures, or take black and white photographs. You *will* continue to take photographs throughout your life, so it is important to make each picture count. Good composition takes time and thought. You will understand some of the "rules of composition" better when you have looked at many visual examples.

1. Good photos should have a focal point such as a tree, rock, or person, even when they are basically landscapes. Sometimes shooting low and having foreground in the picture will add that needed impact.

2. The center of interest is usually not in the center of the photo. Remember to avoid the "bull's eye syndrome."

3. All unnecessary details should be eliminated. Change position or move in close. Simplicity is important. Avoid shooting all photos at eye level. A bird's eye or worm's eye view may eliminate unnecessary detail and make even the ordinary subject look more interesting.

4. Look at the subject, then deliberately make your eye go to one corner of the viewfinder and follow the outline of the picture all the way around the viewfinder. Eliminate anything that detracts from the subject as you want it to be seen.

5. Leave space in front of a moving subject. For example, a person should be walking into the picture rather than out of it.

6. In taking photos of people, consider using the camera vertically, as people are vertical. If you are not shooting the entire body, crop (cut off) at the shoulder, waist, hip, knees, but usually not at the ankle or wrist.

7. Place the subject at one of the intersections of an imaginary tic-tac-toe grid. This is called the "rule of thirds."

8. Let the horizon be on the top or bottom third of the rectangle rather than in the middle of the picture.

9. Look for visual perspective—lines merging in a hallway, shooting straight up a building.

10. Diagonal lines used to lead the eye to the subject are strong. Horizontal lines tend to be restful.

11. Balance can be formal with everything symmetrical on each side, but can also be informal, with the largest subject on one side and a number of smaller ones to balance it.

12. Repetition of lines or similar shapes such as circles or triangles add interest to a composition.

13. One should always be aware of contrast—that lights and darks emphasize the subject.

14. RULES OF COMPOSITION MAY BE BROKEN!!

The rule of thirds

Student Project 10.1: TO COPY A PHOTOGRAPH

MATERIALS

Copy Stand
Photo flood lights
18% Gray Card
Sepia toner
Macro lens or close-up rings

Old or new photos can be reproduced by taking a photograph of them. The diagram below shows a copy stand. A tripod could also be used to hold the camera.

DIRECTIONS

1. Place the photo under clean glass on a copy stand or counter. Focus on the picture. It may be necessary to use close-up lenses or a macro lens to get small photos in perfect focus.

2. Direct light from photo-flood lights on either side. By looking through the viewfinder you can see if there are any "hot spots" (areas that are brighter than others).

3. Place a gray card on top of the photo and take an exposure reading of the gray card. Remove the card and expose the picture.

4. Develop the film normally. After printing, these photos can be toned with sepia toner to resemble antique prints.

The copy stand may or may not have lights attached. When items are too large for a copy stand they can be placed on the wall and photographed.

BLUE PRINT PHOTOGRAM

FOR THE TEACHER

A photogram is a method of exposing light-sensitive paper without a negative. Many found objects can be used for this such as seashells, sunglasses, and jewelry, or cut-outs can be made of black construction paper. Remind students that a photogram can be like a snapshot—it may be taken quickly without any thought as to composition, or it may be carefully composed. This is a good opportunity to talk about pre-visualization and composition using some of the elements and principles of design. The same design that is used on the blue print paper may also be used in the darkroom on photographic paper.

Blue print paper may be handled in dim light, but it should be kept covered until the student is ready to use it. The photogram may be exposed with a sunlamp or direct sunlight. The paper is developed in ammonia fumes, and you can watch it develop through a clear plastic container. It may be necessary to turn it for even developing.

SAFETY NOTE: *Although ammonia has an unpleasant smell, used in such small quantities it is harmless.*

Experiment first with each student making a small photogram before trying something larger. The paper is relatively inexpensive, so it is possible to make much larger prints than 5 by 7 inches. This is particularly effective with 8 by 10 inch Kodalith positives. The exposure time varies from 10 seconds to 10 minutes, depending on how intense the sunlight is. You will know the exposure is complete when the area exposed to light turns from yellow to white.

My students made a 30 foot by 36 inch photogram by combining 8 by 10 inch transparencies. We made a large developing chamber by taping four sheets of plexiglass together to form a square and placing plexiglass on top of the chamber. The ammonia was put in a 5 by 7 inch tray inside the chamber. We were able to watch the developing process this way. A tall cardboard box would serve the same purpose. The ammonia does lose its effectiveness after being open for some time.

MATERIALS

Student Project 10.2: *Blue Print Photogram*

Blue print paper; may be purchased in 3 ft. by 150 yd. rolls or in small packages; called "Diazo black line positive dry reproduction paper"

Ammonia

Small tray or cup for ammonia

Developing container: may be wide-mouthed gallon jar, 36 by 48 inch cube of plexiglass, large cardboard box, tube of rolled heavy acetate

Scissors or X-acto knives

Black construction paper

White paper, cut same size as blue print paper

Opaque and translucent objects

Glass or plexiglass (optional)

Student Project 10.2: BLUE PRINT PHOTOGRAM

DIRECTIONS

1. Make several thumbnail sketches to give an idea for a finished photogram. Experiment with ideas for the photogram before beginning. Suggestions: Cut shapes from black construction paper, perhaps geometric shapes, animals, people, or scenes. Use opaque or translucent objects (shells, leaves, stones, or negatives), in combination with cut paper.

2. Take the blue print paper out, but keep it face down or covered with black paper until you are ready to expose it. Place objects or design on the blue print paper, holding them close to the paper with glass or plexiglass.

3. Expose the print to sunlight for ten seconds. Areas left covered the entire time will remain white.

4. Roll the paper inside a large jar. A container with $1/2$ cup of ammonia in the middle will give off fumes that will develop the paper.

FURTHER SUGGESTIONS

1. Use Kodalith (high contrast film) negatives to block out light. Large negatives could be used in combination with other materials.

2. Black and white drawings can be transferred to overhead transparencies in a school copy machine and used to make blue prints. This enables you to use line drawings or strongly contrasted photographs on transparent plastic. Blue print paper is relatively inexpensive yet can be an exciting way to make images on photo-sensitive paper.

BLACK AND WHITE PHOTOGRAM IN THE DARKROOM

FOR THE TEACHER

Teaching students to make a photogram in the darkroom gets them into the darkroom early in a course without them needing to know everything they must later know about printing.

Photographic paper is light sensitive. Although it may be handled in safelight without exposing, exposure to white light will turn it gray or black on developing. To make a photogram in a darkroom, expose it with an enlarger light. If an enlarger is not available, an overhead light could be flashed on in a totally darkened room.

The same design procedure is followed which was used in making a photogram outside the darkroom, except that the developing process is different. Different values may be achieved by exposing partially, moving objects, and exposing again.

MATERIALS

Student Project 10.3: *Darkroom Photogram*

Enlarger or other light source

Timer

3 non-metal trays 5 by 7 by 3 inches or larger

Tongs

Photographic developer

Stop bath

Fixer

Photographic paper,
 5 by 7 inches

Safe light

Black construction paper

X-acto knives

Glass or plexiglass

Photo 10–1 This student darkroom photogram was created with found objects and black construction paper.

204

Student Project 10.3: DARKROOM PHOTOGRAM

DIRECTIONS

1. Make thumbnail sketches for ideas for the finished photogram. Black construction paper designs block out light.

2. In the darkroom, place the objects or the construction paper cut-outs on the emulsion (shiny) side of photographic paper. If using paper designs, hold them in place with a sheet of glass. Expose at f11 for approximately 5 to 7 seconds.

3. Place the paper in developer and agitate by gently rocking the tray back and forth for $1\frac{1}{2}$ to 3 minutes until parts of the photogram are black.

4. Place paper in stop bath and agitate for 15 to 20 seconds to stop the developing process.

5. Place paper in the fixer and agitate for 3 to 5 minutes. The image will then be permanent.

6. Wash the print for 5 minutes to remove chemicals.

7. Air dry the paper.

FURTHER SUGGESTIONS

1. Make a "paper negative" by placing the wet paper on top of an unexposed piece of wet photographic paper. Gently use the palm of the hand to put them in close contact and shine a light through the back of the photogram to make a reverse print. Use an approximately 45 second exposure at f11.

2. Do a silhouette of your face by putting it under the enlarger to block out light. You may also place your hands on the paper, expose them and turn off the enlarger, then move your hands around and re-expose them to give different values of a design.

3. Use permanent markers or dyes to color some portions of the photograms.

4. For a dramatic presentation, mount colored and black and white photograms from the entire class closely together on one large board.

PINHOLE CAMERA

FOR THE TEACHER

The pinhole camera is a direct method of taking photographs on paper without the interim step of developing film that is necessary for exposing most photographs. The image will be a negative image rather than positive, but nevertheless interesting. There are many sizes and varieties of pinhole cameras including a room-sized one made at a college in California that held 8 to 10 people. Sheet, roll, Kodalith films, black and white and Cibachrome (color) paper can be exposed in a pinhole camera. The camera itself can be made of almost any type of box that can be made dark. One teacher encourages his students to go to junk shops to find containers that might look sculptural yet function as pinhole cameras.

This project is a simple camera that uses photo paper. The paper can be cut round-shaped to go on the end of an oatmeal box or mailing tube for a telephoto effect, or left rectangular to fit on the side of a box, giving a wide-angle effect. Exposure times vary from 30 seconds to five or more minutes depending on the amount of light available. If the exposure is too long (the paper is dark) or too short (the paper is light), double or halve the exposure next time, making educated guesses rather than trying to "inch up" on exposures.

A closet or a darkened room is needed for loading the "camera" and developing paper.

MATERIALS

Student Project 10.4: *Pinhole Camera*

Oatmeal box, mailing tube, shoe box, or biscuit tin

Box lid with V-shape cut in side to hold the camera steady

Masking tape

Black poster paint or spray paint

Aluminum foil

Rubber band

Needle (smallest size available)

Cutting knife

Black construction paper

Safe Light

Resin coated paper

Trays for developing (non-metallic)

Photographic developer

Stop bath

Fixer

Running water or water tray

This pinhole camera and box-lid holder may have an opening in either an end or the side.

Student Project 10.4: PINHOLE CAMERA

DIRECTIONS

1. Paint the inside and lid of an oatmeal box with black poster or spray paint.
2. Cut an opening 2 by 2 inches on the side of the box. Tape a 3 by 3 inch piece of aluminum foil over the opening. Cut piece of black construction paper 6 by 6 inches square.
3. Make a tiny opening in the center of the foil with a needle.
4. Place the black paper over the aluminum foil by taping it at the top and holding it to the box with a rubber band.
5. In a changing bag or totally dark place, put an unexposed sheet of photographic paper inside the box, directly opposite the hole in the foil, with the emulsion side facing the hole. Your "camera" is loaded!
6. To expose the paper, it is necessary to experiment, since exposure times vary considerably depending on the time of day and the brightness outside. The exposure will be too long for the "camera" to be hand held. It could be from five seconds to five minutes, depending on the light situation and the size of the hole.
7. To compose a photo, squat or lie down and put your eye where the "lens" of the camera will be, to see if the picture will be interesting. The subject should be immobile, such as a parked car, building, or tree, although a non-moving person could be included for a 30 second or less exposure.
8. Place the box on the ground or on a stool and brace it so it won't roll by either standing it on end or putting it on a box lid with a V cut in the sides.
9. To expose the photo paper, lift the black paper from the front of the box and tape it open. Do not touch the box during exposure. Replace the black paper after exposure, and hold it in place with the rubber band.
10. After exposure, take the paper out of the box in a darkroom, exposing it only to the safelight. A safelight will not expose it further.
11. Place the paper in developer, agitating it gently for one or two minutes. If the paper turns dark quickly, it means the exposure time was too long.
12. Place the paper in stop bath for fifteen seconds.
13. Place the paper in fixer for three to five minutes, agitating frequently.
14. Wash the paper for five minutes to remove chemicals.
15. Air dry the photo.
16. Either dry mount or mat the photograph.

FURTHER SUGGESTIONS

1. A deep metal cookie tin makes a good telephoto pinhole camera. Use a hammer and nail to dent outward the center of the lid. With fine sandpaper, sand the dent until a *tiny* hole is made. Keep this covered with paper except when exposing a picture. Paint the inside of the tin black, and cut paper to fit inside the end of the box. A lid from a plastic film container can be taped on with electrical tape to make a good "lens cover."
2. Read directions in this chapter for developing Kodalith film. Expose this high-contrast positive sheet film in the pinhole camera. Unlike photographic film, this film can be loaded in red safelight. After it is developed, contact print it onto paper.

Student Notes 10.2: THE SINGLE LENS REFLEX CAMERA

Each camera has its own system, and it is a good idea to keep your instruction booklet with the camera until you understand it. Although many of the new 35mm cameras are of the "point and shoot" variety or automatic, you still should understand how the controls—the aperture and shutter—affect the appearance of a photograph. The effect of the controls remains basically the same even on a complex camera.

Aperture openings.

1. The *lens* is used for focusing, and has aperture setting rings, depth of field scale, and distance scale.

2. *The aperture* is an opening in the lens of the camera through which the light passes to expose the film. The opening size may vary to let in more or less light.

 a. These openings are represented by "f numbers." The larger the opening, the smaller the number that represents that opening.

 b. A relationship of each number to openings is shown at right.

 c. Each f-stop lets either half as much or twice as much light into the camera as the opening next to it.

 d. Larger lens openings (f2, f2.8, f3.5) are chosen if you wish to blur out the foreground or background in a photo (such as in portrait or photograph of a flower). When the opening is large the subject on which the camera is focused will be sharp, whether it is close or far away.

 e. *Depth of field* controls sharpness or lack of sharpness in a photo. More of the picture will be in focus with the smaller lens openings such as f11, f16, and f22.

3. The *shutter speed button* indicates the speed at which a photo is taken.

 a. Numbers such as 2, 15, 30, 60, 500, 1000, or 2000 represent fractions of a second that the shutter is open. Number one represents one second; number 500 is $^1/_{500}$ of a second.

 b. If using a flash, check instructions for the flash synchronization speed (usually 60 or 125) and use the shutter speed at that setting. Failure to use the proper setting will result in half photos.

 c. The lowest *safe* hand-held shutter speed is 60 ($^1/_{60}$ of a second). To control camera shake, the shutter speed should not be slower than the focal length of the lens. (Example: a 125mm lens should be exposed at $^1/_{125}$ of a second (125), and a 200 millimeter lens should not be exposed at less than $^1/_{250}$ of a second (250). (There is no 200 on the shutter release.)

 d. If a photo must be taken at $^1/_{30}$ of a second or less (30), become a "human tripod." Brace against something, hold the camera firmly against your forehead, take a deep breath, and gently squeeze the shutter release. If a delayed timer is on the camera, use it to avoid shaking the camera when you press the shutter release. A cable release screwed into the shutter release also prevents touching the camera during exposure. This is an advantage at slow shutter speeds.

 e. To stop action ("freeze" everything in the picture), a shutter speed of $^1/_{500}$ or faster is preferred.

 f. To "pan" (stop action while blurring the background), set the shutter speed at 30, then follow the action, moving the camera. Release the shutter and continue to "follow" the action. Example: A

bicycle is going by; while following the bicycle with the camera, expose and briefly continue following the action.

g. *The aperture and the shutter speed* work together to control the amount of light that comes through the lens. All the above information about depth of field and stop action takes for granted that there is enough light for proper exposure. Most modern cameras have built-in light meters to determine a proper exposure. Some have a small built-in flash to augment lighting when there is not enough.

h. *Compensation for backlighting.* In some instances, such as backlighting (the sky or a window behind the subject), or bright nighttime stage lighting, the camera may be fooled, and important details such as faces can be lost. For backlighting, open up the aperture one or two stops (plus 1 or 2 on an automatic camera).

4. *The ISO or ASA indicator* refers to the International Standards Organization or American Standards Association speed ratings given to film. When film is purchased it will always have this number on the packaging. Purchased film is DX coded for the ISO number, and in many cameras is automatically set. The higher the ISO or ASA number, the faster the film. Fast film allows picture taking where there is little light. A recommended general purpose film for use in school is 400 ISO. It has a high enough speed to be able to use it indoors, but still has reasonably fine grain. If the ISO number is lower, more light is needed for exposure. Color print films now come with ISO up to 1600 and more. One disadvantage to higher speed film is that there is more grain (clumping of particles of silver), which some do not find as attractive as a finer-grained film.

5. *Loading the camera.* Many cameras are self loading once the film is inserted and carried over to the other side. For those that are not, instructions follow:

a. Check to make certain the camera is loaded. Place the film cassette on the left side. Engage it in the take-up slot on the other side and advance once to make sure it is engaged before closing the back of the camera.

b. Close the camera back and turn the film rewind crank until the film is taut inside the cassette.

c. Advance the film three times more, and watch the rewind crank each time to make sure it is turning around. If it turns when the film advance lever is moved, then that assures that the film is loaded.

d. Check the ISO to be sure it is properly set. (if you accidently expose the film at the wrong ISO, just continue to expose the *entire roll* at that speed.) Even if the film is commercially developed, time can be adjusted to make up for "pushed" or "pulled" film.

6. Instructions to follow when going shooting for the first time:

a. Load the camera and make sure the film is engaged.

b. Set the ISO.

c. Focus the camera or use the distance scale on the lens to estimate distance.

d. Do not shoot at a shutter speed of less than 60 unless you have a tripod or have the camera braced on something. A beanbag could be used to hold the camera steady.

DEVELOPING FILM

FOR THE TEACHER

A schedule for having students mix chemicals will make your job easier. Write explicit instructions for mixing each chemical on 3 by 5 inch cards and post it near where the chemicals are mixed. By having a number of people responsible for each chemical, there is usually someone there to do it when needed.

MATERIALS

Student Notes 10.3 *Developing Film*

Photographic thermometer (must be accurate)

Film changing bag

Light tight developing tank with reel

Beverage-type can opener to open purchased film

Scissors

Chemicals:

 Film developer (Kodak D-76, diluted 1:1 is recommended)

 Stop bath

 Fixer

 Hypo-clearing agent

 Wetting agent (such as Photo-flo)

Plastic negative sleeves (holder for up to 35 negatives)

Clips or clothespins for hanging film to dry

Student Notes 10.3: DEVELOPING FILM

1. *Load film in tank:* The film must be taken from the cassette in absolute darkness and placed on a reel inside a developing tank.

 a. Place the following items into a changing bag or on a counter in a *totally dark* place: scissors, reel, spindle, light-tight developing tank, spindle, and lid.

 b. For bulk-loaded film, hit the extending spindle on a tabletop to force the lid off. If you are using purchased film, remove the end with a beverage opener. Remove the film.

 c. Cut the curved leader off the film before beginning to roll film onto the reel. Begin with a straight edge on the film.

 d. Put the loaded reel(s) into the tank and close top securely, being sure the spindle is in the tank to prevent light leaking in.

 e. The tank may now be taken out into daylight.

2. *Develop:* Before beginning to develop, take the temperature of the chemicals. Film developing time is dependent upon the type of film and the type, dilution, and temperature of the chemical. Follow directions for developing time given with the film.

 a. All chemicals should be from 68 to 70 degrees Fahrenheit. If the temperature is lower or higher, adjust the developing time according to the manufacturer's directions.

 b. Mix 5 ounces of D-76 to 5 ounces of water per reel and pour into the tank. Begin timing as you begin pouring the chemicals.

 c. Tap the tank on the counter top. Agitate for the first 30 seconds, then agitate for 5 seconds of every 30 for the entire developing time.

 d. At the end of the developing time discard the developer.

3. *Wash:* Fill the tank with water, then empty.

4. *Stop bath:* Pour stop bath into tank, agitate for 15 seconds, then empty back into stop bath jug. Stop bath may be reused. "Indicator" stop bath will turn purple when exhausted.

5. *Wash:* Fill the tank with water, then empty.

6. *Fixer:* Pour fixer into the tank.

 a. Tap the tank on the table (to remove bubbles), agitate first 30 seconds, then agitate 5 seconds out of every 30 seconds for 4 minutes.

 b. Pour the fixer back into the jug. Open the top of the tank and lift out the spindle and reel, making sure that the film is a translucent dark purplish gray. If the film looks opaque it has not fixed long enough, and should be returned to the fixer. A simple test to see if fixer is still good is to put a small piece of film into the fixer. If it turns clear, the fixer is still good.

7. *Hypo-clear:* Leave the tank lid off; rinse in water, then fill the tank with hypo-clear. Soak the film in hypo-clear for two minutes. Pour hypo-clear back into jug.

8. *Wash:* Wash in running water for 5 minutes.

9. *Photo flo:* This is a wetting agent, used to eliminate spots; soak in photo flo solution one minute. Pour Photo-flo back into jug.

10. *Squeegee:* Remove film from the reel. Either use a film squeegee, or use the first two fingers of your hand as a squeegee. Pull the film through them one time, gently, to remove excess water. It is possible to scratch the wet film because the emulsion is still soft. HANDLE FILM ONLY BY THE EDGES. NEVER TOUCH THE EMULSION.

11. *Drying:* Attach to a line or clotheshanger with clothespins or bulldog clips. Put a clip on the bottom end to help film dry straight. Allow it to dry at least 1½ hours before using.

12. *Negative storage:* Cut the film into strips of 5 frames each and place them in a plastic negative sleeve to keep from scratching them.

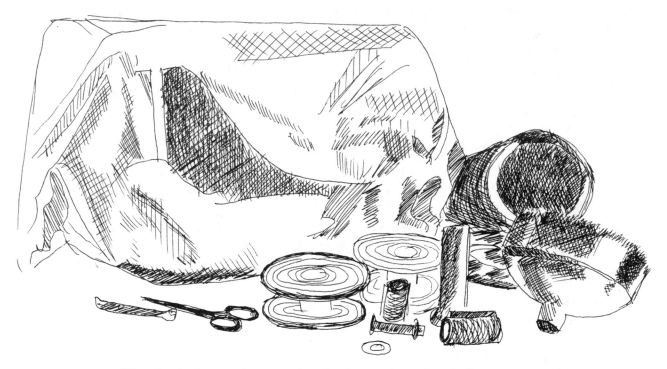

Film developing equipment: changing bag, reels, tank, spindle, cassettes, reels.

BASIC BLACK AND WHITE PRINTING

FOR THE TEACHER

Enlarging one's own negatives is one of the most exciting moments in doing photography. Routinely following directions such as the ones given here will give consistently good photos and achieve the best results economically. To "encourage" students to follow routine procedure, require a proof sheet and test strips to be paper-clipped onto each mounted photo that is turned in. If these are missing, make deductions for each. Looking at these also helps you find out quickly if they understand the procedures. Use variable contrast filters to add or reduce contrast in a print.

MATERIALS

Students Notes 10.4: *Directions for Printing and Dry Mounting Photos*

Enlarger(s)

Negative carrier(s)

Grain focuser (critical focus)

Timer(s)

Easel(s)

Scissor(s)

Pieces of heavy 8 by 10 inch white cardboard

Heavy glass 11 by 14 inch (either with polished edges or edges bound with tape)

Developing trays

Tongs

Sponges

Paper towels

Darkroom chemicals: developer, stop bath, and fixer

Mounting press

Tacking iron

Mounting tissue

Student Notes 10.4: DIRECTIONS FOR PRINTING AND DRY-MOUNTING PHOTOS

DIRECTIONS

Always move prints from one tray to the next by using tongs. Hold the photo over the tray for a moment to drain excess chemicals before moving.

1. *Developer:* Leave the print in for 1 to 2 minutes. If the photo is properly exposed, you should not see an image before 20 seconds. If not properly agitated, the print will be "muddy," with partial development.
2. *Stop bath:* 15 seconds: continuous agitation.
3. *Fixer:* immerse print. Agitate for 2 to 4 minutes.
4. *Wash:* 5 minute wash is recommended. Discoloration may show up later if not well washed.

PROOF SHEET

1. *Make a proof sheet:* Remember "emulsion to emulsion." Lay all negatives dull (emulsion) side down on shiny (emulsion) side of paper. Place a clean sheet of glass on top to hold them flat. When a negative is held in place this way, it is called "contact printing."

 a. For a 5 by 7 inch print, expose the paper at f11 for approximately 5 to 7 seconds

 b. For a 8 by 10 inch print, expose the paper at f11 for approximately 15 seconds

2. *Develop the proof sheet.*
3. *Select the best negative from the proof sheet.*
4. *Clean the negative* with a negative cloth. Don't wipe your hands on the cloth, as chemicals will ruin the negatives.
5. *Put the negative in the negative carrier. NEVER DRAG YOUR NEGATIVES ACROSS THE CARRIER, AS THEY WILL GET SCRATCHED.*
6. Place the white cardboard on the easel for ease in seeing the negative.
7. *Open the aperture* all the way (the numbers are the same as on a camera, with the smallest number being the largest opening on an enlarger).
8. *Focus the enlarger.* If available, a magnifying glass or a focusing aid will help in getting it as sharp as possible. If desired, the picture may be improved by cropping.
9. *Reset the aperture.* Normally try to print from f8 to f16. In order to get all the detail, an ideal exposure would never take less than ten seconds.
10. *Make a test strip.*

 a. Cut a one inch wide strip of photographic paper and place it emulsion side up in the easel.

 b. Set the timer for 20 seconds (for a 5 by 7 inch print)

 c. Expose the entire strip for 3 seconds.

 d. Cover 1 inch at one end of the strip. At regular intervals such as 3 to 5 seconds move the cardboard to cover another inch of the paper until the entire paper is covered.

11. *Develop the test strip.* Use tongs to move the test strip from chemical to chemical. Remember to use separate tongs for each chemical and put them back into the proper tray to avoid contamination.

12. *Evaluate the test strip.* Look for whites, black, and intermediate grays. If there is not much contrast, a filter is needed.

13. *To use a polycontrast filter:*

 a. Choose the proper exposure time from the test strip.

 b. If there are no strong blacks and whites, use a high numbered filter.

 c. When using a filter, add exposure time to your white light time. Instructions for exposure time will come with the filters.

14. *Make a trial print:* Use a filter when making the print. At this point evaluate the print under white light for any dust spots or scratches. If some areas of the print are too dark or too light, you can "burn" or "dodge" the print by using your hand to hold back light in some areas while adding more light in others.

15. *Make final print:* Follow regular developing procedures. Remember to wash with running water for 5 minutes.

16. *Dry the print:* Resin coated paper may be dried with a hair dryer or air dried for a short time.

DRY MOUNTING

Prints normally are mounted in a dry-mount press, but it is also perfectly acceptable to mat the prints. They usually have at least a $1\frac{1}{2}$ inch border. An illustration of dry-mounting is in the appendix.

1. Either use pre-cut mounting tissue, or cut tissue the same size as your print. Tack the mounting tissue at the center of the back of the picture with a tacking iron.

2. On a paper cutter, or using a straight edge and X-acto knife, cut through both the print and dry mounting tissue to remove the edges from the photo.

3. Measure in from the edges of the mount board and make light pencil marks where the picture will go before tacking it to the board.

4. Lift the picture slightly so that the iron does not actually touch the photograph. Tack a corner of the mounting tissue to the mountboard. Do the same in the other corner.

5. Place the photograph in the mounting press for 30 seconds at 180 degrees. Use a sheet of plain paper on top of the photo and mount board to protect the surface while dry-mounting.

6. Resin coated paper will adhere to the background better if it is put under a weight to cool for 5 to 10 minutes.

7. Using pencil, sign photographs in the lower right hand corner.

Student Project 10.5: KODALITH

DIRECTIONS

Printing negatives on Kodalith film (a high contrast film that lacks intermediate gray) is a simple procedure. Kodalith ranges in size from 35mm film to very large sheet film. It is sensitive to light, but, unlike ordinary film, may be developed in red light. If you were to see Kodalith outside a darkroom, it would be pink on one side and dark red on the other. In the darkroom, under red light, you will see only a dark side and a light side.

MATERIALS

Kodalith film: 35mm roll film, 4 by 5, 5 by 7, 8 by 10, 11 by 14 inch sheet film

Kodalith A and B developer: Mix one gallon A and one gallon B, combining equal amounts of A and B when needed

Developing trays

Red safelights

To make a 35 mm contact print:

1. Working under a red safelight, take a piece of Kodalith film and place the light (emulsion) side up on the enlarger base board. Use any negative which has good contrast and place it emulsion side down on top of the 35mm piece of Kodalith. Place a piece of glass on top of these two pieces to hold them flat.

2. Raise the enlarger to normal height for a 5 by 7 inch print. Turn the enlarger to f11, and expose for about 5 seconds (the time will vary somewhat depending on your negative).

3. Put the exposed Kodalith in special Kodalith developer (made by mixing Kodalith A and Kodalith B solutions in equal parts). Agitate until the image is developed, then quickly move it to the stop bath. If the image is overexposed, it will turn dark very quickly.

4. Place the Kodalith in the stop bath for 10 seconds.

5. Put the Kodalith in fixer for 2 minutes. The pink backing will disappear and you will see clear areas.

6. Wash the film for 5 minutes.

7. Put it in photo flo for 1 minute to eliminate spotting.

8. Air dry (by hanging or by holding in front of fan for 5 minutes).

You now have a *Kodalith positive,* which can be printed as if it were an ordinary negative, by placing it in the negative carrier and enlarging it onto a photographic paper. This will result in a print that looks like your original film *negative*. There may be specks on the print, but this is just the nature of Kodalith.

If you prefer a positive print (which most people do), then you need to go through the contact printing step once again by taking the dry *Kodalith positive* and contact printing it with another piece of Kodalith film just as you did the first time when you used a normal negative. This will result in a *Kodalith negative* which, when printed, results in a high contrast positive print of your original negative.

One other option is to sandwich and tape a *Kodalith film positive and negative* together slightly offset, so that you can see a little light coming through the outline. Tape them together with clear tape. Expose this at approximately 15 seconds at f11, and it makes an outline of your original negative.

FURTHER SUGGESTIONS

1. Make two positive and two negative prints, dividing them on a paper cutter and mounting them in patterns.

2. Expose a normal negative and Kodalith negative sandwiched and taped together.

3. If the positive and negative Kodalith prints are exactly the same size, they are impressive when they are mounted side by side.

4. Contact print a negative *print* (made on photographic *paper*) by wetting a sheet of unexposed photo paper and placing the negative PRINT on top of it (emulsion to emulsion). With both pieces of paper wet, press them together with a squeegee to eliminate any air bubbles, then place them under the enlarger. Approximately a 45 second exposure at f11 will give a positive print. This first print negative which you made is called a *paper negative*.

5. Expose 35mm film directly in the camera. Purchased 35mm Kodalith has directions for exposure. It is developed under red light in a tray of Kodalith A & B developer by holding each end and running it back and forth through the tray. Watch it carefully and put it immediately into fixer to stop developing.

6. Print directly on Kodalith sheet film in various sizes such as 5 by 7 or 8 by 10 inch. These films may be used in the following ways:

 a. Contact print the large film positive to make a large film negative, then contact print either or both of them to paper. The large sheet film has finer detail than a 35mm contact print.

 b. Project the Kodalith positive onto a wall with an overhead projector to make a huge mural.

 c. Let color show through the Kodalith either by placing various colors of fadeless paper on a board behind it, or by painting on the back with acrylic paints. If you make a mistake, the acrylic washes off. Combinations of paper and painting also are effective. These must be matted in order to hold the Kodalith in place.

WHAT TO DO WHEN THEY'RE NOT IN THE DARKROOM

FOR THE TEACHER

In a perfect world all students would always be busy taking photographs, developing film, or printing in the darkroom, but because students must take turns using equipment, there are days when many of the students are sitting in the classroom. A number of projects described here for those non-darkroom days are logical extensions of what they have been doing. They can manipulate extra prints in a variety of ways. Encourage students never to throw away their bad prints, but to save them for experimenting.

1. *Hand colored prints*

MATERIALS

> Student Project 10.6: *Hand-Colored Photographs*
>
> Prisma color pencils
>
> Dr. Martin's or Marshall's dyes
>
> Toner: sepia, blue, orange
>
> Oil paints
>
> Acrylic paints

2. *Photo etching*

MATERIALS

> Student Project 10.7: *Photo etching with Ink*
>
> India ink
>
> Pen holders and fine pen nibs
>
> Farmer's reducer: a two part chemical, A & B, which when mixed together in equal parts becomes active.

3. *Photo montage*

MATERIALS

> Student Project 10.8: *Elongated Photomontage*
>
> Student Project 10.9: *Photomontage Collage*
>
> Rubber cement or dry-mount tissue
>
> Masking tape
>
> Mount Board

Photo 10–2 Using the imagination when combining different images can lead to a strong photograph. These self portraits were cut out and attached with rubber cement, then rephotographed. Student work.

218

Student Project 10.6: HAND-COLORED PHOTOGRAPHS

DIRECTIONS

Long before the advent of colored film, photographers and artists were hand-coloring photographs. A recent resurgence of this technique is seen in commercial art. Some of the methods used in the old days are just as effective today. Use restraint in hand coloring with some of the methods, as the colors are quite strong and can overpower the image. While often it is enough to color only one or two areas, some pictures are quite effective when totally covered with color.

Presentation of finished products is important. Although most black and white prints should be mounted on black, white, or gray mount board, when color is added to a print, a related color could be used in the mat. The print could even be double mounted.

Toning. Slightly "old fashioned" looking photographs such as of houses, underexposed (light) portraits, and some landscapes may be given a brownish color by toning with sepia or copper toner. Snow scenes and portraits also look good when toned with blue toner. Toners come in a variety of colors and may be purchased at photo supply stores. Follow directions on the package.

Immerse a well-washed print in a tray of toner until the entire print is the desired color. Prints can be partially toned by brushing toner on in areas. To keep part of the print the original color or a toned color, you may cover it with rubber cement to prevent toner from touching the area. Several colors of toner may be used by applying resist. After toning, wash well and air-dry. Toning is especially effective in combination with hand-coloring.

Prismacolor pencils give a soft effect when carefully and evenly applied to the surface of a matte-finish print (glossy paper does not work with pencils). If you see streaks, go over the coloring softly with a pencil to make the color more even.

Oil paints were the original hand-coloring method used in photography. Put a tiny amount of paint on a paper palette and dilute the paint with turpentine. Make a "brush" out of a toothpick with a small amount of cotton twirled onto the end. Give oil-tinted photos a soft look by using a cotton ball to wipe the paint and blend the colors.

Dyes are concentrated colors that are diluted with water. A drop of dye is adequate for any coloring task (Dr. Martin's Dyes are favored, as they are concentrated). These are strong, vibrant colors used more for startling effects or as attention-getters than to simulate natural colors. Use these sparingly, or dilute them.

Acrylic paints: Dry mount a photo on a large sheet of mount board. Paint an "extension" of the scene in the photograph onto the mount board. Apply some paint onto the photograph itself, but leave most of it black and white. It is not necessary to apply paint all the way to the outside edges of the board.

Sheet Kodalith film can also be painted on the underside with acrylic paints and matted. These are quite dramatic in appearance.

Student Project 10.7: PHOTO ETCHING WITH INK

DIRECTIONS

Use any black and white photograph, since the photograph will be bleached away to leave an ink drawing on the white paper. Save dark, light, or dirty prints, as it makes no difference in the final result. This technique is especially suitable for complex prints and portraits.

1. Go over the lines on the print with pen and India ink, creating differences in value by the use of cross hatching. Remember that the entire photograph will disappear, so the drawing must be interesting and complex. If this is a portrait, and there is no background, invent one!

2. This drawing does not have to be completed all at once, but may be worked on for a number of days. Allow the ink to dry overnight before bleaching, or it may smear.

3. Place the print in a tray of Farmers' reducer and gently agitate it by rocking it back and forth until the grays disappear (approximately 15 minutes). It is not necessary to bleach it entirely.

4. Wash the print and air-dry. Do not squeegee, since it may cause the ink to smear.

FURTHER SUGGESTIONS

1. Hand color the etching after the picture has dried.
2. Combine etched photos with others in a photomontage.

Photographic etching. Student work.

Student Project 10.8: ELONGATED PHOTOMONTAGE

DIRECTIONS:

A photomontage is a combination of several photographs that are visually or conceptually linked with one another. The result may be one negative printed a number of times, or a collage using details from several photographs.

Elongated photomontage. To make this montage, print a negative two or three times exactly the same way.

1. Use the paper cutter to neatly slice the photographs. Each cross-slice may be the same width, or they may vary by getting wider at the bottom.

2. Place two or three strips of masking tape sticky side up on a table. Combine the photographs by alternating slices from each photo. Hold them in place by pasting them to the masking tape. When you are satisfied, carefully pick up the slices and coat the backs generously with rubber cement. Allow it to dry completely.

3. Cut a mount board larger then you estimate the finished picture will be.

4. Coat the mount board with rubber cement. Allow it to dry completely.

5. Carefully lay the pieces on the coated mount board. The two dried surfaces of rubber cement form a permanent bond. Remove excess cement by using a pencil eraser. An alternative method of mounting: place dry mount tissue on the back of the photo and mount it in a dry mount press.

FURTHER SUGGESTIONS

1. Stand in one place and take at least ten different views of the same subject. Develop each one of these in a similar manner. Place them together on a board by matching up borders. It doesn't matter that the sides will not be even.

Sketch of elongated photomontage. Student work.

Student Project 10.9: PHOTOMONTAGE COLLAGE

DIRECTIONS

When planning a montage, look critically at existing photographs for a suitable combination of pictures. Aim for originality and incongruity.

1. Use an 8 by 10 inch or larger print for a base. Carefully cut out other pictures to be added to this one.

2. Use an X-acto knife, and cut at an angle so that there is a very thin edge without the white backing showing. If necessary, you may sand the pieces to make a slanted edge. Zig-zag edges help disguise joints when they are cut from a patterned photograph. It is possible to disguise white edges with diluted india ink. Cuts that follow an outline are the most inconspicuous method. Avoid straight lines unless they follow the outline of an object.

3. Cut out more pictures than you plan to use so that you can pick and choose. Look for bizarre combinations.

4. Glue these pieces onto the base print with rubber cement or positional mounting adhesive.

5. To make the collage more puzzling to the viewers, re-photograph and print these collages.

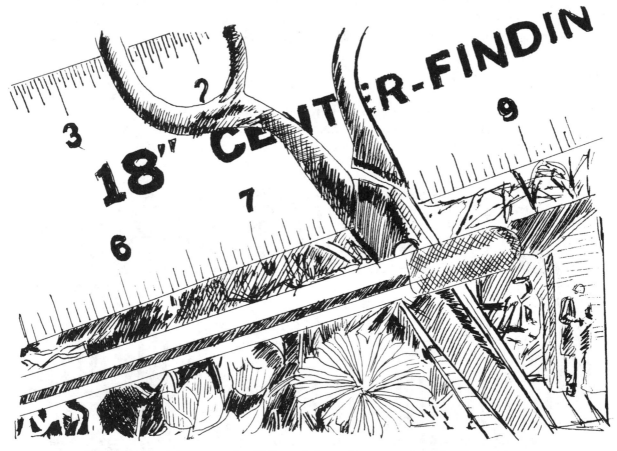

This photomontage was made of bits and pieces from a number of different photos.

Chapter 11: BASIC SURVIVAL STRATEGIES FOR YOUR ART PROGRAM

OBJECTIVES

The Goals of an Art Program: The Contemporary Curriculum

- To discuss what a student should learn from a contemporary curriculum
- To reinforce the underlying basis of the art curriculum: the elements and principles of design

Winning Support for Your Art Program

- To discuss ways of getting support for the art program from the administration, staff, students, parents, and community
- To specifiy public relations methods
- To offer specific means of increasing visibility for the art program

Organizational Techniques

- To share organizational techniques from many experienced art educators

INTRODUCTION

Teach visual literacy

The purpose of art education is to teach students to see and interpret. Art students learn to become design-literate consumers. Students should become aware of design, whether found in nature or objects designed by people. Good taste is not necessarily instinctive. Discussions, criticism, and analysis of good and poor design should be part of every art course. Get students to find examples of "kitsch" (good design taken a step beyond its intended use—for example, a reproduction of the "Pieta" used as a clock). Explain that every time they select something to wear, or decorate a room, they are making choices about design. Developing creativity, imagination, and originality is basic to the study of art.

In order to develop confidence in art, students must feel confortable taking risks. When analyzing a student's work, find a balance between praising the work too highly (unless it deserves it) and appearing to hate it. Art is personal, and criticism has to be tactful. Rather than saying "That's all wrong," encourage the student to appraise the work with questions such as, "What do you think might happen if you moved this line?" or "What do you think you could do to improve this?" Let them know that yours is only one opinion, and that ultimately they must make the final decisions.

Above all, never draw on students work. If you want to show a way to improve it, use a piece of tracing paper, place it on the artwork, and draw on the tracing paper, then wad it up and throw it away.

Some students get discouraged because they do not draw as well as others. Help them to understand that not everyone is born knowing how to draw and that practice is necessary for improvement. As in any other discipline, learning to draw is a skill-building exercise. Ask them if they expect to be able to play a concerto the first time they sit down at a piano or to do an olympic routine on a balance beam without learning some basics first.

Even if students' drawing skills are below average, many other ways of creating art are open to them. Their ideas are as important as the ability to draw. Let them know that there are as many ways of making art as there are artists.

TEACH THE UNIVERSAL CURRICULUM OF ART

THE HISTORY OF ART: As the world is changing, so are techniques of art. Let us hope we never get so caught up with gadgetry and the latest in technology that we forget we are visual artists, and our field has a history as well as a future. The underlying curriculum is based on the elements and principles of art, an ordered way of looking at art in a historical context and a way of bringing order to the art produced by students.

THE UNDERLYING CURRICULUM: At any grade level, in any art discipline, universally understood and unifying design concepts are taught. The elements of art are *line, color, shape* or *form, texture,* and *value.* The principles of art are *repetition, space, variety, rhythm,* and *emphasis.* Teaching art is showing students how these elements and principles affect their own work and that of others.

SKILL-BUILDING PROCESS IN THE ART CURRICULUM: If all art is taught through the use of these concepts, you are establishing a base for the natural skill-building process that occurs in the art curriculum, just as skills are developed in math or writing. One of the grade school art specialists in our district recently remarked, when observing work done by high school students, "These are the same things we do, but they look so different!" Students who have taken formal art courses in elementary school do build on those lessons ard are far more visually sophisticated and confident of artistic ability than those who have not taken art as younger children.

CURRENT THEORY IN ART EDUCATION: Current art education theory encourages the teacher to plan each lesson as more than a series of steps that lead to a finished product. Research by the Getty Trust and the National Art Education Association states that a quality art program should have four components: studio art, art history, art criticism, and aesthetics. Teaching technique and skills to students is only part of an effective art program. Students resist talking about art, yet discussion must be encouraged. Consciously incorporate art history into whatever technique you are teaching. Showing art history slides before each project acquaints students with many different ways of interpreting subjects and with quality art. Train the students to make aesthetic judgments and verbalize those judgments.

SETTING UP THE CURRICULUM

CURRICULUM GUIDELINES: Each school or district has curriculum guidelines. These may change from year to year, or even from school to school within a district. Many states require a fine arts credit for graduation, which encourages growth in art departments. If curriculum changes need to be made, *you* will be the expert who is asked for advice.

Most junior high or middle schools require at least a quarter of art. An introductory course is expected to cover at least one project in each of the elements of art. A semester course should be called Introduction to

Art, Design Arts, Design, or Basic Design. In schools that have Art I, Art II, Art III, and Art IV, most of the elements and principles would be taught in Art I and reinforced in more advanced courses.

An art curriculum is almost what you make of it. Although state and district guidelines are set, as of now no states require that students be tested in art. However, many have already formulated expectations of what the student will learn in art. One particularly effective poster published by the South Carolina Department of Education (available for purchase through the National Art Education Association) called "Basic Art Skills" defines what a student should have learned in secondary art. With their permission, an outline is given here:

Component one, aesthetic perception: visual and tactile.

1. Recognize design elements.
2. See underlying structures.
3. Discriminate visual characteristics.
4. Recognize variety in visual and tactile characteristics.
5. Categorize visual and tactile characteristics.
6. Respond aesthetically to visual and tactile characteristics.
7. Analyze aesthetic perceptions.

Component two, creative expression: artistic knowledge and skills.

1. Use artistic skills.
2. Apply design elements and principles.
3. Express three-dimensional qualities.
4. Create in print media.
5. Create in craft media.
6. Create in the photographic medium.
7. Utilize environmental design.
8. Recognize career opportunities.

Component three, visual arts heritage: historical and cultural.

1. Recognize varying cultural themes.
2. Analyze the creative process.
3. Recognize the artist's role.
4. Recognize varying cultural styles.
5. Recognize the function of the visual arts in a community.
6. Recognize visual arts from world cultures.

Component four, aesthetic valuing: analysis, interpretation, and judgment.

1. Analyze design elements.
2. Recognize use of design elements.
3. Recognize art media and processes.
4. Recognize artistic mood.
5. Describe aesthetic characteristics.

6. Discriminate artistic style.
7. Analyze aesthetic similarities and differences.
8. Recognize artistic characteristics.
9. Recognize aesthetic characteristics.

DEVISING A LESSON PLAN: You may be the only art teacher in your school, or one of several, in which case you may be specializing to some extent. You may well be teaching something for which you find yourself not quite as well qualified as you would like. Remember that you know the basics of art or can learn them. Read books to teach yourself new techniques. Ask questions of people who do know how to do a technique you would like to learn more about. Invite experts to share their knowledge with your classes.

Devise a lesson plan for each new unit. Some theorists feel that each lesson should be presented orally, written on a board, and visually demonstrated to reach students' different learning styles. Take advantage of the film strips, VCR tapes, movies, laser disks from galleries, and slides that may be borrowed from libraries. This takes planning but is worth the extra effort.

Keep the art program educationally sound

1. ENCOURAGE CREATIVITY: Imagination is developed by teaching students to look for an unusual but elegant solution to a problem. In addition to teaching practical skills such as drawing, painting, photography and appreciation, art teachers are also developing the right side of the brain, the intuitive, creative side.

2. INTEGRATE WRITING: Educators are realizing that students can improve their communication skills by "writing across the curriculum." Many students enjoy writing poetry or prose to illustrate their artwork. Students may write a research paper on some aspect of art or a biographical sketch of an important person in the field. Invite a reading specialist or English teacher in to discuss possible approaches in writing poetry or prose.

One teacher I know has her students write in a journal each day for the first five minutes of class while she is taking attendance and getting organized. Sometimes she puts up a piece of work for them to analyze in writing, or asks them to list ten things a color such as red reminds them of. She might ask them to describe themselves or their family. She collects and grades these weekly and says it helps her understand the students, gets them settled down to work on art, and helps them put thoughts about art into words.

3. APPLY CURRENT RESEARCH: and be open to change. Keep abreast of current research in your field. Don't make changes just for the sake of change, but enhance your program by teaching more historical background or art appreciation skills. Analyze your curriculum to see if you are trying new things or if you have made recent changes.

GETTING SUPPORT FOR THE PROGRAM

Although art specialists understand the importance of fine arts courses in education, it may be necessary to demonstrate their importance to others. Schools are dependent on taxpayers and others for financial support. If that support is withheld, the fine arts are sometimes the first thing to go. It is good for the students, the school and the community to let others see what art students are doing.

The school administrators and guidance department should play a vital part in decision making about

your curriculum. However, you are the art expert and must be prepared to inform them about what is happening in your field. Let administrators know that art has a curriculum just as any discipline does.

Make your school look good

Just as succesful sports programs, musical and dramatic events give students opportunities to share their talents with others, an art program should show what the art students are doing. One advantage to displaying artwork is that it needn't be a one-time event, but is something that can always be on view.

1. *MONUMENTAL ARTWORK FOR THE SCHOOL:* Look for an empty spot crying out to be filled with a large work of art, or see if existing decorations need to be replaced. Get permission first. To get inspiration, look at artwork being done for new buildings and hotels. Instructions for murals are given in the painting chapter, and large bas-relief wall sculptures are described in the chapter on three dimensional design.

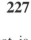

2. *CHANGING ART DISPLAYS:* Establish changing displays of art around the school, such as a permanent display cabinet with monthly exhibits done by various school departments. Student artwork may be displayed on bulletin boards or mounted behind plexiglass throughout the school. Effort is needed to keep these displays up to date. Students are often reluctant to donate their best work, so occasionally do a classroom assignment especially for the school. In a printmaking or photography course ask the student to give one print to be displayed in the school.

3. *PRINCIPAL'S COLLECTION:* At the end of the year, have a contest in which the winner will leave a work of art as part of a permanent display in the principal's office, the library, or other prominent location. A parents' organization could sponsor this contest, furnish a small prize, and frame the work of art. It costs little more to affix a brass plaque with the student's name and the year to the frame, and the student will appreciate the honor.

Photo 11–1 This 7′ x 27′ tapestry was created during class time, based on self portraits.

4. *PERMANENT EXHIBITS OF STUDENT ART:* Display student art in administrative and guidance offices in your school. The art can be matted or framed. Make certain that the artwork stays fresh by changing the mats if needed and changing the exhibit from time to time.

Show the administration your program

1. *KEEP THEM INFORMED:* When a student or staff member has done something special, send a memo to the principal and announce it in a daily bulletin. Let your principal know if student artwork is being displayed somewhere in town. Invite all administrators to all of your school shows. Send them handwritten invitations and personally invite them to come. Discuss student artwork with administrators. If they want to learn why some art might be considered better than others, point out a student's creative approach to problem solving. Discuss different approaches to the same project and why you encourage those differences.

2. *ENCOURAGE VISITORS:* Invite administrators, teachers, and parents to visit your class if you have something special going on, or even if your haven't. Encourage visitors to talk with students, to discuss their work with them. The opportunity for an administrator to talk with students during class is rare. Visitors enjoy observing both the bustle and quiet activites of the art department.

3. GET ADMINISTRATIVE SUPPORT FOR YOUR BUDGET: A strong art program costs! You will never have as much money as you would like but try to get enough to support a strong curriculum. Keep accurate records of your expenses. Plan ahead for large expenditures. If your project is large and will improve the looks of the school, perhaps it can be funded by the administration. If the curriculum is changing, try to get sufficient money to start new courses from some source other than your yearly budget. Conserve supplies and keep equipment repaired. Some districts auction items no longer needed, with the proceeds going back to the department that sold them.

Gaining support from the staff

1. ANNOUNCEMENTS: Send other teachers copies of an art department newsletter. Put special notices about student accomplishments in the daily announcements and in a principal's newsletter.

2. SPECIAL INVITATIONS TO SCHOOL SHOWS: Invite other teachers and their students to all-school art shows by written and personal invitations. One of the schools in my district originated a huge one-day all-school show at the end of the semester. Because the show is on for one day only, students and teachers make a real effort to come and see the work done by the students. See the appendix for suggestions on organizing the all-school show.

3. ACT AS RESOURCE PERSON FOR OTHER TEACHERS: Many non-art teachers realize that students learn when asked to do visual interpretations in other subjects. As your school becomes more "art-oriented," it benefits everyone. Many teachers simply want suggestions or ideas. Most teachers are considerate and realize that your time is limited. Send a memo to the teaching staff letting them know how you can help them (without having your own program suffer).

If asked, help with suggestions for posters and decorations for bulletin boards or dances. Many teachers sponsor fund-raising activities and dances and just need ideas. Have them find out if they have art students involved in such activities, and be willing to share ideas with those students.

Gaining support from the students

1. DISPLAY STUDENT WORK: Make students proud that they "belong" to the art department. Because constantly changing exhibits is time consuming, let students help in creating displays. Even though you may prefer to exhibit only wonderful work, all students benefit from having their work exhibited. Hang the strongest work in the middle and on the ends of a display, and eveything begins to look good. Students truly learn from seeing their work displayed on a wall along with other interpretations of the same project. Talking about the work helps them become aesthetically discriminating.

2. ASK STUDENTS FOR SUGGESTIONS: If the classes are good, students will support the program. No form of advertising for enrollment is as strong as student discussion about courses. Examine your classes each year; see which projects were less successful than others or which are out of date. Ask the students—they will tell you. Try new things. Don't be afraid to "bomb" once in a while. A good saying for art teachers is "it is better to be among the wounded than the watchers." Just as art teachers constantly encourage students to try new things, they should be willing to improve their courses.

3. ARTIST OF THE WEEK: Hang the work of one student in a prominent place, identifying that student as "artist of the week." A certificate may be given to each student who achieves that status.

INCREASE COMMUNITY AWARENESS OF ART

PUBLIC RELATIONS: Inform your community in many ways that you have a strong art program. Without the backing of business leaders, parents, and taxpayers, your program could get lost. With their support, it can be enriched.

1. ART NEWSLETTER: Send an art department newsletter to all parents, staff, administrators, and other supporters, with information about local art exhibits and art classes. If you live in or near a large town with a museum, give dates for any special exhibitions that people might like to see. Mention anything newsworthy that has been done by art students for the school or any outside recognition they have received. Discuss what is happening in one of your classes. This newsletter could go out twice a year, simply to inform parents, students, and teachers of art happenings in your school and community.

2. PRESS RELEASES: Many large school districts have a public relations office, with publicity going through that office. Local newspapers are usually pleased to receive five by seven inch black and white glossy photos of a newsworthy item. If you are sending the item to more than one paper, send different poses to each. Send a number of photos so they may choose. If called, many newspapers will send someone to photograph a unique activity. Newsworthy items also should be covered in the school newspaper and daily bulletin.

3. MEDIA COVERAGE: Local TV or radio stations offten are looking for newsworthy items. Telephone to ask if they would be interested, then follow up with a news release. Some items considered newsworthy:

1. Dedication of monumental artwork for the school
2. Student winner of a major competition
3. A visiting artist or artist-in-residence working with the students
4. Almost any unusual activity, such as making paper or marbling (see Crafts chapter)
5. Residents of retirement homes working with students
6. Student winner of scholarship to art school
7. School district or business-sponsored art exhibit
8. Profile of one student or teacher

SCHOOL–BUSINESS PARTNERSHIPS

Many business people are willing to help students. You can often receive unexpected support with nothing more than a phone call or letter. Listed below are some ways that businesses are involved in schools around to country.

ART COMPETITIONS: This type of contest involves recognition of the student in two ways: a cash prize and the thrill of seeing one's design reproduced. See the appendix for suggestions on "Entering Student Art Competitions."

1. *Billboard contest:* Approach the owners of a billboard or an advertising firm to see if they would be willing to put a student-designed public service announcement on a billboard. Appropriate themes could be about drunk driving or an announcement about Youth Art Month.
2. *Poster competitions:* One local foundation sponsors a competition for posters against crime.

3. *Transit authority competition:* The local bus company might furnish large sheets of plywood for students to paint public services messages.

4. *Temporary murals:* In some towns merchants are pleased to offer windows as blank canvasses for students to paint at Halloween. Downtown construction sites often have "temporary" fences that remain in place for at least a year. Merchants often supply paint and offer substantial prizes.

5. *Design a logo:* Recently a local dentist offered generous cash prizes for students to design a logo. If a "real" project fits into your program, it is meaningful to the students.

INTERNSHIPS: Students may work in an advertising firm or photography studio, for example, and receive high school credit.

PLACES FOR STUDENT EXHIBITS: Banks often are delighted to host a small student exhibit and occasionally offer prizes.

MAJOR EQUIPMENT RESOURCE: Businesses may be willing to donate a one-time major purchase. For example, a printing company in a small town in Missouri totally financed the establishment of a darkroom and commericial art studio for the local high school. Ultimately it will benefit them, and it certainly benefited the high school.

As businesses are upgrading equipment such as computers or copiers, they may be willing to donate good used equipment to the school. Even if they cannot help you the first time you ask, they'll keep you in mind for the future. Follow up requests with written memos.

TIPS ON CLASSROOM ORGANIZATION

The purpose of organizing your workplace and methods is to let you enjoy your students and do what you were hired to do—teach them about art. Not all teachers are so fortunate as to be able to teach what they also *do*. Let your joy in teaching be reflected in your surroundings. Your room should *look* like an art classroom. It should be colorful and contain displays of student work as well as examples of work done by other artists.

To keep surfaces clean, artwork-in-progress and materials should be stored away from sight as much as possible. Here are a few tips gleaned from teachers who appear more organized than average.

What the room must have

1. Seats for each student that face the teacher. Don't allow students to sit with backs to you or to sit behind you. Most art teachers don't lecture a great deal, but make sure you see their eyes when you are talking.

2. A workplace for each student where belongings may be put either on or under the table.

3. Space for drying student art projects. A drying rack is recommended for convenience.

4. Teacher's desk. This should be close enough to students so you don't have to raise your voice to be heard from the back of the room. The teacher's desk drawer should be off limits to students.

5. Place to store student work. This should be organized by class, with shelf space or drawers for portfolios or flat work. If nothing else is available, open industrial shelving can serve the purpose.

6. Storage for work that will be exhibited or used in special shows.

7. Clean-up area: sinks with enough room on both sides so more than one person can use them at a time.

8. Fire extinguisher.

THE DAILY ROUTINE: HOW TO KEEP YOUR SANITY

1. Take attendance immediately. Accuracy cannot be stressed enough.

2. Generally a number of students may want your immediate attention. Either work out a "take a number" system or have them line up. Ask if anyone needs something that will take a simple "yes" or "no" so they don't have to wait in line. Let your students know that they are entitled to one and a half minutes of your time every day, and that you will genuinely try to see each one for that time. Naturally it doesn't work out that precisely, but it is very easy to let students get lost in the shuffle, and all students truly are equally entitled to that time.

3. Move around in your classroom. Although it is more comfortable to sit at your desk and let students come to you, many students are shy about asking for help. When you move around you can tell if a student could use your help. You'll never find what the "hiders" are doing if you don't go to them.

4. Begin cleaning up in plenty of time so students can do a good job. Usually it takes a minimum of five minutes before the end of the hour.

SAFETY TIPS

Students must be taught safe procedures. Some of the materials artists work with required special precautions. For example, permanent markers contain organic solvents, and should be used in a well-ventilated room. Keep abreast of current research on art materials. Certain procedures are standard for your protection and that of your students. An excellent book, *Safety in the Artroom*, by Charles A. Qualley (Davis Publications, Inc., 1986), will answer specific questions about most media.

1. Have safety goggles available if students are working with anything that might damage an eye. Insist they wear them for certain tasks such as sculpture or working with dangerous chemicals.

2. If working with anything that might damage skin or where the directions say to wear gloves, students should wear disposable gloves.

3. The room should have a window or exhaust fan for proper ventilation. If you are using sprays or noxious substances, have the students take them outside to work.

4. Flammable solvents should be properly stored in a metal cabinet.

5. Each art room should have a functioning fire extinguisher good for paper, wood, or chemicals. This should be routinely checked to make sure it will function.

6. A kiln should be in an area that is not accessible to students. If it is not in a separate room, it can have a wire enclosure separating it from students. The kiln and other dangerous equipment should have DANGER signs posted. It must be adequately ventilated.

7. Paper cutters *must* have a guard next to the cutting edge. Secondary students should be given instructions in proper use of the paper cutter.

8. Extension cords and wall outlets must be checked periodically to eliminate danger of electric shock.

GRADING

There are as many ways of grading as there are teachers, but the idea is to make it as easy as possible and still be fair and accurate. Explain to yourself why you gave a work of art a certain grade so that you can explain it to the student if he or she wants to know. The student is entitled to know at any time in the course

approximately what grade is being earned. Try to keep up with grading so that it does not become overwhelming. Students appreciate immediate feedback.

PERCENTAGE-POINT SYSTEM: Grading on a percentage system can make your life easier. Secondary students are accustomed to being graded on percentages in other classes and understand perfectly well what grade they are receiving when you tell them they have a 75 percent. With such a system, an 89 percent is a much more specialized grade than a B plus. It tells that student that it was almost an A, but lacked a little something, and trying harder next time will improve the grade. It is easy to compute at any time in the course, and final tabulation may be easily done on a calculator. The student may even keep track of the grade.

Decide what your percentage grades represent. Check with colleagues in other disciplines to see what represents an A and what percentage marks a failing grade in your school. The most common values are:

A 90-100 percent
B 80-90 percent
C 70-80 percent
D 60-70 percent
F Below 60 percent

Determine what your total number of possible points could be for a grading period. For example, if you assign 100 points per project, then twelve projects will give you 1200 possible points. Assign 200 or 300 points for difficult or time-consuming projects. Simple projects receive less credit than a normal project. Simply add up the points the student has earned and divide by the number possible (e.g. 1200) to reach the percentage grade. A total point-percentage system has a number of advantages:

a. It is easy to give extra credit in points (five or ten).

b. Points may be deducted if work is excessively late.

c. Points may be given for perfect attendance or deducted for tardies.

d. Weekly points for cleaning up may be added on (or deducted).

CARE OF MATERIALS AND EQUIPMENT

At times metal rulers and scissors may seem to be consumable supplies rather than equipment. Keeping equipment organized and available in the art room can be a challenge. Here are some tried and true methods from a number of teachers:

1. Spray scissors with enamel so they will be easily identifiable and so ugly that no one will want them. If you have a number of teachers, each can use a different colored enamel.

2. Write with permanent marker in very large letters on anything that might be borrowed. A sign out sheet for supplies helps keep them under control. If loaning valuable things (or even your own pencil) to students during the class, have them leave a "forfeit" (such as car keys or a watch) until the equipment is returned.

3. If students or teachers want to check something out overnight, always have them sign an equipment sign–out sheet.

4. Expensive equipment should be engraved with an engraving tool. Most schools have one, or they may be borrowed from the local police.

5. One teacher asks each student to make a deposit on a brush, which is then his or hers until the end of the course. If the brush isn't kept in a safe place (a pocket in a notebook or a student locker) and disappears, the deposit is forfeited.

6. A student could be responsible for counting materials or books at the beginning and end of each hour. Store set number of supplies in cans (example: 25 rulers, 25 pencils). Supplies should be put away each hour and taken back out when needed.

7. Provide storage drawers for paper.

8. Organize storage for supplies. There rarely is enough room for storage, so keep reorganizing until you can't refine any further. Just as a kitchen has a place for everything, the art room should have a permanent storage place for everything. As you get materials out, put away other items not being used. Have locking storage someplace in the room where expensive or irreplaceable items or equipment are kept. If there is something you can't bear to throw away for the moment, but don't intend to use for a long time, there may be storage elsewhere in the school away from the art classroom.

9. As new supplies come in, label them with the year's date. Remove the old supplies and put the new ones at the back so you use the older items first. If this means you never have supplies that are reasonably fresh, then give some of your older paper and paint to teachers in other disciplines.

THE STUDENT'S PART IN ALL THIS

KEEPING THE ROOM CLEAN: The student has some responsibility for the physical surroundings in an art class. Without a great deal of help from *all* students, the teacher will be ineffective. It is not fair to rely only on the few students who always want to help. All students have to be taught to be responsible. Most are willing to put away their own work when finished at the end of the day and clean up after themselves, but have to be "encouraged" to clean the work areas in the room. You simply do not have the time to clean, and you should not expect your custodian to do much more than clean the floor.

A clean-up chart lets students know what is expected of them. They need to be reminded most days, but it is fair, and will eliminate most grumbling. When selling it to your students, tell them:

1. It does not rely on any one student being there to do a certain job.

2. An entire table (or group of desks) is responsible for a certain part of the room. That table does that section for one week. The next week it has a different job.

3. This should not be done for extra credit; it is part of the grade.

4. Students must understand that they still clean up after themselves. The clean-up chart is just for extra things that must be done such as cleaning up the paper cutter table, cleaning around the sink, picking up scraps off the floor, and leaving the work tables totally clean. If it is done each hour, the room looks pretty good all the time and no one suffers too much.

5. For extra-big jobs, such as scouring the sink or cleaning out a cabinet, a student may be allowed to gain points, erase a tardy, or gain some other privilege.

PREPARING FOR SHOWS AND DISPLAYS: From the first day of class, have students save their work in a tagboard portfolio. Don't let artwork go home without a firm promise that you will get it back the next day. Students enjoy helping to get their work ready for shows. You may wish to help them select the best

work to mat. When it is time to actually hang the show, they should see to it that their work is properly labeled and put in a stack with the work to be hung.

TEACHING EACH OTHER: How can a teacher ever give each student the time needed to teach him or her individually? Although some students catch on quickly, every student has the opportunity to be an "expert" on at least one project a year. Suggest that students discuss with their classmates which thumbnail sketches are most sucessful, for example. It naturally evolves that students help each other in most art classes. Some classes, such as drawing, do not need the interaction necessary in some other classes, but it is always good for students to talk with each other about their work. Art classes offer a wonderful oportunity for young people to get to know each other.

KNOWING WHAT IS DUE AND WHEN: The teacher should help as much as possible by making wall charts with due dates or even individual calendars. Ultimately, the student is responsible for getting work in on time. If this means coming in before or after school or taking work home, so be it.

UNDERSTANDING THAT WE'RE ALL IN THIS TOGETHER: Students and teachers work together to help make a class successful. It is not the total responsibility of one or the other. Encourage students to ask questions when they don't understand. If there is something they especially want to learn, they should let the teacher know now. Don't be afraid to let them know that you are also asking questons of yourself, willing to make changes and always trying new approaches to teach them discipline.

APPENDIX

SKILLS TO TEACH

Certain useful skills should be taught in a basic secondary art course. They are applicable in many courses, and most students will come to classes with some general knowledge.

1. *Safety in cutting.* Students should know how to use an X-acto knife and a metal ruler to make a straight cut on paper.
 a. To cut a "window" in paper or cardboard, the cuts should be made slightly beyond the corner so the corner will be perfectly square.
 b. Students should be shown how to use the grid on a paper cutter to ensure that they make a straight cut.
 c. If you allow them to cut with a single-edged razor blade, remind them that the free hand is *always* held behind the razor, where it would not slice the hand if it should slip.
 d. If students are cutting with lino-cut or wood-cutting tools, the hand should be behind the tool, or it almost certainly will get cut. Use a bench hook to hold the linoleum in place (metal bench hooks are available through art catalogues).

2. *Measuring.* Secondary students should have had some experience in measuring but many have difficulty and should be given some pointers. You may show them how to use a T-square. They should assume that a precut edge on the paper is straight. Tell them to cut the outside dimensions of the mat first to conserve paper. After the opening is removed they can save it for another project.

3. *Making a thumbnail sketch.* Students should be shown how to work out ideas. They need to understand that a thumbnail sketch is a quick rough sketch, not a finished product. They need to try several ideas quickly to come up with one that is worth turning into a more finished sketch. Generally, the first sketch is not wonderful, but as it evolves it becomes personal. Point out that these will not be graded, but they are simply a way to come up with original ideas. Let them know that you would expect to see a minimum of three sketches finished within a ten minute period. You may even demonstrate how quickly and roughly one is made.
 a. On a pieces of newsprint or tracing paper, make a number of shapes approximately 2 by 3 inches in proportion to the paper that will be used.
 b. Put down an idea quickly. The act of drawing almost seems to make good ideas come.

4. *Gluing and pasting.* Attaching one piece of paper to another can be messy unless proper technique is taught. Students have probably worked with white liquid glue, rubber cement, and library paste. If pasting down many things such as letters, place a sheet of newspaper underneath when applying the glue to allow it to go to the edges.
 a. Rubber cement gives a smoother result for most work. For a permanent bond, put a coat of cement on the back of the work to be pasted and on the front of the surface on which it will be pasted. If both are allowed to dry before being put together, the bond is permanent. Excess rubber cement may be rubbed away with finger, eraser, or a ball of dried rubber cement. A rubber cement "lifter" may be obtained in an art supply store. *Avoid inhaling rubber cement fumes.*
 b. White liquid glue must be applied carefully, or it can cause unattractive wrinkling. Put small dots of glue at least one half inch from the edge; apply a thin line of glue all the way around and 1/2 inch from the edge, or smear the glue over the entire back of the piece to be glued.

5. *Dry-mounting* artwork to a background requires a dry-mount press and dry-mounting tissue. It is mostly used for affixing photographs to mount board, but does have other applications. To dry-mount, lightly tack the dry-mount tissue to the back of the item to be mounted. Trim the edges, cutting through the artwork and the tissue at the same time. After carefully measuring and marking, place the artwork on the mountboard, and place in the mounting press. Pull down and leave in the press approximately thirty seconds. Directions that come with the dry-mount press will give temperatures for various materials.

6. *Signing a work of art.* Students love to see their names on artwork, but remind them that the proper ways of signing work do not detract from the work of art itself. These conventions for signing have evolved through centuries. Identification of original work from copies is often determined by the signature of the artist.

 a. An original print must be signed in pencil in the lower right-hand corner, just below the border of the print. A title may be written, also in pencil, in the lower-left corner. If the print is one of a series of identical prints from the same plate (an edition), the print should be numbered. For example, if the print is the eighth print of a series of forty, the print would be numbered 8/40. The first number represents the order of the print in the edition, and the second number represents the number of prints in the edition. If the print is not identical to other prints in an edition, the artist puts AP (artist's proof) in the middle. If there is only one print (mono-print), this identification would not be necessary.

 b. A photograph is signed in pencil, either on the dry mount board or on the mat.

 c. A pencil drawing is signed in pencil and an ink drawing in ink.

 d. An oil, acrylic, or tempera painting may be inconspicuously signed in paint, perhaps in a slightly different value of the color on which it is painted. Generally, the signature is in the lower right corner of the painting.

 e. Most other media such as pastel or watercolors are signed in pencil.

DRY MOUNTING

1 TAKE DRY MOUNT TISSUE OF PROPER SIZE

TURN DRY MOUNT PRESS TO 180 FOR RESIN COATED PAPER

USE TACKING IRON TO TACK MOUNTING TISSUE **2** TO CENTER OF BACK OF PHOTO

3 TRIM EDGES AND TISSUE AT SAME TIME ON PAPER CUTTER.
1. PUT STRIP OF CARDBOARD ON TOP TO HOLD FLAT.
2. USE GRID LINES ON PAPER CUTTER TO MAKE SURE YOU CAN STRAIGHT.

PLACE PHOTO ON MOUNT BOARD, MEASURING TO MAKE SURE THE BORDERS ARE EQUAL
4

LIFT CORNER OF PICTURE **5** TACK 2 CORNERS TO MOUNT BOARD

SET IN DRY MOUNT PRESS BETWEEN PIECES OF CARDBOARD (PICTURE SIDE UP)
6

7 LOWER PRESS AND PULL BAR FORWARD FOR 30 SECONDS

8 LIFT PRESS REMOVE PHOTO SET UNDER WEIGHT TO FLATTEN (5–10 MINUTES)

Student Notes: MATTING WORK

MATERIALS

X-acto knife

Mat board

T-square

Metal ruler

Masking tape

Push pin

1. Cut a piece of mat board that is larger than the picture by at least two inches.
2. Find the center of the mat board. Mark the horizontal and vertical measurements on the back of the mat board.
3. Determine the size of the opening. Generally, it is 1/2 inch smaller in both dimensions than the picture so that it overlaps the picture by 1/4 inch.
4. Measure that distance from the center of the mat and make a mark.
5. Use a T-square to make a straight line. Where the corners intersect, use a push pin to make an indentation that is easy to see when cutting. It helps to know when to stop.
6. Place scraps of mat board or a special rubber square for mat-cutting underneath the mat while cutting it.
7. Use an X-acto knife and a metal-edged ruler to cut along the ruler a number of times until the knife goes through the board. Hold the ruler down firmly so it doesn't slip. Remember to cut slightly past the corners to make them neat.
8. When the mat is cut, turn the artwork face down and place masking tape all the way around, with half of the tape free. Turn the artwork face up.
9. Carefully center the mat on the artwork and gently put in place. Turn it over and rub the masking tape in place to hold the artwork in.

PREPARING A PORTFOLIO

The portfolio presented by an artist seeking a job is quite different than that of an art student seeking admission to an art school The job-seeking artist will be quite specialized in one area. The art student should show a variety of skills such as drawing, painting, and basic design.

Preparing a portfolio is a good way to organize student artwork, select the best from it, and have a record of the work done in high school. It shows the student's ability and versatility. Generally portfolios are made by students who intend to go on to a career in art and must have a portfolio for admission to an art school. Whether students plan to attend art school or not, each one should have a portfolio simply to see the progress made in a course and to keep work together and organized.

Various universities around the country hold regional portfolio days where representatives of art schools from all over the nation look at student portfolios. These recruiters are looking for unusual ability and often offer scholarships to students with outstanding portfolios. Qualities that will attract reviewers are spontaneity, sensitivity, and a strong sense of design.

Advanced placement college credits may be received for an outstanding portfolio. For further information on preparing a student for advanced placement, write to Advanced Placement Program, CN6670, Princeton, NJ 08541-6670.

PORTFOLIOS ARE ORGANIZED IN TWO WAYS: Examples of original artwork may be submitted, or slides of artwork may be shown. Three-dimensional, fragile, or large work would always be shown by slides. A portfolio for actual artwork need be nothing more than 24 by 44 inch tagboard folded and taped on three sides. Two pieces of foam core may be used instead of tag board. Professional artists' portfolios may be purchased at art supply stores or through catalogues.

Although some art schools prefer to see actual artwork, usually slides are used to apply for admission or advanced placement. If sending the artwork, send matted work that is similar in size. One disadvantage of sending the artwork itself is that it can only be in one place at a time, and you may wish to be considered by a number of schools.

WHAT SHOULD BE IN THE PORTFOLIO?: A good portfolio should contain from twelve to twenty works of art. If a student has taken a number of art courses, a variety of media should be represented. Copies of published work are unacceptable. An interpretation of a masterwork could be considered, but paintings and drawings copied from magazines or photographs taken by anyone but the artist are just not done. Originality and creativity cannot be stressed enough. Size of the work is not important, though variety in media is desired. Consider including something less than perfect if the student has stretched and shown imagination. The following are the three important skills to include in a portfolio:

1. *Drawing:* a portfolio should have good examples of drawing in a variety of media such as pastels, colored pencil, magic marker, ink, charcoal, and conté crayon. A sketch-book could be included. The best drawings are familiar objects, people, nature, and architecture.

2. *Painting:* acrylic, oils, pastels, watercolor paintings. Drawings made with colored media could take the place of painting in the portfolio.

3. *Design:* include a poster, publicity flyer, photographs or lay-out to show ability to combine a variety of elements.

The student may wish to explore one medium in depth and might have a large number of works that evolved in a given field of concentration (such as studies of the human form). It is best to avoid having work that only reflects classroom assignments. A student who is submitting a portfolio should show evidence of original thinking and depth. Quality is far more important than quantity.

Student Notes: TO PHOTOGRAPH A PORTFOLIO

MATERIALS

35mm single lens reflex camera

Tripod

Two photo flood lights with 3200 K bulbs

Cable release

18% gray card (may be purchased at a
photography store)

Ektachrome 160 ISO film for tungsten lighting

Plastic slide sleeves

A copy stand may be used for photographing
small work

Neutral cloth as a background for
three-dimensional objects.

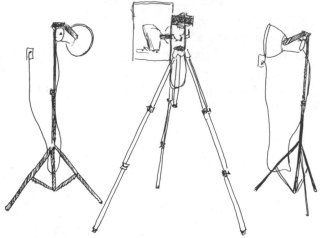

Photographing a portfolio.

DIRECTIONS

To photograph the artwork, it is important to have even lighting without reflections. The following procedure
is recommended.

1. Turn off overhead lights and work well away from a window.

2. Pin the work on a wall with a neutral background.

3. Place the lights level with the center of the artwork and at a 45 degree angle slightly in front of the
 camera.

4. Place the camera on a tripod and use a cable release to avoid camera shake. Look through the
 viewfinder to make sure there is no glare (hot spot) on the artwork.

5. Have someone hold an 18% gray card directly in front of the artwork, and take the camera up to it.
 Get close enough so you see only the gray card, and take a reading for proper exposure on it. Make
 sure you don't block out the light while doing this. Trust the gray card! Cameras will "see" too much
 or too little light and will compensate by closing down on white backgrounds and opening up on dark
 ones. If you don't move the lights, it is possible to take photos of a number of different works of art
 without changing exposure. To be absolutely certain you have photos with "true" color, you may
 wish to bracket by taking readings with the gray card, then overexposing one or two stops and
 underexposing one or two stops.

6. Back up and take the picture according to the exposure reading taken on the gray card. Rarely does a
 work of art have the exact proportions of the camera. You may either take only a portion of the
 artwork and fill the viewfinder, or you may tape the slide later (underneath the slide mount) with
 silver tape available from a photo supply store. Students may wish to take five shots of each work of
 art if they are sending out a number of slide sleeves for admission to college.

7. Slides of artwork may be taken outside in shaded daylight at mid-day (to assure a full spectrum of white light) with outdoor slide film, but the results may be less reliable. If doing this, bracket the exposures to get one that is perfect.(Take one slide at a perfect reading,then overexpose one slide and underexpose another slide to try to get a good result.)

8. After the slides are developed, select the best twelve to twenty and put them in slide sleeves. Some schools say to use absolutely no tape on slides, as it makes it difficult to view them if they should stick in a slide tray. Put a mark or red dot on the lower left hand corner. Number and label them as follows: Name, date when work was done, medium, size, title of artwork. Include a separate sheet with numbers corresponding to the slides. After each number on the list give the artwork's size and medium.

THE ALL-SCHOOL SHOW

1. *Enter show on school calender.* Plan early to schedule the show near enough to the end of the year that you will have a minimum of two good works of art from each student. End-of-semester shows are another option.

2. *Prepare for the show from the beginning of the year.* Each student should have a tagboard portolio in which work is stored. From the beginning teach students how to mount or mat their work. The mats may not be wonderful at first, but you will be grateful for the help in matting later. It is better not to let artwork go home before the show, as you will have great difficulty getting it back. If you do let it go home, one way to ensure it will be returned is to deduct points if it is not.

3. *Honor some outstanding students.* Students with outstanding work may group their work with a hand-lettered card with their name on it. This is a privilege students look forward to.

4. *Display methods.* Plan ahead for ways to display your show, using available walls, purchased display systems, or hand-made displays. Folding display cubes made of foam core (T.M.) and folding screens may be made rather inexpensively. Wonderful display screens may be made by hinging two or three hollow-core doors together and painting them, as one of our local malls has done. They are light enough to be stored away until needed.

5. *Label artwork.* Make a page of 1-1/2 by 3 inch labels on white card stock with the name of the school, a line for the student's name, grade, art class, medium, and teacher. Have students print their names with black fine line marker. Avoid damaging the mat by attaching the labels with masking tape on the top back of the label and the lower back of the mat.

6. *Get parental help.* Interested parents may be willing to help hang the work. Serving refreshments can be the responsibility of a student art club or parents. Students generally are willing to bring in cookies or brownies if asked (and offered extra credit).

7. *Security.* If there is any possibility of damage to work, assign students to watch the exhibit between classes.

8. *Publicity* is very important.
 a. Talk it up in class. Encourage students to mention the show to their parents and to especially invite their teachers.
 b. Announce the show in a newsletter and daily bulletin.

 c. Select a piece of student artwork to be reproduced for a flyer with information about the exhibit. If possible, mail it to the students' homes (see if another school mailing is going out at a good time so you can "piggyback" your invitation in that mailing). If not, give it to the students to take home shortly before the show. Put copies in teachers' mailboxes along with a note inviting them to bring their classes to the show. Send copies to administrators and colleagues in other districts.

 9. *Demonstrations.* You may choose to have students demonstrate art in the evening. People enjoy seeing artwork created, and a few tables set up where students are working will receive favorable attention. Set up a schedule and get a commitment from students to be there to "show their stuff."

All-district show. A number of school districts have a once-yearly exhibition of work from all levels in the district. An exhibit of this type should not replace the all–school show, as it usually involves a limited number of the best pieces. It may be held in a park recreation hall or a shopping mall. If it is held in a mall, the merchants may take care of publicity and invitations.

ENTERING STUDENT ART COMPETITIONS

Teachers sometimes differ on whether students should be allowed to enter competitions because of their own feelings about how it might affect the student if the work is rejected. However, students are often in competitive situations such as sports, debates and play tryouts. Learning to handle disappointment could be considered part of education. Prepare the student for the possibility of rejection as well as acceptance. Let him or her know that contests are usually decided by only one person, and if you thought enough of the work to recommend submitting it to a juried competition, then that means it has a chance.

 Read the directions carefully about how and when the work must be presented and returned. If work has to be mailed and returned by mail, make sure you consider this a worthwhile competition. Follow presentation directions to the letter. If the regulations specify framed work with wire attached for hanging, the work may be rejected if it is not sent in that way.

 If the student is accepted in the competition let the student and his or her family know so they may attend any reception. Attend the reception yourself if at all possible.

 Normally the sponsoring agency will announce the winners in a competition. If this is a National Scholastic competition, they will take care of sending publicity to local newspapers. Simply being accepted in a juried competiton is an honor, and you should announce it in the daily bulletin and an art newsletter, and possibly in a local newspaper.

Points to consider in entering competitions

1. You need not have every student participate in every competition, but you could allow three or four to substitute a contest entry for a classroom assignment.
2. Any competiton is defeating the purpose of art education if it requires the student to use artwork done by another artist as part of the entry. An example is a theme park that wants specific cartoon characters in the poster.

What types of competitions are available?

COMPETITIONS THAT ACCEPT GENERAL ARTWORK: National Scholastic exhibits often are held regionally for secondary schools. The work of regional winners goes on to final judging in New York. If you do not have a regional exhibit, the work may be sent directly to New York. For more information on where regional exhibits are held or how to send the work directly to New York, write: Scholastic, Inc., 730 Broadway, New York, NY 10003. A nominal handling fee must be paid in advance before work will be accepted.

National magazines often mention contests for the work from secondary and grade-school students. Some of these have major prizes for the student and the school. University-sponsored art shows of high school student work are common, and the prizes may be scholarships for that school. Before entering a student's work, perhaps you should consider whether that student would go to that school if he or she won the competition.

Local professional artists' organizations may sponsor young artists' competitions.

Parks and community recreation departments sometimes sponsor secondary art exhibitions.

Local businesses sponsor competitions.

COMPETITONS FOR SUBJECT-SPECIFIC ARTWORK: Statewide agencies often depend on schools to design posters. Statewide winning work is sent to Washington, DC, to compete against other state winners for a poster to be used nationwide. One of these competitions is sponsored by State Agencies for the Handicapped.

An open competition may be sponsored for photographs to be used in state publications. Photography exhibits are often sponsored by parks departments or animal shelters with the proviso that the subject be directly related to the sponsor's interests. Charitable foundations sometimes sponsor a yearly show with prizes.

ORGANIZE A FIELD TRIP

Offer students a different environment in which to draw, photograph, or absorb something about the field of art by taking them away from the school. Many field trips will have a measurable impact on art done by the student. Decide what you feel is important to get from the field trip, and prepare students carefully for it. Follow up when the class is back in school.

1. The field trip can offer an enriching experience to students that they can look forward to and plan for from the first day of class. Here are some general guidelines to follow:
2. The primary goal of a field trip is to bring back all the students who went with you!
3. Let students help you decide where to go.
4. Plan as far ahead as possible to avoid conflicts in dates with other school activities.
5. Always have a place where students who wish to bring lunch may eat it, even if most students prefer to buy lunch.

6. Keep an accurate list of who is on the bus. Have two students count with you, and make sure everyone is on before the bus leaves for the next destination. The buddy system and your attendance list should let you know quickly if someone is missing.

7. Make a list of materials or equipment needed. Let students assist you in distributing and collecting them to ensure the supplies are on the bus.

Places To Go

- Outdoor food markets or a farm where produce is displayed
- Zoo
- Artist's studio
- Museum
- Center of the city
- Park
- Architectural tour of old houses or interesting buildings

When To Go

If you will be outside, plan your trips when weather conditions are best. If a special museum exhibit is scheduled at a certain time, obviously you take it at the available times. Often a specially-trained guide is provided to explain the exhibit. Ask in advance if chaperones other than the teacher will be expected.

Between the fifth and twelfth week of the quarter is a good time. By then students will have learned skills that could be used on the trip, but enough time is left in the course to get benefit from what the student has drawn, photographed, or learned on the trip. If a student does not go, make provision for that student to be supervised at school.

Transportation

A school bus, the least expensive form of transportation, holds forty to fifty students. Check with your transportation office to find out the hours they might be available to you and what the cost is.

Charter buses are also available. Your school or district transportation office pobably will advise you which company they perfer.

Fill the bus to make the trip economically feasible. Two art classes might share the bus, or invite a teacher from another department to join you for an interdisciplinary experience.

If all classes are going to the same destination, several buses may be needed. Plan on having at least one adult on each bus.

For weekend field trips by train or plane, work through a travel agent for the best value.

Under *no circumstances* allow students to drive on a field trip. If students are injured while driving, it is yours and the school's responsibility. It would be possible to let parents drive a group if the school agrees.

Finances

If no money has been budgeted for field trips, students can pay for the trip. In calculating the trip's cost, assume that fewer students will actually go than say they will. That way if someone is ill, or backs out at the

last minute, you should be able to absorb that cost. This also allows you to pay the transportation if a student genuinely cannot afford to pay for the trip.

Fund-raising activities may be needed to finance overnight trips.

It is best if the money is collected by the bookstore or secretary at your school who handles money. Give the person who is collecting the money a list of students who are going. Don't accept the money unless the student has a signed permission slip from home.

The Permission Slip

The permission slip should explain where the student is going, what time the bus will leave and return to the school, the cost, and arrangements for lunch. Every student must have a permission slip signed by a parent or guardian. Do not take a student without one! Students may not understand the reasons behind this, but you must protect yourself and the school district from possible lawsuits in the event something happens on the trip.

Teacher Notification

At least two weeks before your trip, send a note to the teachers explaining the purpose of the trip and the date. Include a list of students who will be going, alphabetized and separated by grade level. State that you are willing to allow students time out of the art class for make-up work. In addition to your note, students should present a field trip notice to each teacher and let the teacher know they appreciate being allowed to go.

Preparing Students For The Trip

ACADEMIC EXPECTATIONS: Let students know in advance what they are expected to achieve as a result of this field trip. If you are going to a museum, take advantage of any visual aids prepared for the exhibit by the education department of the museum. A zoo trip might be prepared for by talking about and showing animals in artwork throughout history.

- If drawings or sketches are expected, be specific about how much you expect them to accomplish.
- If photographs will be taken, tell them the minimum number expected.
- If visiting a museum show, they may be asked to represent something they saw either by writing about it or interpreting it in a work of art.

EXPECTATIONS FOR BEHAVIOR.: You need to tell students very clearly what behavior is expected. A field trip could be less than successful if they are not well prepared. Secondary students sometimes resent being asked to stay in line and close to the teacher, so a different set of "rules" may apply for some locations.

1. Students should never go anywhere without a "buddy." Explain that it takes more than one to help keep track of the time they must be back on the bus. Suggest all students wear a watch. If they don't have one, suggest they carry a clock or borrow a watch from a parent.
2. They must be back on the bus at_____(approximately ten minutes before you really must leave).
3. Define the exact boundaries within which they must stay.
4. Let them know that they could destroy all hope for future field trips if they don't abide by the rules and use good common sense. Although it seems excessive, suggest that they think carefully about whether a behavior or act might embarrass their parents, teacher, or school. Stress to them that they

represent your school. Experienced teachers suggest abiding by school rules as a guideline. Clearly state consequences if your "rules" are broken.

5. Talk about appropriate dress for the location and the weather. If jackets or umbrellas might be needed, students must bring them along, but may leave them on the bus if they aren't needed when they get there.

6. They should not touch artwork. It is amazing how many adults are not aware that oil from fingertips can damage artwork.

THE IN-SCHOOL FIELD TRIP

This type of "trip" takes one hour of a school day and is planned when a guest speaker or visiting artist is willing to speak to all the art classes for one or two periods. Many states have artists-in-residence who will speak to schools. You may be asked to pay expenses for a speaker, or the administration or a parent group may agree to pay for this. It can be a very rewarding experience for students. The procedure for organizing is:

1. Reserve a place where all students may fit comfortably (such as the auditorium or gym).

2. Follow the notification procedure for teachers, as previously listed.

3. Ask the speaker if a slide projector, screen, podium, and public-address system are needed.

4. Prepare the students as discussed previously.

5. Invite parents and other classes if room permits.

THE OVERNIGHT TRIP

An overnight trip might be something really special for an art club or selected serious art students. Worthwhile experiences might be gained from visiting a large city in your state or a neighboring state to see a special exhibit.

1. A special exhibit may have long lines or may be impossible to get into. Make advance arrangements with the institution you will be visiting to ensure there will be no waiting.

2. If cultural institutions or art colleges might interest students, arrange visits to these.

3. If you can't fill the bus with your students, collaborate with colleagues from other schools.

4. Have more than one chaperone. Discuss accommodations for students with coaches and other teachers who take teams and groups on overnight field trips.

5. Comply with school, district, and state education department regulations regarding transportation of students.

6. If going by plane. arrange to be met by a bus at the destination and to have bus transportation the entire time you are there. Bus company representatives can give details.